AFRICAN AMERICAN WOMEN WARRANT OFFICERS - THE NEW TRAILBLAZERS

Farrell J. Chiles

Dedicated

to

Annie Laurie Grimes, United States Marine Corps

Doris "Lucki" Allen, United States Army

Doris H. Hull, United States Coast Guard

and

To all African American Women Warrant Officers

Thank you for your Trailblazing Spirit.

Acknowledgements

Special thanks to all the African American Women Warrant Officers, their families, fellow Warrant Officers, and friends who contributed the biographies, stories, articles and photos to make this project successful.

African American Women Warrant Officers - The New Trailblazers

Contents

Foreword

African American Women Warrant Officers - The New Trailblazers: An Unrecorded History

Few records and statistics are available regarding female warrant officers; moreover, less regarding African American female warrant officers. According to the Warrant Officer Historical Foundation, available records indicate that March 1944 was the date of initial accessions of women into the Warrant Officer Corps, after authorization in January 1944. The first African American woman warrant officer in the Army was not appointed until 1950, according to Department of Defense records.

Gathering and recording historical data across the Armed Forces regarding African American female warrant officers is significant in capturing their premiere contributions or "firsts" in their career fields. Hence, the aim of the author, Farrell J. Chiles, in gathering data to publish this book, African American Women Warrant Officers - The New Trailblazers.

Throughout military history, African American women warrant officers have broken down barriers, created new opportunities, championed justice and risked their lives for the greater good. As creative, talented and determined African American female warrant officers, these women have sacrificed a great deal in the pursuit of equal opportunities in the Armed Forces and all aspects of life. For many, their commendable leadership paved the way for every woman, not just African American women, in the Armed Forces. Such as Summer Levert who became the first African American female boatswain's mate in the U.S. Navy to hold the position of chief warrant officer and Tywanda B. Morton, senior property book officer, who became the first female and African-American promoted to Chief Warrant Officer Five in the Maryland Army National Guard.

Farrell J. Chiles' book introduces and celebrates the achievements of aspiring, trailblazing African American Women Warrant Officers who paved or are currently paving the way for future generations of female warrant officers. Notable is the fact that his persistence in

recording African American Women Warrant Officers' history and contributions provides critical black history knowledge.

Very respectfully,

Ida Tyree Hyche, Esq.
CW5, USA, Retired

Introduction

I felt it important to highlight the careers and achievements of African American Women Warrant Officers as a unique and special phenomenon within the Warrant Officer Cohort. Their pioneering spirit of joining the military and their decisions to become Warrant Officers are trailblazing actions that must be recognized.

African American Women Warrant Officers are unique. Provided the opportunity, they have excelled at every level of the Warrant Officer "ladder".

They have served in Vietnam, Afghanistan, Iraq, and other places around the world.

They have served as Command Chief Warrant Officers in the National Guard and Army Reserve.

They have served as TAC Officers and instructors at the Warrant Officer Career College. They have served as Senior Warrant Officers at the Major Army Command (MACOM) levels.

They are definitely the Trailblazers in the military today. Whether serving in the Army, Navy, Marines, or Coast Guard they have shown remarkable leadership and their accomplishments are noteworthy.

I am in awe of their accomplishments and unless we see the significance of their contributions and continually tell HerStory, we will never know the impact of their military service.

This book is a compilation of biographies and stories of African American Women Warrant Officers from my previous three books, plus newly submitted biographies and stories that focuses solely on the careers of African American Women Warrant Officers.

African American Women Warrant Officers have demonstrated outstanding leadership within the Warrant Officer Cohort and in the military. They are experts in their fields; advisors and trainers; and role models and mentors.

President Barak Obama is quoted as saying, "Today, every American can be proud that our military will grow even stronger with our mothers, wives, sisters, and daughters playing a greater role in protecting this country we love."

1

That quote definitely includes African American women - especially, African American Women Warrant Officers.

I am honored to present HerStory. I congratulate these outstanding Trailblazers.

Regards,

Farrell J. Chiles
CW4, USA, Retired

"Until the lions have their own historians, the history of the hunt will always glorify the hunter"

- African Proverb

Warrant Officers' Definitions

Navy Chief Warrant Officers (CWOs) are technical specialists who perform knowledge and skills of a specific occupational field at a level beyond what is normally expected a Master Chief Petty Officer (E-9). The Chief Warrant Officer Program provides commissioning opportunities to qualified senior enlisted personnel.

A Marine Corps Warrant Officer, or WO, is a technical expert in an assigned field of specialty. A WO is higher in rank than an enlisted Marine, yet not as high as a regular officer. Unlike regular officers, Warrant Officers are chosen strictly from among the Corp's enlisted members.

Coast Guard Warrant Officers are mature individuals with appropriate education and/or specialty experience whose demonstrated initiative and past performance show they have the potential to assume positions of greater responsibility requiring broader conceptual, management, and leadership skills. While administrative and technical expertise is required in many assignments, Warrant Officers must be capable of performing in a wide variety of assignments that require strong leadership skills. Enlisted and officer experience provides these officers a unique perspective in meeting the Coast Guard's roles and missions.

The Army Warrant Officer is a self-aware and adaptive technical expert, combat leader, trainer, and advisor. Through progressive levels of expertise in assignments, training, and education, the warrant officer administers, manages, maintains, operates, and integrates Army systems and equipment across the full spectrum of Army operations. Warrant officers are innovative integrators of emerging technologies, dynamic teachers, confident warfighters, and developers of specialized teams of soldiers. They support a wide range of Army missions throughout their careers. Warrant officers in the Army are accessed with specific levels of technical ability. They refine their technical

expertise and develop their leadership and management skills through tiered progressive assignment and education.

HerStory of African American Women Warrant Officers

The first African American Woman Warrant Officer was appointed in 1950. I would love to know who she was, but I was unable to find her information through my research.

From 1950 – 1952, there still remained only one African American Woman Warrant Officer. From 1953 – 1960, no African American Women was a part of the Army strength. In 1972, there were five and by 1978, there were 12 African American Women Warrant Officers.

By 2013, the number of African American Women Warrant Officers had increased. The tables represent their participation on Active Duty and in the Reserve Forces. Of significant importance, the percentage of Army African American Women Warrant Officers compared to White Women Warrant Officers was 41.5% to 39.3%.

African American Women Warrant Officers
Active Duty Forces by Pay Grade – Including Coast Guard
September 2013

Rank	Army	Navy	Marines	Coast Guard
W-5	12	3	1	0
W-4	72	6	0	2
W-3	182	18	7	5
W-2	303	14	10	9
W-1	88	0	10	0
Total	637	41	21	16

African American Women Warrant Officers
Reserve Forces by Pay Grade – Including Coast Guard
September 2013

Rank	Army Reserve	Army National Guard	Navy Reserve	Marine Corps Reserve	Coast Guard Reserve
W-5	2	5	0	1	0
W-4	15	13	0	0	0
W-3	33	29	0	0	0
W-2	97	59	0	2	0
W-1	15	12	0	0	0
Total	162	118	0	3	0

African American Women Warrant Officers saw opportunities in the Warrant Officer Corps and their dedication to service has made a difference in the success of the American military.

African American Women Warrant Officers' Timeline

1950 - Annie L. Grimes of Chicago, who was destined to become a chief warrant officer later in her career, joined and went to Marine boot camp in February 1950

1966 - CWO Annie Grimes became the first African American woman appointed as a Warrant Officer in the Marine Corps

1970 - CWO2 Annie Grimes became the first African American woman to retire with 20 years of service

1977 - GySgt Mary Vaughn was the first African American woman to receive a Regular Commission as a Warrant Officer in the United States Marine Corps

1980 - CW3 Doris "Lucki" Allen retired after 30 years of military service to include three tours in Vietnam

1993 - CWO Carmen Cole was selected as a Warrant Officer becoming the first female in the Marine Corps to become a Motor Transport Maintenance Officer

1994 - Mary F. Carter was the first female presented with the United States Army Warrant Officers Association's Albert Holcombe Memorial Award as Warrant Officer of the Year

1995 - Doris Hull became the first active duty African-American woman to be promoted to Warrant Officer in the Coast Guard

1996 - Harriet Thompkins made history by becoming the first African American female Chief Warrant Officer (CWO) in the United States Coast Guard Reserves

1999 - Aurelia "Viki" Murray became the first African American female in the history of the Army to be promoted to the rank of Chief Warrant Officer Five.

2000 - CW3 Ida Tyree Hyche was selected as the Reserve Officers Association's first woman Warrant Officer of the Year

2006 - CW3 Belynda Lindsey served as the only Legal Administrator in country during her tour in Iraq

2006 - CWO2 Apple G. Pryor, assigned as the Main Propulsion Assistant onboard the CGC Boutwell, was the first African American female Naval Engineering Chief Warrant Officer of the Coast Guard

2007 - CW4 Martha Ervin served as the Senior Warrant Officer for the Combined Forces Command in Kandahar, Afghanistan

2007 - CWO2 Apple G. Pryor became the first African American woman CWO Naval Engineer in the Coast Guard

2008 - Donna Gialone became the third African-American woman to achieve the rank of Chief Warrant Officer (5) in the United States Navy

2008 - CW4 Sharon Mullens was the first African American female Warrant Officer HHC Commander in a forward-deployed contingency operation

2009 - CW3 (Retired) Doris "Lucki" Allen was inducted in the Military Intelligence Hall of Fame at Fort Huachuca, Arizona

2013 - Chief Warrant Officer Four Vickie Slade became the first Legal Engagement Warrant Officer in the Department of Defense

2014 - Chief Warrant Officer Five (Retired) Karen L. Ortiz was inducted into the Quartermaster Hall of Fame

2015 - Chief Warrant Officer Five Janice Fontanez became the first woman to hold the position of the Command Chief Warrant Officer of the District of Columbia National Guard

2015 - The U.S. Army Warrant Officer Career College renamed its Distinguished Honor Graduate Award to The CW3(R) Doris Allen Distinguished Honor Graduate Award

2017 - The U.S. Navy's CWO5 Valencia Simmons-Fowler became the first African American woman to achieve the highest rank in the information warfare community

2017 - Chief Warrant Officer Two Summer Levert became the Navy's first African American woman Bostswain's mate (while in the well deck aboard amphibious transport dock ship USS Verde (LPD 19)

2017 - Chief Warrant Officer Two Cicely Williams became the first African American female rotary-wing pilot in the Nevada Army Guard

2018 - Chief Warrant Officer Five Cheryl D. Monroe became the first African American female CW5 in the ammunitions field

2018 - Chief Warrant Officer Four Petrice McKey-Reese, U.S. Army, Retired, inducted into the Army Women's Foundation Hall of Fame

African American Women Warrant Officers

Alana N. Alamon-Scott, Warrant Officer One,
U.S. Army National Guard

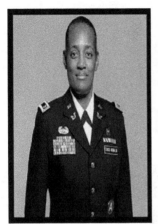

My path to becoming a warrant officer has been dynamic. Initially, I started my warrant officer process while deployed and compliant with active duty requirements. However, after the deployment and returning to my National Guard unit, I discovered that my warrant officer accession would be completed within National Guard requirements, which required changing some documents.

After completion of my basic course and returning to my unit, I have had to face many challenges as the first full time legal administrator in my state. I have so many great, innovative ideas that I want to implement to position my organization for greatness. However, I quickly learned that any change to an established order is not an easy task.

Despite the difficult learning experiences, I have had fantastic opportunities. I participated in a couple presentations with the Command Chief Warrant Officer of the SC Army National Guard, made a formal presentation to the Adjutant General of the South Carolina Army National Guard, and co-chaired the statewide Paralegal Training event. My current ongoing project involves meeting with statewide command judge advocates and associated personnel officers in effort to revitalize and obtain ownership of the career management for paralegals. Once this project is completed, my next project will be to empower the command judge advocates to create and manage consolidated legal offices at brigade and command levels.

In reflecting over my military career, I have realized that every experience has served as a foundational platform for the next level. Typically, paralegals in the Army National Guard have multiple MOS's and I have been extremely fortunate to have only one MOS for

my entire career. As a result of my rise through the ranks, I am able to personally empathize, understand and identify with the complaints of the paralegals in my state. I am very passionate about my craft, I am excited about the opportunities that present themselves, and I am looking forward to a rewarding career as a legal administrator.

Very respectfully,

Alana N. Alamon-Scott
WO1, JA, SCARNG
Legal Administrator
Office of the Staff Judge Advocate
South Carolina Army National Guard

P.S. Ms. Alamon-Scott is the first African American, the first female, and the first African American female Legal Administrator in the history of the South Carolina Army National Guard. Also, she became the first African American and first female in the Army National Guard Trial Defense Services.

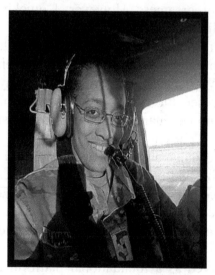

WO1 Alana N. Alamon- Scott

WO1 Alana N. Alamon- Scott

Chief Warrant Officer Three Doris I. "Lucki" Allen, U.S. Army, Retired

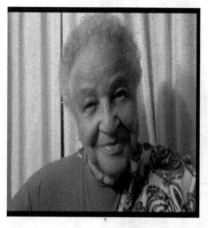

Doris Allen was born on May 19, 1927 in El Paso, Texas. She joined the Army in October 1950.

Doris "Lucki" Allen, a Specialist Seven (SP7) in the Women's Army Corps (WAC), volunteered for Vietnam at the age of 40 in 1967. She served as the Senior Intelligence Analyst, Army Operations Center, Headquarters, U.S. Army at Long Binh, Vietnam. She later served in the position of Supervisor, Security Division, Office of the Assistant Chief of Staff, Security, Plans, and Operations, Headquarters, 1st Logistical Command, Vietnam. She was appointed as a warrant officer in the spring of 1970. At the time of her appointment, she was one of only nine female warrant officers in Military Intelligence and one of only 23 in the entire Army at the time.

At the Military Assistance Command Vietnam (MACV) in Saigon, she was OIC of the Translation Branch CDEC (Combined Documents Exploitation Center) where all captured enemy documents were translated and analyzed. Allen saw documents naming her on a list of human targets - intelligence personnel - to be eliminated. She decided at that time to end her third Vietnam tour.

Allen's assignments after Vietnam included tours at the Army Intelligence Center and School at Fort Holabird, Maryland and Fort Huachuca, Arizona; a student at the Defense Language Institute, completing the French and German courses; with the intelligence unit at the Presidio of San Francisco; as a Special Agent with a MI Brigade in Germany, and as the Senior CI Agent and Security Manager at the Presidio of San Francisco. She was the first female graduate of the Interrogation of Prisoners of War (IPW) Course at Fort Holabird and later served as an instructor for the course.

Ms. Allen was promoted to Chief Warrant Officer Three in 1978. She retired in 1980 after a distinguished 30 year career.

CW3 Allen's awards and decorations include the Bronze Star (2 Oak Leaf Clusters), Meritorious Service Medal, Army Commendation Medal, Good Conduct Medal (6th award), Army of the Occupation Medal (Japan), National Defense Service Medal (1 Oak Leaf Clusters), Vietnam Service Medal (10 campaigns), United Nations Service Medal, the Republic of Vietnam Campaign Medal, the Korean Service Medal, Presidential Unit Citation, Meritorious Unit Commendation, and the Vietnam Cross of Gallantry with Palm.

Doris Allen received her bachelor's degree from Tuskegee Institute (now Tuskegee University) in Alabama. She also holds a Ph.D. in psychology from the Wright Institute in Berkeley, California. CW3 Allen was inducted in the Military Intelligence Hall of Fame at Fort Huachuca, Arizona in 2009. She is the first and, thus far, only African American woman elected in the MI Hall of Fame.

In 2014, Doris Allen published a book, entitled, "Three Days Past Yesterday – A Black Woman's Journey Through Incredibility". In June 2015, the U.S. Army Warrant Officer Career College renamed its Distinguished Honor Graduate Award to The CW3 (R) Doris Allen Distinguished Honor Graduate Award.

Ms. Allen currently resides in Oakland, California.

Chief Warrant Officer Two Amber L. Allsup, U.S. Army Pennsylvania National Guard

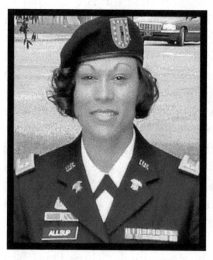

Amber L. Allsup, was born on 12 January 1984 in Hershey Pennsylvania and raised through childhood in Carlisle, Pennsylvania by her mother Judie A. Shealer-Peterson, father Ronald J. Coleman, and later her step-mother Vivian A. Coleman. She married her husband, Blake E. Allsup on 29 June 2008. Together they have four children, Adazhay A. Allsup, Adomani A. Allsup, Adamiya A. Allsup, and Adonijah A. Allsup.

Ms. Allsup enlisted into the military on 3 October 2001, at the age of seventeen, and only days after the horrific September 11th 2001 terrorist attacks on the United States, CW2 Allsup made the conscious decision that her mission in life was to protect those she loved by building a career in the armed forces. After graduating from Carlisle High School, Class of 2002, CW2 Allsup left for Basic Combat Training (BCT) at Fort Jackson, South Carolina. Advancing on to her Advanced Individual Training (AIT) she progressed to the Quartermaster School at Fort Lee, Virginia in the winter of 2002. On 29 May 2014, Ms. Allsup graduated from Fort Rucker, Alabama and was appointed as a new Quartermaster Warrant Officer in the Warrant Officer Cohort.

Assigned to the 2nd Battalion, 166th Regiment, CW2 Allsup serves a WOCS Chief Instructor and TAC Officer for the Officer Candidate School (OCS), Warrant Officer Candidate School (WOCS), and Pre-Warrant Officer Candidate Course (PWOCC).

CW2 Amber L. Allsup is a fulltime Chief Warrant Officer for the Pennsylvania Army National Guard.

On a fulltime basis, CW2 Allsup serves as a Federal 920B Supply Systems Technician. By holding the position of supervisor at the Unit

Equipment Training Site (UTES) located at Fort Indiantown Gap (FIG), Pennsylvania. Ms. Allsup offers her expertise in logistics to accommodate the training of Army units across the United States.

For the past 16 years, Ms. Allsup has devoted her profession to the armed forces, being awarded an array of Army medals for unprecedented performance and accomplishments. CW2 Allsup was nominated as the Warrant Officer of the Year in 2015 for her outstanding performance. CW2 Allsup is Master Fitness Trainer Certified. She has received multiple Army Achievement Medals, Army Reserve Component Achievement Medals, National Defense Service Medal, Armed Forces Reserve Army Medal, and the Army Reserve Component Overseas Training Medal in 2005 for outstanding performance while attending training in Grafenwöhr, Germany. She has also obtained numerous Army Physical Fitness awards from various trainings and competitions.

Alongside her fulltime military career, CW2 Allsup serves as the Treasurer of the Unite States Army Warrant Officers Association, Keystone Chapter of Pennsylvania. She is a fulltime student at the University of Phoenix pursuing a Master's Degree in Business Accounting.

CW2 Allsup is also the officer mentor for the "Female to Female Mentorship Program" of the Army Reserve Regional Training Site at FIG. She continues to stay actively engaged in her community, competes in marathons, half marathons, various races and fitness challenges, all while continuously working to advance in all that she does.

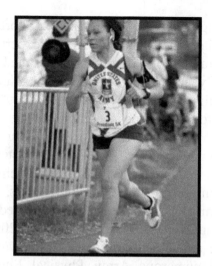

Amber L. Allsup

CW2 Amber L. Allsup

Chief Warrant Officer Five Shirley Temple Ashley, U.S. Army, Retired

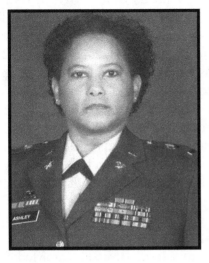

CW5(R) Shirley T. Ashley retired from Active Duty on October 1, 2010 culminating a 34-year military career. In her final assignment, she served as the Theater Food Advisor, Headquarters United States Army Europe and 7th Army, Deputy Chief of Staff, G4, Heidelberg, Germany. She was the first female Soldier to serve in this prestigious position.

CW5R Ashley was born in Lewisville, Arkansas. She enlisted into the U.S. Army in May 1976 and attended basic training at Fort McClellan, Alabama. She was awarded the 92G MOS and after 12 years of distinguished service, she received her Warrant Officer appointment as a Food Service Technician, after completing the Warrant Officer Candidate Course at Aberdeen Proving Ground, Maryland.

Throughout her superb enlisted and warrant careers, she served in a wide variety of challenging assignments that included deployment to South Florida as the Food Service Technician for the 46th Corps Support Group, Fort Bragg, North Carolina, in support of Humanitarian Relief efforts for victims of Hurricane Andrew; Food Service Technician, Camp Kasey, 2nd Infantry Division, Republic of Korea; First Female Food Service Advisor, Headquarters, United States Army Military District of Washington, DCSLOG, Fort McNair, Washington DC; Food Service Training Developer / Writer, United States Army Combined Arms Support Command, Training Directorate, Fort Lee, Virginia; First Female Command Food Advisor, 1st Infantry Division, DCS, G4, Leighton Barracks, Wurzburg, Germany; and Task Force Danger Food Advisor, Operation Iraqi Freedom II, Camp Spiecher, Tikrit Iraq.

During deployment of Operation Iraqi Freedom II, she was lauded (bronze star medal) by the Task Force Commander for superb duty performance in ensuring that high quality meals were provided on a continuous basis to twenty-six thousand Task Force Soldiers and Multi-National Forces located twenty-seven forward operating bases. This action included the procurement and placement of 122 refrigerated vans to "store" and "push" 1st Infantry Division Task force rations ensuring Soldiers had a continuous supply of fresh food.

CW5R Ashley completed every level of the Warrant Officer Education System including the Contracting Officer Representative Course, Warrant Officer Staff Course, and Warrant Officer Senior Staff Course. She holds a Bachelor of Arts Degree from the University of Maryland. She is a 2013 Inductee as a Quartermaster Distinguished Member of the Regiment and is a recipient of the Distinguished Quartermaster Order of Saint Martin.

CW5R Ashley,

is authorized to wear the Legion of Merit, Bronze Star Medal, Meritorious Service Medal (with 5 oak leaf clusters), Korean Defense Service Medal, and the Humanitarian Service Medal.

Chief Warrant Officer Four Roslyn "Roz" A. Barbee, U.S. Army, Retired
Director of Training, Total Workforce Development, Deputy Chief of Staff G-1, HQs US Army Materiel Command, GS-15, US Army Civilian

Born - South Central Los Angeles 3 older brothers, - only baby girl - biracial parents (Black mom from Memphis) and (Jewish) white dad. Parents divorced at one year old. Mom worked for city as an accountant on $20 per week child support. Dad rose to own large shoe corporation. Grew up rough - became a CRIP to survive junior high school. Made it through high school - Gardena 10th 11th, Los Altos High School (suburbs: 11th - 12th). Principal Mauch encouraged me to be amazing! Completed the Los Angeles County Sheriff Intern Academy - had too many familiar faces in jail system.

I joined the Army in 1985 after attending Arizona State University majoring in Aerospace Engineering. Enlisted as a Commo - Electronic Maintenance Repairer; got pregnant and had 1st of three daughters within first year by former drill sergeant-- such an embarrassing shameful story on the Army).

I got accepted for both OCS and Warrant Officer Candidacy School within 5 years; Got married (just because Army said sole and single parents were unfit); accelerated to become Warrant Officer Candidate. Broke foot last two-week of completion - refused to leave. Under Chief Harry Hobbs' watch, I petitioned to return back at same training day to complete training - 8 weeks later - attained commission. Became Honor Grad. Served time to do the grind across the Army - had 2 additional daughters. Divorced; have fantastic Vet girlfriends to "party with" to this day! They are Ride or Die! Served

almost 23 years; attained rank of CW4; retired; worked as a Training Lead with the PEO Missile and Space.

I became Executive Officer within the Army Materiel Command - now GS-15, as the Director of Training. Personal challenges have been many - survived brain surgery 2013. Love life adventures, discrimination, harassment, injuries, love relationships - all a part of life's journey - and I continue to mentor, listen and learn! Loving life!! Greatest accomplishments - Loving the opportunity to bring a smile to any life my life touches!

Roz Barbee
Director of Training, DCS G-1
HQ, US Army Materiel Command (AMC)

Professional Experience:

Ms. Roslyn "Roz" Barbee combines her extensive educational degrees and experience as a Senior Chief Warrant Officer and Instructor to continually bring a wealth of knowledge to the Army Materiel Command (AMC) Training and Workforce Development Division. Ms. Barbee's commitment is focused on Strategic Readiness of the military and civilian workforce and all supporting elements necessary to effectively and efficiently Train, Execute and Win. As the Division Chief, Ms. Barbee serves as a direct voice of the Commanding General to the entire Army Materiel Command enterprise of 100,000 personnel on all matters of military and civilian training associated with the Materiel Readiness of the organization. Ms. Barbee's 23 years of active military service culminated as being recognized as the first female and highest ranking Chief Warrant Officer in her career field, while serving as the Deputy Division Chief of the Warrant Officer Training Division at the U.S. Army Ordnance, Electronics Maintenance and Munitions Center and School.

Career Chronology:
- 2018- PresentTotal Force Training and Development, Deputy Chief of Staff G-1

- 2015- 2018Chief, Training Division for the Deputy Chief of Staff, G-3/4 Current Operations, Headquarters, U.S. Army Materiel Command
- 2011-2015Executive Officer for the Deputy Chief of Staff, G-3/4, Current Operations Directorate, Headquarters, U.S. Army Materiel Command
- 2011-2011Branch Chief, AMC Lessons Learned Program, Headquarters, U.S. Army Materiel Command
- 2009-2011Lead, Training Development & ILS Team, PM Integrated Air and Missile Defense Program, PEO-Missiles and Space
- 2008-2009Lead, Training Development & ILS Team, PM Non-Light Of Sight (NLOS), PEO FMS

College Education:
- Florida Institute of Technology, M.S., Human Resource Management, 2013
- Florida Institute of Technology, M.S., Logistics Management, 2013
- Embry-Riddle Aeronautical University, MBA- Aviation, May 2001
- Austin Peay State University, BS Public Management, 1998

Significant Training/Special Skills:
- AMC Focused Life Cycle Sustainment Plan, Director Training, 2017
- UNC-Chapel Hill, Advanced LOGTECH Program, 2014
- Army Management Staff College, Continuing Education for Senior Leaders, November 2012 & Advanced Civilian Education System (CES), 2011
- Warrant Officer Senior Staff Course, 2005
- University of Alabama, Huntsville, Professional Designation in Advanced Contract Management, September 2004

Certifications:

- Defense Acquisition University (DAU) Facilitator/Instructor Certification, 2018
- Financial Industry Regulatory Authority (FINRA), Arbitrator, current
- Defense Acquisition University, Level 3 Certified Acquisition Professional – Life Cycle Logistics, 2010
- Department of the Army Systems Coordinator (DASC) – PEO Missile and Space Certificate, 2009
- LEAN Six Sigma Green Belt Certification, Army Aviation & Missile Command, 2006
- Contracting Officer Representative Certification, 2006

Publications:

- Improving Logistics Automation Support, Army Logistics University publication, contributing author

Activities, Awards and Honors:

- Numerous Military Awards
- Numerous Commander's Coin recipient for "On-The-Spot" recognitions and accomplishments

Professional Memberships and Associations:

- Toastmasters, Club, Redstone Premier Providers, current
- Life Member, US Army Warrant Officers Association, (Past President, Painted Rock Chapter, Fort Irwin, California).
- Active Member, Alpha Kappa Alpha Sorority, Incorporated
- Prince Hall, Order of the Eastern Stars

Roz Barbee with friends at the Redstone
Arsenal

Roz Barbee and daughters

Chief Warrant Officer Roxana Beattie,
U.S. Army Reserve, (Deceased)

CW3 (Retired) Roxana Beattie joined the Army Women Corps in 1976 as an active Army Reserve, Troop Program Unit member of the 445th Civil Affairs unit, Oakland Army Base, Oakland, California.

In 1988, while assigned as a Senior Supply and Retention NCO, with the 353rd Psychological Operations Battalion, Presidio of San Francisco, California, she was accepted as a warrant officer candidate. After completing the tactical first phase Warrant Officer Entry Course, Fort McCoy, Wisconsin and the technical Warrant Officer Basic Course at Fort Lee, Virginia, Md. Beattie was appointed a Quartermaster Corps Warrant Officer in 1990. Her initial assignment was as a property book officer and a long list of additional duties with the 801st Engineer Port Construction Company, Oakland, California.

In 1994, she transferred to the 55th Materiel Management Center (MMC), Fort Belvoir, Virginia, 55th Theater Support Command (TSC), Eighth Army, Korea. In 1996, Chief Warrant Officer Beattie was mobilized with NATO-IFOR, Operation Joint Endeavor, Bosnia.

Ms. Beattie attended and completed a wide variety of civilian and military schools in her 28 years of service. Without a break in service, she retired in 2004.

Beattie's military awards and decorations include the Meritorious Service Medal, Army Commendation Medal with four oak leaf clusters, Army Achievement Medal with two oak leaf clusters, Armed Forces Service Medal, Humanitarian Service Medal, NCO Professional (#3), National Defense Service Medal with Bronze Hour glass, Armed Forces Reserve Medal with Silver Hour glass, Armed Forces Reserve Medal with "M" device, Army Service Ribbon, Army Reserve Component Overseas training Ribbon (#2), NATO Medal, and the Army Forces Expeditionary Medal.

Ms. Beattie had a distinguished career in the federal service with the Department of Defense.

CW3 (Retired) Roxanna Beattie died in July 2009 in Woodbridge, Virginia.

Pamela Renee Bethea, Chief Warrant Officer Three, U.S. Army

Pamela Renee Bethea was born April 10, 1982 to Larry and Bernice Eddins from Memphis, Tennessee. She attended Raineshaven Elementary, Bellevue Middle School and graduated from Central High School. Only having knowledge of her Father's military background in high school JROTC, she entered the United States Army delayed entry program in May 2000.

After contemplating about college and her future opportunities in Memphis, Tennessee, when her summer session of college ended in July 2000, she joined the United States Army as a Private August 15, 2000. Her father was thrilled to hear his baby girl was going to serve in the United States Army to fulfil a dream he always desired.

Pamela Bethea completed Basic Combat Training and Advanced Individual Training; and was awarded the MOS 75B-Personnel Administrative Specialist. Pamela grew up with a Family background of serving people within the church. Customer service and providing personnel support came easy assisting Commanders in taking care of Soldiers overall welfare and well-being. 9/11 was a devastating time for our country and although her Family members were concerned about her future in the service after her initial enlistment she remained serving her country.

Throughout her military career she was faced with many challenges. One in particular, Fiscal Year (FY) 2005, the Army still at war, transforming MOS' merging all 75 series, this MOS now is over strength. The new MOS 42A Human Resources Specialist caused her to receive a mandatory reclassification notification. The letter of instructions provided two options: select a new reclassification MOS (88M, 92W or 92F) or the no later than date for promotion suspense date, January 1, 2005.

On January 1, 2005, Pamela was promoted to SGT; in that movement, she realized that she was given another opportunity to remain in her field of Human Resources Specialist and she had to be the best to remain in her field. Rising through the ranks from Sergeant to Sergeant First Class before 10 years of service, she knew then she would best serve her remaining career as a Warrant Officer in the United States Army. Another challenge faced during her first board selection for a Warrant Officer Candidate. She was qualified, but not selected. Advancement for promotion is very competitive. Disappointed, but not discouraged, she received an email correspondence to come meet with the Warrant Officer accession branch chief while stationed at Fort Jackson, SC. The first question asked; what made you submit a packet with no Warrant Officer endorsement? With truth and transparency, her many accomplishments: NCO of the year, Leadership award-(Basic Non-commissioned Officer Course), Commandant's list-(Drill Sergeant School) and Drill Sergeant of the Cycle during her tenure as a Drill Sergeant, she figured she did everything to be successful.

Life lesson number #2: building relationships is an important part of having a successful career. She had a responsibly to seek an endorsement from a senior warrant officer Human Resources Technician. Chief Warrant Officer 5 (Retired) Pamela Johnson reviewed her record, judging from her education, military schooling, and future potential, she identified her as a candidate worthy of an endorsement. September 2011, she was selected as a Warrant Officer Candidate. Chief Warrant Officer Five (Retired) Coral Jones, her Army mom, and another mentor, has always provided mentorship and coaching throughout the years for both professional and personal aspects of her life; that relationship has grown beyond military duties.

Throughout her assignments as a Warrant Officer, she has paid it forward by mentoring junior Soldiers and NCO's with the desire to become a Warrant Officer Candidate. She has a responsibility to teach and train; articulating HR capabilities, the "What do we bring to the fight?" as HR professionals. The Army's 40th Chief of Staff, General James C. McConville said it best, "Our Army's people are our greatest strength and our most important weapon system." As an Adjutant

Warrant Officer, we must be servant leaders, selfless, and willing to make sacrifices so that as an Army we all succeed. Still serving 19 years later, she is striving for excellence.

Promoted to Chief Warrant Officer Three on July 1, 2019, she acknowledges Faith and Family has kept her throughout the years. Pamela Bethea is married to Chief Warrant Officer Three Dearonne Bethea. She most admires her husband's vision for not only his career in the service, but for his Family. She values his goals and understands his purpose and sees how he achieves not only his goals, but goals for his military, civilian career and Family business. Pamela and her husband are currently stationed in Honolulu, Hawaii. They have five children: Amya, Treasure, Makaela, Deonna and Dearonne Bethea Jr. The Dearonne and Pamela Bethea Foundation gift fund was established December 20, 2016. Annually, they grant scholarships for students attending Southeast Halifax High School and adopted students from the Elementary and Middle schools in Enfield, North Carolina, hometown of her husband, to enforce children to Strive for Excellence. As an elementary student, Pamela's motto still resonates in her today "I can do anything, I can do anything, all I have to do is try, all I have to do is try!"

 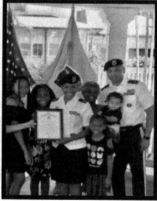

Photo with husband Photo with family
CW3 Dearonne Bethea

Ms. Pamela R. Bethea's Promotion
to CW3, July 1, 2019

Chief Warrant Officer Four Karen D. Bell, U.S. Army, 926th Engineer Brigade, Property Book Officer

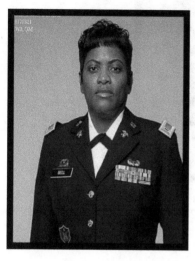

Chief Warrant Officer Four Karen Bell was born in Birmingham, Alabama, in July 1971. She enlisted in the Army in August 1989 as a 92Y, Supply Specialist; and, was appointed as a Warrant Officer from the Warrant Officer Candidate School in Fort Rucker, Alabama in August 2004.

Warrant Officer Four Bell assignments include Property Book Officer, 484th Movement Control Battalion, Springfield, Missouri, Property Book Officer, 926 Engineer Battalion, Birmingham, Alabama, and Property Book Officer 348th Transportation Battalion (Terminal), Houston, Texas.

Chief Warrant Officer Four Bell is currently assigned as the Property Book Officer for the 926th Engineer Brigade, Montgomery, AL Her deployments include Iraq twice in support of Operations Iraqi and Enduring Freedom with the 327th Military Police Battalion and Multi- National Security Transition Command.

Her military education includes Warrant Officer Candidate Course, Warrant Officer Basic Course, Warrant Officer Advance Course, Warrant Officer Staff Course, and Property Book Unit Supply Enhanced Course.

Her civilian education includes an Associate's Degree and a Bachelor's Degree in Logistics and Transportation Management from American Military University. Her awards include the Army Service Ribbon, Overseas Service Ribbon, NCO Professional Development Ribbon, Southwest Asia Service Medal, Global War on Terrorism Expeditionary Medal, Global War on Terrorism Service Medal, Good Conduct Medal, Army Meritorious Service Medal, Army Defense Meritorious Service Medal, Army Commendation Medal with two

Bronze Oak Leaf, National Defense Service Medal with Bronze Star, and Army Achievement Medal.

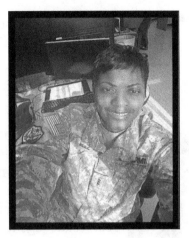

CW4 Karen D. Bell

CW4 Karen D. Bell

Chief Warrant Officer Yvette S Blake,
U.S. Army National Guard, Retired

Born and raised in Newport News, Virginia, I am a retired military warrant officer, serving 27 years in the United States Army. My family consists of a charming husband, handsome twin boys, a beautiful daughter, and two energetic grandsons. I presently work for the Department of Defense and own a small business, which provides a number of financial services. Additionally, I am a licensed real estate agent associated with the CTI Real Estate firm. I hold an associate's degree in graphic design, a bachelor's degree in business administration and management, and a master's in organizational management.

I have had an interest in art, history, reading, and culture for over 30 years. I am a member of the Sisters Sippin' Tea Literary and Social Club. This book club has chapters all over the United States, and we not only read books but also participate in community service programs as well. I've been a collector of miniature dolls for over 10 years. I use my miniature collection to design historical exhibits for various venues. One of my exhibits ("For Love of Liberty") was in Fredericksburg's downtown library last year. My newest interest is Civil War reenacting. I am a member of the 23rd Regiment United States Colored Troops, the Women of the American Civil War group, and a board member of the John J. Wright Educational and Cultural Center Museum.

I joined the museum board in September 2014 and, as a newly appointed board member, I think that I have brought creative ideas that relate to the museum's community cultural and educational venue. My roles at the museum are that of researcher and exhibitor for the

museum's collection. All of the exhibits include related books on the topics.

My research interests include local artists, as well as African American and military studies, with an emphasis on the Civil War. This is why I love libraries. The things you can learn there and the information that you find are breathtaking at times.

Chief Warrant Officer Five Kimberly L. Bonville, U.S. Army, Retired

Kimberly L. Bonville is a native of Denver Colorado. She is a graduate of Metropolitan State College of Denver with a Bachelor of Arts degree in Communications–Broadcasting, and a Master of Science degree in Management from the University of Phoenix.

Ms. Bonville served in the Colorado National Guard as a (63B) Light Wheel Vehicle Mechanic. She decided to enlist into the regular Army in 1987, where she attended Basic training at Fort Dix, New Jersey and Advanced Individual Training at Fort Jackson, South Carolina. During her tenure as an enlisted soldier, she progressed to the rank of Staff Sergeant.

In August 1997, she was appointed to Warrant Officer One as a (915A) Maintenance Technician. Her deployments include Desert Storm/Desert Shield (Saudi Arabia), Iraq (Baghdad), and Kuwait. Kim is the second female, but the first African American Woman to reach the rank of CW5 as a 915E in the United States Army. She is also the first CW5 African American Woman to teach at the United States Ordnance Center and Schools at Aberdeen Proving Ground Maryland. Kim served as an instructor/Writer and curriculum developer for the Warrant Officer Basic Course 915, 913, 914 MOS's at the United States Army Ordnance Mechanical Maintenance School.

Finally, she is the first CW5 African American Woman to work as a Military Evaluator for the United States Army Test and Evaluation Command, working on the Global Combat Service Support Army (GCSS-A) $1.6 billion business information technology system. Kim incorporated her impeccable logistical knowledge and expertise into all test and evaluation strategies, plans and reports. She directly coordinated with DA-G4, Army Materiel Command (AMC), Combined Armed Support Command (CASCOM), DOT&E, and PEO

EIS with her knowledge and expertise it allowed the first initial fielding of WAVE 1 capability to the Army. This increased efficiency of worldwide logistics operations to the Warfighter.

CW5 Bonvlle's assignments were Fort Hood, Texas (Desert Storm/Desert Shield) Saudi Arabia, Joint Readiness Training Center at Fort Chaffee Arkansas, Kitizingen, Germany, Fort Bragg, North Carolina, Mannheim Germany, Hunter Army Airfield Fort Stewart Georgia, Fort Stewart Georgia (Baghdad, Iraq), Fort Carson Colorado, Aberdeen Proving Ground, Maryland, Area Support Group Kuwait (Camp Buehring) Kuwait, Schofield Barracks, Hawaii, Camp Henry Korea, before coming to the United States Army Test and Evaluation Command, Aberdeen Proving Ground, Maryland.

Her awards include Legion of Merit, Meritorious Service Medal with (7th OLC), Army Commendation Medal (2nd OLC), Army Achievement Medal (3rd OLC), Good Conduct Medal (2nd Award), National Defense Service Medal (2nd Award), Southwest Asia Service Medal with 3rd Campaign Stars, Iraq Campaign Medal, Global War on Terror Expeditionary, Global War on Terror Service, Non-Commissioned Officer Professional Development Ribbon (2), Army Service Ribbon, Overseas Service Ribbon (5), Kuwait Liberation Medal (Saudi Arabia), Korean Defense Medal, Kuwait Liberation Medal (Kuwait), Combat Action Badge, and Drivers/Mechanics Badge.

Ms. Bonville on promotion to CW5

Chief Warrant Officer Four Marilynn Bradley, U.S. Army

CW4 Bradley was presented the Samuel Sharpe Medal and a G4 farewell gift for her dedication to Maintenance excellence by Col. Michael A. Balser, U.S. Army Africa G-4 at a ceremony in Longare, Italy on January 21, 2011.

Chief Warrant Officer Two Fresa A. Brown, U.S. Army

My name is Fresa Altagracia Brown, I was born on 25 January 1980 in New York, N.Y. My family is from the Dominican Republic and I am the first generation born in the United States to immigrant parents. At home my family only spoke Spanish making Spanish my primary language. I was raised in the Bronx, NY and went to DeWitt Clinton High School in the Bronx. I am currently married to a very loving man James Ricky Brown II and we have three exceptional boys together Antonio (15), Josiah (8) and Eden (4).

In June 2000, two years after graduating DeWitt Clinton H.S I decided to follow in my older brother's footsteps and joined the Army as a 92Y Unit Supply Specialist and attended Basic Combat Training in Fort Jackson, South Carolina. Upon completion of basic training I attended Advanced Individual Training (AIT) in Fort Lee, Virginia in which I became certified in my logistical expertise of Supply Specialist. Immediately after AIT I went on to Airborne School at Fort Benning Georgia in November 2000. Upon successful completion of airborne school I reported to the 82nd Airborne Division in December 2000. I was assigned to the Headquarters and Headquarters Company, Division Support Command. I performed the duties as a property book clerk in the Division Material Management Center (DMMC). During my time working at the DMMC I came across some of the Army's most exceptional warrant officer's. Their vast logistical knowledge and extreme professionalism made such a drastic impression on me, that I made becoming a warrant officer my goal in the Army. This assignment was unlike any other I faced many challenges there and overcame them all. Later in my military career I will take lessons learned from this assignment and apply them to other challenges.

In January 2003 I was assigned to B Co 112th Signal Battalion, United States Army Special Operations Command (USASOC) as the supply clerk. I provided logistical support during several Operation Iraqi Freedom and Operation Enduring Freedom missions. The logistical support I provided included; ensuring that the Army's equipment was shipped accurately and on time to various places worldwide, and providing all the logistical needs for over 100 Soldiers during a 10 month deployment. In March of 2007 I had the honor of representing the USASOC during the Army Supply Excellence Award Program in which I received honorable mention at the Department of the Army level. It was in the unit that I went through a bitter divorce that left me homeless with a one year old child for 3 months. My story is a story of resiliency and beating all odds.

In June 2007, I was assigned to Fort Belvoir Virginia and became the Supply Noncommissioned Officer of E Co 302nd Signal Battalion. During my time at E Co, I established the company's first ever medical supply account making them able to now order medical supplies if needed. I spent numerous hours preparing for the Command Supply Discipline Program (CSDP) inspection and gained the unit's highest score in historical history. I organized and provided all the logistical support needed for the build of the company's first ever fitness center in order to encourage and motivate those that worked long shifts to workout. I organized and motivated the entire company to participate and compete in numerous run competitions to include Fort Belvoir's Pump-N-Run events, and Fort Belvoir Sexual Assault Prevention Runs. I became the company's first female Equal Opportunity Leader and Representative.

In August 2009, I was then assigned to Headquarters and Headquarters Company 95th Civil Affairs Brigade as the assistant Brigade (BDE) S4 NCOIC. I organized and motivated female runners within the brigade to participate in the Fort Bragg Army 10-Miler Competition. Their hard work and no quit attitude resulted in the team finishing in 3rd place. During my time in HHC 95th CA BDE I attended nights and weekend courses in order to successfully complete an Associates' Degree program in General Studies and received my Diploma in May 2012. I was hand selected by the BDE S4 NCOIC to

assist in the logistical portion of the building of a new company just activated in June 2012 at the 97th Civil Affairs Battalion. While only being there for 3 months I established an entire company supply operations from scratch and provided all the logistical support necessary for the company's first Pacific Command (PACOM) deployment. It was while assigned to this unit that I met the love of my life and married my current husband James Ricky Brown.

In July 2012, I was selected to attend Warrant Officer Basic Course and achieve my short term goal of becoming a 920A Property Accounting Technician. I attended Warrant Officer Basic Course in October 2012 and graduated November 2012. I was later assigned back to the 95th Civil Affairs Brigade in which I was once again hand selected to be the Property Accounting Technician of the newly activated 92nd Civil Affairs Battalion. I was the first ever Property Accounting Technician in this Battalion and my job included procuring Army property in to build four new companies, ordering equipment through the Army supply system, command supply disciple program monitor and warehouse management. I had the honor of representing the USASOC during the Army Supply Excellence Award Program once again as a Property Accounting technician in which I came in second runner up Department of the Army level.

In January 2016, I was assigned to the 307th Expeditionary Signal Battalion in which I the battalion Property Accounting Technician. I am presently assigned to the 307th ESB in Hawaii and I will have currently maintained the unit's logistical property valued at over $150 million flawlessly. I had the honor of competing in the Army Supply Excellence Award Program once again as a Property Accounting technician. My Property Book team won at the Army Cyber Command Level which is one level below the Department of the Army.

While assigned to the 307th ESB, I attended Warrant Officer Advance Course in Fort Lee, VA. While in the WOAC, I participated in a Women's Mentorship Group given by CW5 Nicole Woodyard. The mentorship, sisterhood, and fellowship I received during that short timeframe were unlike any other in my 19 year career and I knew that the rest of the Army would benefit from this mentorship technique. I

took this technique back to my home station in Hawaii and began my own Women's Mentorship group.

Since developing this program in 2017 at my unit, it has only grown. The mentorship group focus is **Personal Awareness and Professional Growth** with each group having a different theme for that event. The themes vary from; chapters of Her-story, resiliency, knowing that you're good enough and most recently believing in one's self (you can and you will). My unit has had some unfortunate event by suffering the loss of two female officers to suicide in the recent years. These groups have helped women get through these difficult times by instilling in them that as service members we will all go through difficult times in our lives and we will have our rainy days but if we push forward and hang on our sunshine will come.

I have had many guest speakers that include other female Warrant Officers, female Sergeants' Major, and female officers. Most recently I had a visit from the U.S. Army Network Enterprise Technology Command (NETCOM) Command Sergeant Major Jennifer Taylor. All of the guest speakers tell a story; a story of hard work, motivation, determination, resiliency, and beating all odds. I have been personally approached by other female service members that have attended her groups acknowledging that my groups have really changed their perspective on life and the military itself.

In May 2018, I was awarded the Bachelor's Degree in Supply Chain Management from Ashford University with a GPA of 3.44. My vast logistical knowledge and 19 year Supply experience in the Army has been key in achieving this goal of getting my degree. My long term goal is now to receive a Master's Degree from a prestigious institution like Pennsylvania State University in which I started attending in August 2018. I also have a goal of being the best mother I can be to my boys and show them that success can be achieved if you work hard. My family is the reason why I work so hard. I want to always be an example for her children to follow and allow them to have a better life than what I did. I am an example that a Hispanic female from the Bronx, N.Y can overcome all obstacles and become a very successful woman. I am a very proud Soldier, Wife and Mother and I am humbled by the opportunity to attend Penn State. Throughout

my career I strongly believe that God has brought me to this point in my life.

CW2 Fresa A. Brown

CW2 Fresa A. Brown

Chief Warrant Officer Four Nicole R. Burkett, U.S. Army

Date and Place of Birth: 15 December 1974, Dallas, Texas
Enlisted Military Service: 24 years
Source and Appointment Date: Warrant Officer - October 2003
Years of Active Warrant Officer Service: 18 years
Total Years in Service: 24 years
Military Education:
Warrant Officer Senior Staff Course (2017)
Warrant Officer Senior Staff Follow On Course (2017) Joint Logistics Course (2017)
Equal Opportunity Course (2012) Warrant Officer Staff Course (2012) Sexual Harassment/Sexual Assault Response Course (2011) Warrant Officer Advance Course – Property Book Officer (2010) Warrant Officer Basic Course – Property Book Officer (2004) Action Officer Development Course (2012)
Property Book Unit Supply Enhanced Course (2005) Warrant Officer Candidate Course (2003)
US Army Basic Training – Fort Jackson, South Carolina
US Army Advance Individual Training – (Supply) Fort Lee, Virginia
Primary Leadership Course – (Non-Commissioned Officer) Fort Campbell, Kentucky
Basic Non-Commissioned Officer Course – (Supply) Fort Lee, Virginia

Civilian Education
MS - Human Resources DEC 2012 Central Michigan University
BS - Healthcare Administration JUN 2008 Austin Peay University

Decorations, Service Medals, and Badges:
Army Service Ribbon Overseas Service Ribbon (4)
NCO Professional Development Ribbon
Korea Defense Service Medal
Global War on Terrorism Expeditionary Medal Global War on Terrorism Service Medal
Good Conduct Medal
Army Good Conduct Medal (8) National Defense Service Medal Afghanistan Campaign Medal (2) Joint Commendation Medal (1) Valorous Unit Award (4ID) Military Unit Commendation (4ID) Army Achievement Medal (6) Army Commendation Medal (4) Meritorious Service Medal (5) Bronze Star Medal (2)

Chronological List of Appointments:
W01 USAR Oct 2003 – Oct 2005 W02 ARMY Oct 2005 – Aug 2009 W03 ARMY Aug 2009 – Jan 2014
W04 ARMY Jan 2014 – Current

Chronological Record of Duty Assignments:

Active Duty:
Enlisted Assignments:
101st Personnel Services Battalion, Delta Detachment: (Supply Clerk) Fort Campbell, Kentucky, 1995-1998
101st Soldier Services Battalion Headquarters Company: (Supply Sergeant) Fort Campbell, Kentucky, 1998-2000
Headquarters and Headquarters Company 3rd Brigade Combat Team: (Supply Sergeant and Platoon Sergeant) Fort Carson, Colorado, 2000-2002
8th Army Non-Commissioned Officer Academy: (Instructor), Camp Jackson, Korea, 2002-2003

Warrant Officer Assignments
864th Engineer Battalion: (Property Book Technician) Fort Lewis, Washington, 2003-2008

308th Military Intelligence Battalion: (Battalion Property Book Officer) Fort Meade, Maryland, 2008-2011

902nd Military Intelligence Brigade: (Asset Visibility Officer) Fort Meade, Maryland, Washington, 2011

759th Military Police Battalion: (Battalion Property Book Officer) Fort Carson, Colorado, 2011-2013

4th Infantry Division: (Asset Visibility Officer) Fort Carson, Colorado, 2013-2016

1st Special Forces Group (Airborne): (Asset Visibility Officer), Fort Lewis, Washington, 2016-2018

7th Infantry Division: (Asset Visibility Officer) Fort Lewis, Washington, 2018 to Current

Deployments:

1st Special Forces Group (Airborne) - (Asset Visibility Officer) Camp Arifjan, Kuwait (2016-2017): Served as Special Operations Joint Task Force- Operation Inherent Resolve Asset Visibility Officer

4th Infantry Division – (Asset Visibility Officer) Kandahar, Afghanistan (2013- 2014): Served as Regional South-Combined Joint Task Force Asset Visibility Officer

864th Engineer Battalion – (Property Book Officer) Bagram, Afghanistan (2007-2008): Served as Task Force Pacemaker Property Book Officer 864th Engineer Battalion – (Property Book Officer) Kandahar, Afghanistan (2005-2006): Served as Task Force Pacemaker Property Book Officer

8th Army Non-Commissioned Officer Academy (Instructor), Camp Jackson, Korea (2002-2003): Served as Small Group Leader/Facilitator/Instructor

CW4 Nicole R. Burnett

CW4 Nicole R. Burnett

Chief Warrant Officer Four Beofra Butler, U.S. Army
Soldier running her 100th marathon in Boston
By Eve Meinhardt, FORSCOM April 8, 2019

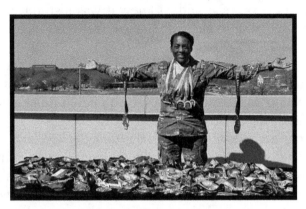

Chief Warrant Officer 4 Beofra K. Butler, administrative executive officer to the commanding general, U.S. Forces Command, poses with her marathon medals, March22. Butler has run 99 marathons since starting with the Marine Corps Marathon in 2008. Around her neck are her medals from five previous Boston Marathons. She will run her 100th race April 15 in Boston. *(Photo Credit: Eve Meinhardt, FORSCOM)*

FORT BRAGG, N.C. - It all started when she was stationed in Virginia 12 years ago. That's when Chief Warrant Officer 4 Beofra Butler saw everyone training for the Marine Corps Marathon and decided to give the 26.2 mile race a try.

As a Soldier, running was already a part of her daily life and physical fitness routine. She had ran several other shorter races to include the Army 10-miler and a few half marathons, so the challenge of a full marathon appealed to her. She wasn't even afraid of the dreaded "wall" that everyone told her she would hit around mile 20 when her body would start shutting down as energy stores ran low and fatigue set in.

"I had never experienced the wall and was feeling pretty great," recalled Butler. "I saw the mile markers for mile 19, then mile 20, then 21. I was feeling good and thinking to myself that maybe I avoided the wall. Then at mile 22, everything from my waist down locked up -- it felt like I really did hit a wall. My muscles were in knots, my toes

were cramping and every time I took a step it just hurt." A lady tapped her on the shoulder and encouraged her to move off to the side and stretch before resuming the race.

"I wanted to cry," she said. "I knew it was just four more miles. I wobbled to the finish along with a bunch of other people doing the exact same thing."

After the race later that night, with ice bags on her legs and a computer on her lap, Butler signed up for her next marathon.

"I just had to do it again for myself so I could figure out how to do it without pain," she said.

Butler ran her second marathon during a deployment, followed by another and another and another. She's preparing to run her 100th marathon in Boston on April 15. The race will be her sixth Boston Marathon and she says that it is fitting because it's her favorite event. "There's something special about running in Boston," she said. "It's the only race you have to qualify for to get in and after working so hard to be a part of it, you really enjoy the moment when you get there. The support of the crowd is amazing and it's just a great place to be. "She got there by figuring out how to avoid that wall of pain.

"For the most part, I don't hit a wall anymore," Butler said. "Now I know what that feels like and I never want to feel it again." How does she do it? The way anyone in the Army does anything -- with an abbreviation. According to Butler, the key to running a successful marathon comes down to the 3P's: pacing, patience and practice. She says that you need to control your pace throughout the entire marathon and exercise patience as those around you start out fast or crowd the track. To refine your pacing and patience, you need to practice. "It comes down to having time on your feet," said Butler. "You have to put in the time and stay positive." Her time comes from running at least five days a week. She averages 10 miles a day with Saturdays being her long run day of anywhere from 13 to 20 miles. She does speed work on Wednesdays, often bringing others along with her to help them train to meet their goals.

As the administrative executive officer to the commanding general of U.S. Army Forces Command, her work schedule can often be hectic

and conflict with her training time. To mitigate this, Butler is a conscientious meal planner, preparing all her meals, to include snacks, on the weekends. She says she often hits the pavement at 3 a.m. just so she can ensure she gets time to run. "I just love the feeling of running," she said. "It's freedom. I don't listen to music. I listen to my heartbeat. My footsteps. My breathing. It's a meditation and I'm always trying to get better."

Butler says that running is wonderful because you can do it wherever you are and with no special equipment. For those aspiring to run in races of any distance, she said that it's important to find a training plan. "Training is a part of learning yourself," she said. "It helps you become more comfortable when you're out there. You need to trust your training and just enjoy the moment."

Despite the fact that Butler says that she could probably roll out of bed and run an impromptu marathon, she still finds ways to challenge herself. Five of her marathons were ultra-marathons ranging from a 50K to a 100 mile race.

Butler's most recent race was her third All American Marathon here at Fort Bragg. She led the 4:15 pace group. Her pacing was right on point with her crossing the finish line at 4 hours, 14 minutes and 37 seconds and still placing first in her age group. Her personal record is 3 hours and 34 minutes and she says that she would like to get that down to 3:30.

"After Boston, I'm not racing again until August," she said. "I'm going to be training for my PR and I'm going to get it."

Chief Warrant Officer Three Deleskia D. Butler, U.S. Army, Retired

Deleskia Butler served in the United States Army as a Chief Warrant Officer Three (CW3) until her retirement on July 1, 2015.

Butler's Warrant Officer Assignments include: from January 2014 – July 2015, she was assigned at Fort Knox, Kentucky as the Human Resources Systems Team Technician primarily serving as the Subject Matter Expert (SME) for multiple human resources functions as it related to personnel accountability systems. Ms. Butler was the Chief, Support Branch, Casualty and Mortuary Affairs Operations Center (CMAOC) from May 2013 – December 2013 at Fort Knox responsible for overall supervision of all personnel and finance-related issues for over 200 Soldiers assigned, attached, or with duty at CMAOC.

Deleskia is a small business owner and a graduate of V-WISE Chicago 2013 and Boots 2 Business 2014. Her business, Distinctive Women, Entrepreneurial Women Making a Difference, is a woman and veteran owned business. She is a member of Alpha Kappa Alpha Sorority, Inc., Mu Delta Omega Chapter, Fort Knox, Kentucky. She is also a charter member of the Louisville Phi Chapter of Kappa Epsilon Psi Military Sorority Inc. Deleskia's dream was to join the military. "I joined the military at age 17. I was your typical hard-headed teenager," Deleskia admitted. She found her passion when she joined the Army. "It was either learn how to run or go home." Deleskia learned how to run, but it wasn't easy. She noticed, however, in the 22 years she spent climbing the ranks that a lot of her troops were struggling too. "Soldiers had a problem passing their 2-mile test. They were seeking a different way to train." In Germany in 2003, Deleskia joined a spin class, where she met an instructor whose energy has been unmatched

by all that she has seen since. "The instructor had rhythm and she played the best music. She was jumping off her bike and was full of energy. I said to myself, 'I want to teach like her!' I started riding and teaching some classes on the base."

By 2011, Deleskia was a certified spin instructor, and with an entrepreneurial mindset, she knew she wanted to open her own business after her time in the military. In February 2016, she opened WorkOut Boutique where Deleskia offers her own twist to a traditional spin class. Ms. Butler has an Associate degree, General Studies from Columbia College and a Bachelor of Science (BS), in Multi-/Interdisciplinary Studies, General from Grantham University. Additionally, she has a Certificate of Entrepreneurialship from Syracuse University.

CW3 Deleskia D. Butler

Chief Warrant Officer Three Christina Carter, U.S. Army

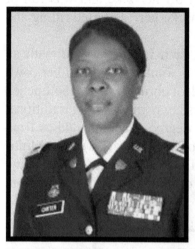

Chief Warrant Officer Three Christina Carter is a native of Alabama. She enlisted in the Army National Guard as an E4 Personnel Information Systems Management Specialist (75F) in January 1998 completing basic and advanced individual training at Fort Jackson, South Carolina. She began her fulltime career in the military while in the enlisted ranks in 2001 as a Personnel Services Clerk with continued advancements as an Initial Active Duty Training (IADT) Manager, the State Personnel Security Manager, and Budget Analyst.

Then "Sergeant Carter", motivation continued by completing Warrant Officer Candidate School receiving her appointment as a Warrant Officer One in September 2009. She went on to complete the Adjutant General's Warrant Officer Basic and Advance courses obtaining her current rank as Chief Warrant Officer Three. She earned a Bachelor of Science Degree in Management of Human Resources from Faulkner University and a Master's Degree in Occupational Safety and Health from Columbia Southern University. She is currently the S1 Chief, Human Resources Technician at the 31st Chemical Brigade, Tuscaloosa, Alabama.

CW3 Carter's deployments include Operation Enduring Freedom, Ft. Benning, Georgia 2003 and Operation Iraqi Freedom, Camp Beuring, Kuwait 2004-2005. Her awards and decorations include the Meritorious Service Medal, Army Commendation Medal (2OLC), Army Achievement Medal (3OLC), Army Good Conduct Medal, Army Reserve Components Achievement Medal (3OLC), National Defense Service medal (2nd award), Army Service Ribbon, Overseas Service Ribbon, Armed Forces Reserve Medal with "M" Device (2nd

award), Global War on Terrorism Expeditionary Medal and the Global War on Terrorism Service Medal.

Chief Warrant Officer Five Mary Frances Carter, U.S. Army Reserve, Retired

Mary F. Carter, CW5, USAR Retired, was born on December 6, 1946 in Union, South Carolina. She began her military service as a PVT-E1 in the Women's Army Corp in November 1965 and served as Administrative Specialist with HQ, USCONARC, Fort Monroe, Virginia until her discharge. She established residence in California and began civilian employment with the County of Los Angeles in 1968; entering the United States Army Reserve in 1973.

Ms. Carter was appointed a Warrant Officer in 1984 with the 349th General Hospital in Los Angeles. She transferred to the 6222nd United States Army Reserve Forces School in Pasadena, California and served as an instructor and personnel records specialist for the 6th Army MOSTC during annual training for three years. She later transferred to the 6218th Army Reception Battalion in Bell, California where she utilized her skills of primary and secondary MOS's serving as the Unit Equal Opportunity Representative and Alcohol Drug Abuse Prevention Program Coordinator.

Ms. Carter transferred to the 104th Division in 1996 performing as the unit Military Personnel Technician duties of processing new soldiers to Active Duty during Annual Training at Fort Lewis, Washington and several East Coast Active Army Bases. She mobilized as Operational Support with the 104th Division 2006 where she served as Strength Management Officer for Operations Noble Eagle and Enduring Freedom. While on Active Duty, she was selected for CW5. Upon discharge, she transferred to the 63rd Regional Support Command; attended the Warrant Officer Senior Staff Course

(WOSSC) and was promoted Chief Warrant Officer Five in December 2008.

Chief Carter earned her Master's Degree of Public Administration in 1986 from California State University – Dominquez Hills; completed the Systems Automation Course and the Warrant Officer Senior Course in 1988. She was presented the United States Army Warrant Officers Association's Albert Holcombe Memorial Award as Warrant Officer of the year in 1994. Ms. Carter also earned the Reserve Officer Award, the Meritorious Service Medal, Army Achievement Medal w/Oak Leaf Cluster, Army Commendation Medal w/Oak Leaf Cluster, Armed Forces Reserve Medial w/Hour Glass, National Defense Service Medal w/BSS and other service medals and ribbons.

Ms. Carter's most memorable experience was her assignment as Warrant Officer at Fort Drum, New York and mobilization assignment as Operational Support for Noble Eagle and Enduring Freedom. During her Active Military Service, she was the interim president of the Southern California Warrant Officer Chapter; Director USAWOA Western Region; member of Reserve Officers Association (ROA), the Employer Support for the Guard and Reserve (ESGR) representative; and other organizations.

CW5 Carter retired after 37 years combined Active and Reserve Military Service. Ms. Carter is currently living in Virginia.

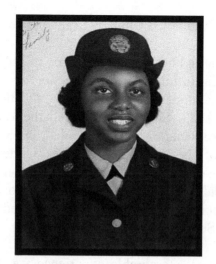

Mary F. Carter, PV1

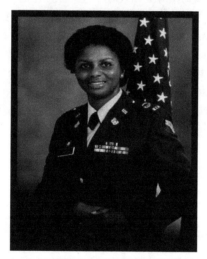

Mary F. Carter, CW4

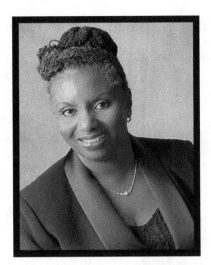

Mary F. Carter, Retired

Chief Warrant Officer Two Shereka Catoe, U.S. Army

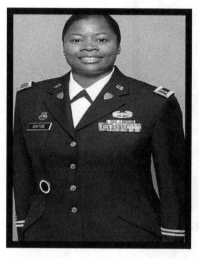

CW2 Shereka Catoe was born September 29, 1976 in Lancaster, South Carolina. She graduated from Lancaster High School in 1995. She later completed her undergraduate studies at Voorhees College in Denmark, South Carolina, graduating with a Bachelor of Science Degree in Sociology in 1999. She is a Webster College graduate with a Masters in Professional Counseling.

CW2 Catoe began her military career in the South Carolina Army National Guard in 2001 as an E4/Specialist, while simultaneously working as a Social Worker in Rock Hill, South Carolina. She was assigned to the 268th ENG DET (FF) as a 71L / Unit Clerk.

She deployed to Mosul, Iraq in 2004 in support of the Global War on Terrorism and crossed trained in country as a fire fighter. In 2011, she attended the Warrant Officer Candidate School (WOCS) at the 218th Regional Training Institute (RTI). She deferred her commission and was appointed on 1 August of 2013. She completed Warrant Officer Basic Course at Fort Jackson, SC in 2014, and is currently assigned to Joint Forces Headquarters in Columbia, SC as the Branch Chief in the G1 / Officer Personnel Management (OPM) section.

CW2 Catoe's additional military education includes the Primary Leadership Development Course, 42A Basic Noncommissioned Officers Course, Facilitator Course, Equal Opportunity Leaders Course, Force Management Course, and Instructor Course.

Her awards and decorations include Meritorious Service Award, Army Achievement Medal (2 oak leaf clusters), Army Good Conduct Medal, Armed Reserve Component Achievement Medal, National Defense Service Medal, Global War on Terrorism, Iraqi Campaign Medal (2 campaign stars), Armed Forces Reserve Medal w/ M Device,

Noncommissioned Officer Professional Development Service Ribbon (w/ numeral 2 device), Army Service Ribbon, Overseas Ribbon, and the Combat Action Badge. She was a Warrant Officer of the Year recipient in 2016.

CW2 Catoe has one sibling and a 20-month-old son named Bryson.

Shereka Catoe

Shereka Catoe

Chief Warrant Officer Four Twana Chapman, U.S. Army

Women's History Month Spotlight: Twana Chapman
DLA Energy Public Affairs

Army Chief Warrant Officer 4 Twana Chapman serves on active duty as the military quality liaison officer for DLA Energy Quality Technical Support Directorate at Fort Belvoir, Virginia.

March 4, 2019 —

Editor's note: Every year March is designated as Women's History Month by presidential proclamation. In honor of this tradition, Defense Logistics Agency Energy is recognizing some of its top-notch female employees who are making a difference as champions of Warfighter support.

My name is:
Twana Chapman

I am:
An Army Chief Warrant Officer 4 serving on active duty as the military quality liaison officer for DLA Energy Quality Technical Support Directorate at Fort Belvoir, Virginia. I am a native of Talladega, Alabama. I enlisted into the U.S. Army in February 2000 as

a petroleum supply specialist. I commissioned into the Army Warrant Officer Corps as a petroleum systems technician in August 2007.

Describe your job in a sentence:

As the DLA senior military quality liaison officer, I spearhead the consolidation and preparation of Post Award Requests and task orders for the optimization and sustainment of commercial laboratory services, equipment purchase, products and services worldwide.

How long have you worked at DLA?

Eight months with DLA Energy, although my career with DLA began in July 2018.

What is your favorite thing about working for DLA?

I enjoy DLA's strategic thinking, strong partnerships and the agency's forward-focused analysis decision making processes for the Warfighter. DLA's diverse joint environment is comprised of an extensive number of subject matter experts that I enjoy working with daily. I embrace the agency's sense of urgency to meet the Warfighter supply chain requirements across all logistical spectrums.

What are your best memories of working here?

I will always uphold DLAs standards and emulate their method of approach as I move forward in my career as a logistician and senior advisor. The DLA strategic "One Team, One Fight" concept and high operational tempo focus on global readiness are my best memories of working at DLA. In addition, I value DLA's Family Day as a great venue for families to see our day-to-day business environment.

How do you make a difference?

By focusing and understanding multiplicity concepts of the leader's mission, vision and goals. I am transparent, flexible and understand the onset of unanticipated mission requirements to support leadership, team members and ultimately the Warfighter.

How do you resolve conflict in the workplace and at home?

Staying mission focused is my primary goal as a team player while focusing on the Warfighter, DLA goals and fostering our strategic partnerships. In the face of conflict, I embrace it immediately by addressing the situation for a definitive resolution, even if it is uncomfortable. Finally, I stay focused spiritually with my family, keeping a great work-life balance by including them in all aspects of my life.

Chief Warrant Officer Three Carmen E. Cole, United States Marine Corps, Retired

WO-3 Carmen Cole a native of Milwaukee Wisconsin began her military career enlisting in the Marine Corps in November 1980. She completed recruit training at Parris Island S.C., in June 1981 and was trained as a motor transport maintenance mechanic at Camp Johnson formally known as Montford Point. She reported to 2d Maintenance Battalion, Camp Lejeune in November of 1981. While there she was meritoriously promoted to Lance Corporal, Corporal and Sergeant. In 1984 she returned to the Parris Island S.C. as a Drill Instructor and Senior Drill Instructor.

In 1986 she reported to 3rd Maintenance Battalion Okinawa Japan where she served as the battalion administrative chief and as a mechanic. In 1988 she transferred to 7th Motor Transport Maintenance Battalion, Camp Pendleton California serving as a Platoon Sergeant and MIMMS clerk. In 1990 she was promoted to Staff Sergeant and became the first female Motor Transport Maintenance Shop Chief in the command.

In 1993, she was selected as a Warrant Officer becoming the first female in the Marine Corps to be a Motor Transport Maintenance Officer. After completing The Basic School for Warrant Officers and the Motor Transport Maintenance Officers course she was assigned to Marine Air Control Squadron-2, Marine Air Group–31, Beaufort, South Carolina serving as the Maintenance Management Officer. She was promoted to CWO-2 during this tour.

In 1996, CWO-2 Cole returned to 3rd Maintenance Battalion, Motor Transport Maintenance Company, Okinawa Japan as the Maintenance Officer. During this tour she assisted with the initial

restructuring and merger of the command with 3d Supply Battalion to form 3d Material Readiness Battalion.

In 1998, she was assigned as the Inspector-Instructor Detachment-2, Augusta Ga., 4th Maintenance Battalion becoming the first female I&I to command the active duty staff in support of the Marine Reserve unit at Augusta Ga. During this tour she was promoted to CWO-3.

On May 1, 2001, CWO-3 Cole retired from the Marine Corps to accept a position as the Senior Marine Instructor of Marine Corps Junior ROTC, Butler High School becoming the first female instructor at Butler High School in their 30 years of having a MCJROTC program. While at Butler High School she was also the softball and soccer coach, PTA treasurer and Teacher of the Year in 2007.

In 2010 she resigned her position at Butler High and relocated to Marine Corps Junior ROTC headquarters Marine Corps Base, Quantico Virginia to become the Marine Corps Junior ROTC Instructional Systems Specialist (ISS). In 2011 she was reassigned and became the first female to be the Operations Manager for Marine Corps Junior ROTC programs with ISS as an additional responsibility.

As the Operations Manager she is responsible for the daily coordination and operations of 6 Regions with 235 MCJROTC programs. She travels throughout the country to promote the MCJROTC program, looking for new locations and potential instructors, she trains new instructors, and ensures all MCJROTC instructors have the tools they need to lead and mentor their cadets.

Carmen Cole is a 1998 graduate of Park University where she received her Bachelor's Degree in Management. She received her Master's Degree in Leadership Education from Augusta State University in 2007. She is married to Angelo Crawford USMC retired. They have 3 daughters; Claudia, Valdosta State University graduate, Taylor, Old Dominion University freshman and Micaela, Colonial Forge High School Sophomore Stafford Va.

Ms. Cole is currently the Montford Point Marine Association Inc., Quantico Chapter 32 Secretary. She is also a member of several veteran and educational organizations.

Chief Warrant Officer Two Pamela Joyce Coleman, U.S. Army

Heart of gold

By Sgt. Duncan Brennan, 101st Combat Aviation Brigade
Feb 26, 2015

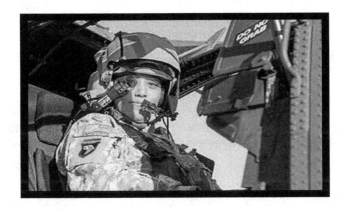

Chief Warrant Officer 2 Pamela Joyce Coleman, AH-64 Apache helicopter maintenance-test pilot, pauses before she conducts a maintenance run up on an AH-64E Apache Guardian helicopter during daily maintenance, Tuesday.

Photo by Sgt. Duncan Brennan | 101st CAB

Chief Warrant Officer 2 Pamela Joyce Coleman, AH-64 Apache helicopter maintenance-test pilot, Company A, 1st Battalion, 101st Combat Aviation Brigade, 101st Airborne Division, has a bright and

engaging smile. She laughs easily and is comfortable talking with just about anyone.

Coleman cares about the people she works with. She not only tries to encourage people professionally, she also tries to make their lives brighter by making them laugh. In the profession of arms, a sense of humor goes a long way in bridging gaps and fostering good relationships.

"One story always stands out to me," said Sgt. 1st Class Veronica Harvey, battalion logistics noncommissioned officer in charge, Headquarters and Headquarters Company, 1-101st CAB. "Shortly after I got to 1-101st CAB, Coleman was getting ready to fly one day. She texted me that they would be flying low when flying past battalion. It was some kind of training flight. When a co-worker and I heard the helicopters get close, we went outside to watch her fly. At this point we couldn't tell who was who. Then one of the Apaches did a turn. All we could see were teeth and a hand just waving at us. I took a picture and sent it to her asking who waves when flying a helicopter. She told me that the other pilot had the controls and she wanted us to know it was her. She does little things to make other people smile."

Coleman was not always an Apache pilot. She joined right out of high school and went into supply. After reaching staff sergeant, she decided to become a pilot. Her time as an enlisted Soldier and her time as a noncommissioned officer influence her day-to-day interactions with everyone around her. "What I love about her the most is that when she made the transition to being a pilot, that caring mentality of an NCO didn't leave her," said Bostic. "On a daily basis Coleman goes in and checks on the Soldiers. She has conversations with them about their ambitions and what's going on in their lives. She talks to the Soldiers, not just the ones in her company, but all the Soldiers. She knows their names, about their Families and a little something about them. She pushes them to be all you can be."

Coleman may laugh easily and make a point to take care of Soldiers, but she also knows what's at the core of her job. Being an Apache pilot isn't always about being nice. She knows how to take care of Soldiers who are fighting for their lives.

"Pam is soft spoken, well-mannered and she's an excellent attack-helicopter pilot," said Bostic. "Don't be on the other end of her 30mm when you're doing the wrong thing because she has no problems laying bullets down."

Coleman understands that being an attack-helicopter pilot is about the ground forces. Supporting the Soldiers on the ground that are in contact with the enemy is the essence of why the Army has the Apache.

"On deployment, we're all about supporting the Soldiers on the ground," said Coleman "There's a feeling that you get when you show up and the ground forces feel protected."

There is something else that sets Coleman apart in the attack-helicopter world. She is a rarity in the Apache world: a black, female pilot.

"She's one of a kind," said Chief Warrant Officer 2 Jason Bostic, instructor pilot, Co. B, 1-101st CAB. "Just digging into aviation history, there aren't many black pilots to begin with. In the attack realm, there aren't that many female pilots. She's always been a strong black female and on top of that, she's a gun pilot and that's not something you find often. She is proud of her heritage and she's proud of what she does."

Even though she is a rarity among Apache pilots, she keeps things in perspective while maintaining her own identity.

"I will be honest with you; at flight school I stuck out," said Coleman. "I am always proud to be a black female and I'm always proud to do what I do because I can influence Soldiers. Here, in the 'Expect No Mercy' battalion, I'm treated like every other pilot."

Coleman attributes her strength and pride to her Family. Her mother in particular continues to be an inspiration to her even when life gets tough.

"My mother is my biggest supporter," said Coleman. "She is my role model. She's so strong; I've always aspired to be like my mother. Basic training was hard for me. Leaving home at 18 was tough, but my mom told me 'they can't make it tough enough.' Any time I'm going through a difficult time I hear her say that. She's always there."

With the stress of the small problems effectively dealt with, Coleman is free to devote that energy to what she loves doing: her job. That enthusiasm for what she does is not lost on the pilots she works with on a daily basis.

"In our community, we're a bunch of serious, type-A personalities," said Bostic. "Coleman is definitely the kind of person that walks into a room and brightens up the mood. She always comes to work with the 'I'm-happy-to-be-here' mentality. She loves her job and it's outwardly displayed every single day."

Mentoring Soldiers is only one part of being in the Army. Maintaining proficiency is a big part of being a pilot. Here again, Coleman shows a solid aptitude across different areas.

"You're not going to outwit her on job-performance things," said Bostic. "You're not going to outmatch her when it comes to regulatory guidance, either. There's no gray area with her, and that's a good thing. She says what she means and means what she says. She's the kind of person to help you up when you fall down. She's also the type to sharp-shoot you when you're wrong."

Coleman has made taking care of Soldiers a core part of being a member of the 101st CAB. Her tactical and technical proficiency have helped Soldiers make it home to see their Families again and has helped turn a team of teams into something closer to a Family.

"She has a heart of gold," said Harvey. "If there's anyone that has issues going on in their life and they need to talk, she's a person that you can talk to. She's always there to listen. She's a good-spirited person. She loves to laugh, and we need that a lot around here. With the stress of preparing for deployment, it helps break up the monotony. I am blessed to be able to call her my friend."

CW5 Roberta Spikes Cummings, Retired, U.S. Army (Deceased)

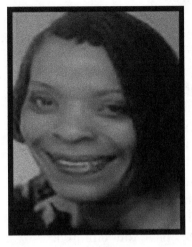

Roberta Spikes Cummings, 69, passed away peacefully on Wednesday, July 24, 2013 at her son's home in Port Orchard, WA, after fighting a long and courageous battle with lung cancer. She was born on May 1, 1944 in Angie, LA. She was a resident of Baton Rouge, LA and a native of Bogalusa, LA. She proudly served in the U.S. Army as an officer. Roberta retired as a Law Librarian and Assistant Professor at Southern University and JROTC Instructor at Glen Oaks High School. She was a devoted member of St. Paul the Apostle Catholic Church in Baton Rouge, LA. She is survived by her son, Joseph Emile Cummings, II and his wife Kristie of Port Orchard, WA; and her grandchildren, Horace J. Wilson of Birmingham, AL, Joseph E. Cummings, III, and Karrington Rae Cummings of Port Orchard, WA. She is preceded in death by her parents, Curtis Spikes, Sr. and Willie Mae Spikes; and daughter, Alicia Cummings. A memorial service will be held in her honor on Saturday, August 17, 2013 at 2:00 pm at the Greater King David Multicultural and Education Center, Baton Rouge, LA 70807. In lieu of flowers donations can be made to the Cancer Services of Greater Baton Rouge, 550 Avenue, Baton Rouge, LA 70806.

*Roberta Cummings was the first African American Female promoted to Chief Warrant Officer Five in the Army Guard and Reserves (AGR) Program.

Chief Warrant Officer Five Georgene F. Davis-Dixon, U.S. Army, Retired

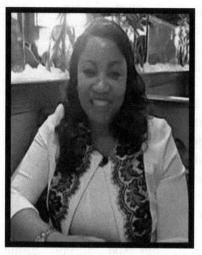

In December 2013, Chief Warrant Officer Five Georgene Davis-Dixon assumed the position of the Senior Army Food Advisor, the first female to hold this position. After joining the Army in November 1986, she attended Basic Training and Advanced Individual Training at Fort Jackson, South Carolina in MOS 92B. She served on active duty for over 28 years and is married to CW4 Bobby Davis. They have four children.

Chief Warrant Officer Five Davis-Dixon served as the Officer in Charge at Field Operations Training Branch, Instructor Writer, and Senior Instructor for the Warrant Officer Advance Course.

Chief Warrant Officer Five Davis-Dixon completed every level of the Warrant Officer Education System. She holds a Master's of Science in Business with a concentration in Human Resource Management from Troy University and has a PhD in Organizational Psychology from Walden University. CW5 Georgene Francis-Davis is a Certified Demonstrated Master Logistician (DML) from S.O.L.E. (Society of Logistics Engineers).

CW5 Davis-Dixon is a 2014 Inductee as a Distinguished Member of the Quartermaster Regiment.

Ms. Davis-Dixon is currently a Human Resources Specialist with the Veterans Administration Hospital in Fayetteville, North Carolina.

Chief Warrant Officer Three, Stacey Dixon, Ed.D., United States Marine Corps, Retired

U.S. Marine Chief Warrant Officer (retired) Stacey Dixon works in National Louis University's Veterans Center, where she follows her passion for helping veterans reintegrate into civilian life. After a 21-year military career, mostly as a scientist, she also wants to teach young people life skills, character development and financial literacy in addition to academic subjects. She's particularly interested in teaching young people in neighborhoods like Chicago's South side Englewood, where she went to high school at Lindblom Tech.

Excerpts from interviews:

You were the first female Meteorology and Oceanography (METOC) Officer in the U.S. Marine Corps (SO amazing). Could you tell us a bit more about what it was like taking on such a groundbreaking role?

In the military, especially the Marine Corps, women are almost always outnumbered. In METOC, the number of women in the field was even smaller. Our customer base was mostly infantry, artillery, and aviation: all male-dominated fields. Working with mostly male officers, not of color in these fields, they rarely took my work and/or briefings seriously. I was often challenged on my forecasts and intelligence briefings or they would ask the male officer or even another enlisted male to confirm my data and analysis.

For me to become an equal and gain the credibility I deserved, I needed to become an officer like them. In 1990, I submitted my first package for the Warrant Officer Program, a program that promotes you from enlisted to officer. A special kind of officer: one with years of technical experience and leadership in their field. In February 2000,

I was promoted to Warrant Officer; after ten years, ten applications, and a lot of pushback. It was groundbreaking, though few acknowledged it. The challenges continued to come, but I now had leverage—and I used it. Eventually, the respect for the work I did was acknowledged by others. But I first had to acknowledge for myself how this precedence would change the outlook for the young women coming up in the field after me.

In the United States (and beyond) few women are earning degrees in STEM, and the percentage is even smaller for women of color. How have you made sense of this inequality? How have you overcome it?

I don't know many people who would endure ten years of rejection in order to achieve a small but important goal. I was brought into the field because of the scores I achieved on their tests. But for ten years, I was told that I was not good enough to be an officer in that same field. Not because I couldn't, but because I was a female and of color. Similarly, science and math were not stressed upon us as girls and especially not girls of color. So when we struggled, we were often reassured that it was okay because girls just aren't good at math and science. Sadly, that message continues to circulate. I've made sense of the fact that I was a victim of that pedagogy from decades ago. I was a product of that mentality. Even though I crossed some of the hurdles of inequality, I didn't celebrate them.

I was promoted to Warrant Officer, on 2 February 2000, in Black History month. There was no story told across the Base or the Marine Corps that acknowledged that moment in Black History. To me, and for many young girls and women of color, it was as it has always been, "not for girls."

Though I continue to struggle with being a woman of color in fields dominated by men, I have learned that we are our best advocates. Every chance I get to tell the story of my journey, I tell it. I tell it for women who have been through much of the same, and for those who need to hear it, so that they can have the courage to push through, despite the stereotypes and the inequality.

What prompted you to enter the military?

My brother Oren joined the Marine Corps, and when he came back on leave I admired the way he had transformed into this great person–very confident, determined and focused. I wanted to be that person. He always talked highly of the Marine Corps and what it was doing for him. I wanted to do the traveling and experience the same things he did.

What was your role in the military?

I started as an administrative clerk, but two years into a 21-year military career, I transferred to meteorology and oceanography and spent the rest of my time in the military there.

I was the first female science officer in the Marines. At that time, meteorology was the only science we had, though now they've opened it up to computer science.

What did you do as a meteorologist?

We supported both the infantry and aviation side of missions. We had to learn the basics of forecasting, including analysis and charts. In our work, we sent up radiosondes, which are instruments which measure temperature, humidity, cloud levels and more. They are carried up by balloons to altitudes of 5,000, 10,000, 20,000 and 30,000 feet, and their measurements gave us the data we needed.

What rank did you achieve?

I entered the Marine Corps as a private first class and climbed the ranks through gunnery sergeant. Then I began submitting my package for the warrant officer program. That required achieving at least the rank of sergeant, six years of service and a competitive record including fitness, required professional training and courses and strong recommendations. After 10 years, I was finally selected and promoted to warrant officer. Before I retired I was promoted to my final rank of Chief Warrant Officer 3.

Warrant officers are considered the technical experts in their fields and represent the experience of the unit. Commanding officers often rely on their counsel in their area of expertise.

Why did you pursue higher education?

My stepdad was pursuing a Ph.D. in psychology before he passed away, so my parents always valued education. I did well in high school, so they anticipated my going to college. But I had my mind set on going into the military. Whenever I had an opportunity to take a class, I did. I was always pursuing education. I got my bachelor's from Thomas Edison State College in Trenton, New Jersey right before I retired from the military. Then I earned my MBA from National College in San Diego, and worked in California as a financial advisor. I returned to Chicago in 2008 and worked on my doctorate from 2011-2015. I earned my Ed.D. from Argosy University.

Chief Warrant Officer Five Yolondria Dixon-Carter, U.S. Army

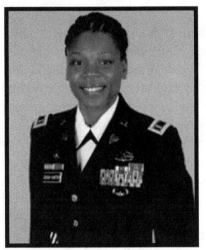

Yolondria Dixon-Carter, Division Headquarters and Headquarters Battalion, 3rd Infantry Division, won Adjutant General's Corps Warrant Officer of the Year (2011). She received the LTG Timothy J. Maude Medal for Distinguished Achievement.

Chief Warrant Officer Five Artavia M. Edwards, U.S. Army California National Guard

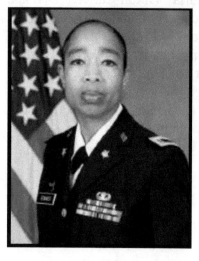

Chief Warrant Officer Five Artavia M. Edwards serves as the Chief Legal Administrator, California Army National Guard, providing senior staff level MOS Proponency and decision-making functions, contemporaneously responsible for national actions concerning manpower, authorizations, and 270A MOS Legal Administrators for recruitment, while collaborating with coordinating the goals of NGB-JA Chief Counsel, with NGB CCWO, and State CCWOs, with dual responsibility for assisting the State Staff Judge Advocate in the total delivery of legal services in the California Army National Guard.

CW5 Edwards has a Juris Doctor degree, a Master of Science degree in Leadership, a Bachelor of Science degree in Business Administration, an Associate of Arts Degree in General Business, and is currently a doctoral student; is a graduate from Airborne and Master Fitness Trainer Schools; served as a Notary Public from 1988 to present; served as a Notary Ambassador, Sacramento, National Notary Association from 1994-2006; is a trained Parliamentarian and member of the National Association of Parliamentarians; is a registered Mediator; is Captain of the California National Guard Marathon Team; competed as a member of Team USA in the July 2011 World Masters Athletics Championships; and is a Martial Artist, Red/Black Belt, and will receive a Black Belt in Taekwondo in 2018, and received gold medals for her performance in State and National Taekwondo Championships from 2015-2017.

CW5 Edwards' military awards and decorations include the Legion of Merit, Meritorious Service Medal (with Oak Leaf Cluster); the Army Commendation Medal (with Oak Leaf Cluster); the Army

Achievement Medal; the Army Reserve Components Achievement Meal (with 2 Oak Leaf Clusters); the National Defense Service Medal (with 1 Bronze Star); the Armed Forces Reserve Medal; the Non-Commissioned Officer Professional Development Ribbon; the Army Service Ribbon; and the USAR Unit Pewter Cup Award.

Chief Warrant Officer Five Martha Ervin,
U.S. Army Reserve, Retired

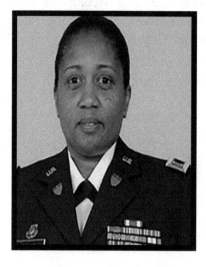

Chief Warrant Officer Five Martha Ervin is the first Black Command Chief Warrant Officer (CCWO) and is assigned as the Chief of Personnel Branch, G1, for the 7th Mission Support Command at the Daenner Kaserne, Kaiserslautern, Germany.

As the CCWO, she represents and advises the Commander of the 7th MSC on matters pertaining to Professional Military Education and training, career management, leader development for Warrant Officers. In addition, she is responsible for lifecycle management for all the down trace units in her area of concentration.

Chief Warrant Officer Five Ervin joined the Alabama National Guard as a Private on 19 May 1980 as a 75B10, Personnel Administrative Specialist with the Co. D., (Maint), (-DAT), 31 Support Battalion, Oxford, Alabama. During her 37 years of National Guard and Army Reserve, she has served in all echelons of the Military Corps with duty in and outside the Continental United States (OCONUS).

She was mobilized in support of Operation Enduring Freedom as the Senior Warrant Officer for the Combined Forces Command in Kandahar, Afghanistan, alongside the 81st Airborne Division. In addition, she served at both the Army Human Support Command in St. Louis, MO and Fort Knox, KY that supported over 5000 Soldiers in lifecycle management. Her previous assignment was with the 87th Army Support Command-East, in Birmingham, Alabama as the Command Chief Warrant Officer/Senior Warrant of the G1/Deputy where she spearheaded the deactivation of the unit and it down trace.

Ms. Ervin has a Bachelor's Degree in Business Management from the University of Phoenix and she is over 95 percent completion of her Master degree program.

Chief Ervin's military decorations and awards include the Meritorious Service Medal with 4 Oak Leaf Cluster, the Army Commendation Medal, the Joint Service Achievement Medal, the Army Achievement Medal, Army Reserve Component Achievement Medal with 4 Oak Leaf Clusters, National Defense Services Medal, Afghanistan Campaign Medal, Global War on Terrorism Medal, Armed Forces Reserves Medal with silver hourglass with "M" Device, NCO Professional Development Ribbon with the number 2, Army Service Ribbon, Oversea Ribbon, Army Reserve Components Overseas Training Ribbon, North Atlantic Treaty Organization (NATO) Medal.

CW5 Ervin has served as the President of United States Army Warrant Officers Association's Fort Knox Derby Chapter, and also served as the Vice-President of the Adjutant General's Corps Regimental Association for the European Chapter.

Ms. Ervin retired in July 2019 after 39 years of military service.

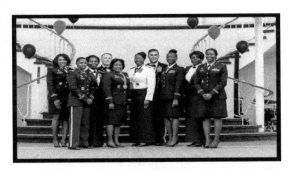

Picture of all the AG Warrant Officers who were assigned to the 21st Theatre Sustainment Command (TSC) at the 2019 AG Ball. CW5 Ervin received the Major General Horatio Gates Gold Medal, the highest award authorized by the Adjutant General's Corps Regimental Association.

Chief Warrant Officer 4 Martha Ervin, attached to a U.S.
National Command Element in Kandahar, Afghanistan,
went on a humanitarian trip to the village outside the base
to hand out school supplies and clothes to the local people.
(Picture by CSM Williams with the 82nd Airborne Division,
Home based at Fort Bragg, NC.)

Chief Warrant Officer Four Melissa Farmer, U.S. Army, Retired

CW4 Melissa Leigh Farmer was born and raised on the south side of Chicago, Illinois. She was the oldest of four children. She has an Associate Degree fin General Studies from Austin Peay State University which she earned during her military career. Farmer has been writing since the age of 12. She was a writer for her high school newspaper where she won first place in an all-high-school writing competition sponsored by the Chicago Sun Times.

Before joining the Army, Farmer worked in housekeeping at the Hilton Hotel in Chicago. The job wasn't rewarding enough for her, so she joined the Army.

CW4 Farmer enlisted in the active component in 1994 after completing six years in the Army Reserves. Farmer's first duty station was at Camp Red Cloud, Korea in 1994. She was appointed as Warrant Officer in 1999 and in 2001 received the United States Army Europe General Douglas MacArthur Leadership Award.

In 2005-2006, she deployed with the 101st Division, Special Troops at Forward Operating Base (FOB) Speicher in Tikrit, Iraq.

Ms. Farmer is the author of a book titled, "Army strong Women". The 138 page book is geared towards an audience that is not familiar with the military. In the book she answers the question that she always received from women when she was out and about in uniform, "What's the Army like?"

In 2008, CW4 Melissa Farmer was selected as the Training and Doctrine Command Warrant Officer Instructor of the Year.

Melissa Farmer has a Master of Science (M.S.) in Hospitality & Tourism from Roosevelt University.

Chief Warrant Officer Five Janice L. Fontanez, U.S. Army National Guard, Retired

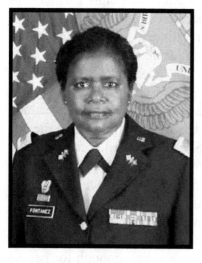

Chief Warrant Officer Five Janice L. Fontanez assumed her duties as the Senior Signal Warrant Officer, Advisor Army National Guard (ARNG) CIO/G6, National Guard Bureau (NGB) July 2013. As the Senior Signal Warrant Officer ARNG CIO/G6 she provides leadership, guidance, mentorship, technical input and direction on information systems, networks, cyber operations, governance and polices to senior leaders, Warrant Officers, and non-commissioned officers in the ARNG.

CW5 Fontanez began her military career began August, 1975, when she enlisted in the United States Army Reserve, in Athens, Georgia. She later joined the District of Columbia ARNG in July, 1978. CW5 Fontanez served in the enlisted ranks, rising to rank of Sergeant First Class as a member of Headquarters, District Area Command. In 1989, she attended Warrant Officer Candidate School at Fort McCoy, Wisconsin. CW5 Fontanez received her appointment as WO1 November, 1989 at Fort Gordon, Georgia after completing Signal Warrant Officer Basic Course. CW5 Fontanez served in varies assignments from 1989 – 2003 while serving in the District of Columbia ARNG. Her duty assignments included System Programmer/Analyst, Telecommunication Manager, and Information Management Branch Chief.

In 2003, CW5 Fontanez was accepted in the Active Guard Reserve (AGR) Title 10 program, supporting the ARNG CIO/G6 directorate as the Guard Knowledge Online (GKO) Webmaster, where she managed resources, personnel, architecture and design of GKO secure and non-secure portals capabilities. In 2009, she served as the ARNG Enterprise Chief Computer Network Defense (CND) and was

responsible for coordination and execution of the ARNG Information Assurance and CND program for GuardNet XXI. In 2011, CW5 Fontanez was selected as the Senior Signal Warrant Officer Advisor ARNG, TRADOC Command, Signal Center of Excellence, Fort Gordon, Georgia. As the Senior Signal Warrant Officer advisor ARNG, she was the principle advisor to the Deputy Assistant Commandant ARNG, 442nd Signal BN Cyber Leader College on all Reserve Component actions; advisor to NGB Command Chief Warrant Officer (CCWO), 54 states, territories and the District of Columbia CCWO's on Signal training and education. Her civilian education includes a Bachelor of Arts degree in Business Management.

CW5 Fontanez's military decorations include the Meritorious Service Medal (with 3 Bronze Oak Leaf Clusters), Army Commendation Medal (With 1 Bronze Oak Leaf Cluster), Army Achievement Medal, Army Service Ribbon, Armed Forces Reserve Medal (With Gold Hourglass), National Defense Medal (With Bronze Service Star), Non-Commissioned Officer Professional Development Ribbon (With Numeral 3), Global War on Terrorism Expeditionary Medal, and the United States Army Signal Regiment Bronze Order of Mercury.

Chief Warrant Officer Five Cindy E. Frazier, U.S. Army

Cindy Frazier is a native of Brunswick, Georgia. She entered the United States Army on 15 September 1988. She completed Basic Combat Training and Advanced Individual Training at Fort Jackson, South Carolina as a Unit Supply Specialist (76Y). She graduated as the Distinguished Honor Graduate of Advanced Individual Training. After serving seven years as a Noncommissioned Officer and achieving the rank of SSG, she received her commission through the Warrant Officer Candidate School in December 1996.

Before her appointment as a Warrant Officer, She served as the supply sergeant of Headquarters and Headquarters Company, United States Army Garrison, Fort Riley, Kansas and was the recipient of the Chief of Staff, Army, Supply Excellence Award for FY 1995.

CW5 Frazier was selected to serve on the FY16 Chief Warrant Officer Three, Four and Five Promotion Board as well as the Chief Warrant Officer Two, Three and Four Selective Continuation Board. She was also selected to serve on the FY12 Chief Warrant Officer Promotion Accessions Board. CW5 Frazier is currently assigned as the 920A Training Developer, CASCOM G3, QM TD.

CW5 Frazier has served in a variety of assignments that include Battalion Property Book Officer (PBO), 260th Quartermaster Battalion (PS), Hunter Army Airfield, Savannah, Georgia; Division Property Book Team Chief, 2nd Infantry Division, Camp Casey, Korea; Brigade S-4, 513th Military Intelligence Brigade, Fort Gordon, Georgia; PBO, 202nd Military Intelligence Battalion, Fort Gordon, Georgia; PBO, 532nd Military Intelligence Battalion, Seoul, Korea; Resident Research Fellow, Training With Industry (TWI) at Logistics Management Institute, McLean, Virginia; Instructor/Writer, Army

Logistics University, Technical Logistics College, Fort Lee, Virginia; Logistics Management Specialist, Combined Security Transition Command-Afghanistan, CJ4, Kabul, Afghanistan; Course Manager, Warrant Officer Staff and Senior Staff Follow On Course, Fort Lee, Virginia; Chief, Supply Excellence Award Program, Fort Lee, Virginia and Senior Logistics Advisor, G4 Supply and Services, Headquarters, First Army Rock Island Arsenal, Illinois, Dean, Technical Logistics College, Army Logistics University.

CW5 Frazier has deployed to Saudi Arabia and Iraq in support of Operations Desert Shield and Storm (1990-91) and Kuwait, Iraq and Afghanistan in support of Operations Enduring Freedom and Iraqi Freedom (2003, 2004-5, and 2010-11). In addition, she participated in exercises in Egypt in support of Bright Star (1998) and Puerto Rico (2002).

CW5 Frazier is a Distinguished Member of the Regiment, recipient of the Quartermaster Corps Distinguished Order of Saint Martin Medal, the Military Intelligence Corps Saint Knowlton's Medal, and US Warrant Officer Association Leadership Award and a graduate of the Logistics Executive Development Course (LEDC). She holds an Associate of Arts in General Studies from Barton Community College, Great Bend, KS, and a Bachelor of Science Degree in Human Services (cum laude) from Upper Iowa University, Fayette, Iowa and a Master of Science Degree in Logistics Management from Florida Institute of Technology, Melbourne, Florida. She also completed the Systems, Applications and Products on Data processing (SAP) based Enterprise Information Systems (EIS) Certification.

CW5 Frazier's military education includes: Warrant Officer Staff and Senior Staff Courses, Warrant Officer Advanced and Basic Courses, Basic Noncommissioned Officer Course, Primary Leadership Development Course, Advanced Force Management Course, Logistics Assistance Program Operations Course, Advanced Life Cycle Logistics, Level I, GCSS-Army Middle Manager's Course and other countless logistics courses.

CW5 Frazier's awards and decorations include: the Legion of Merit Medal; Bronze Star Medal (1OLC); Meritorious Service Medal (2OLC); Joint Service Commendation Medal; Army Commendation

Medal (6OLC); Army Achievement Medal (5OLC); National Defense Service; Afghanistan Campaign Medal; Iraqi Campaign Medal; NATO Service Medal; Korean Defense Service Medal; Global War on Terrorism Expeditionary Medal; Global War on Terrorism Service Medal, Parachutist Badge, Demonstrated Master Logistician and various other service medals and ribbons.

CW5 Frazier is a proud member of Kappa Epsilon Psi Military Sorority Inc. and shares her life with her husband, Stephen Brackett, her two daughters (Shemeka and Jasmine), son-in-law's (Taurus & Travis) and grandsons (Najeeb & Nadir).

CW5 Cindy E. Frazier
Biographical Summary:

Date and Place of Birth:
08 July 1964, Brunswick, GA

Enlisted Military Service: BASD: 19880915
8 years

Source and Appointment Date:
Warrant Officer – December 1996

Years of Active Warrant Officer Service:
22 years

Total Years in Service:
30 years

Military Education:
Instructional Design Course (2019)
Common Faculty Development Course (2018)
GCSS-A Middle Manager's Course (2017)
Senior Training and Education Managers Course (2013)
Initial Faculty Development Course (2012)
Logistics Assistance Program Operations Course (2012)

Warrant Officer Senior Staff Course (2011)
Small Group Instructor Training Course (2010)
Advanced Force Management Course (2009)
Warrant Officer Staff Course (2007)
Logistics Executive Development Course (2006)
Logistics Training Team Operators Course PBUSE (2006)
Support Operations Course Phase 1 (2005)
Warrant Officer Advanced Course – Property Accountability Technician (2005)
Warrant Officer Basic Course – Property Book Accountability Technician (1997)
Property Book Unit Supply Enhanced Course

Civilian Education
MS- Logistics Management- August 2006, Florida Institute of Technology
BA – Human Services- June 1996 Upper Iowa University
AA- General Studies- May 1995, Barton Community College

Certifications:
Systems Applications and Products on Data Processing (SAP) based Enterprise Information Systems (EIS) (2012)
Advanced Life Cycle Logistics (2009)
Demonstrated Master Logistician (2009)

QM/MI Medals:
Distinguished Member of the Regiment (QM)
Quartermaster Corps Distinguished Order of Saint Martin
Military Intelligence Corps Saint Knowlton
US Warrant Officer Association Leadership Award

Decorations, Service Medals, and Badges:
Legion of Merit Medal (1)
Bronze Star Medal (2)
Meritorious Service Medal (2)
Army Commendation Medal (7)

Army Achievement Medal (6)
Joint Meritorious Unit Award (1)
Meritorious Unit Commendation (1)
Army Good Conduct Medal (3)
National Defense Service Medal (2)
Southwest Asia Service Medal (3)
Afghanistan Campaign Medal W/AD (1)
Afghanistan Campaign Medal (1)
Iraq campaign Medal (2)
Global War on Terrorism Expeditionary Medal (1)
Global War on Terrorism Service Medal (4)
Korean Defense Service Medal (1)
NCO Professional Development Ribbon
Army Service Ribbon (1)
Overseas Service Ribbon (5)
NATO Medal (1)
KLM Saudi Arabia Medal (1)
KLM Kuwait Medal (1)
Basic Instructor Badge (1)
Parachutist Badge (1)
Driver/Mechanic Badge (1)

Chronological List of Appointments:
W01 USAR Dec 1996 – Dec 1998
CW2 RA Dec 1998 – Nov 2003
CW3 RA Dec 2003- Jul 2007
CW4 RA Aug 2007 – Sep 2012
CW5 RA Oct 2012- Present

Nominative Assignments:
Logistics Executive Development Course/FIT- (MS in Logistics Management)
Training With Industry (TWI) - Logistics Management Institute, Mclean, Virginia (Resident Research Fellow)
Technical Logistics College, Army Logistics University, Ft. Lee, Virginia (Dean)

Chronological Record of Duty Assignments:

Active Duty:
US Army Basic Training – Fort Jackson, South Carolina
US Army Advance Individual Training – (Unit Supply) Fort Jackson, South Carolina
HQ & A Co., 9-1 Aviation, Ansbach, Germany (Supply Clerk)
HHC USAG, Ft. Riley, Kansas (Supply Sergeant)
260th QM BN, Hunter Army Airfield, Savannah, Georgia (PBO)
HHC, MMC DISCOM, Team 4 Camp Stanley Korea (Team Chief)
202nd MI BN, 513th MI BDE, Ft. Gordon, Georgia (PBO)
HHC ALMC, Ft. Lee, Virginia (LEDC/FIT)
532nd MI BN, 501st MI BDE, Yongsan Korea (PBO)
USA Student Detachment, Richmond, Virginia (TWI)
ALU, Staff and Faculty Co., Ft. Lee, Virginia (Instructor)
HHC, 23rd QM BDE, Ft. Lee, Virginia (Chief, Supply Excellence Award)
HQs First Army, G4, Rock island, Illinois (Senior Logistics Advisor)
Technical Logistics College (Dean), Ft. lee, Virginia
HHC, CASCOM, QM TDD (920A Training Developer)

DEPLOYMENT(S):
Combined Joint Task Force CJ4- Camp Eggers, Afghanistan (Logistics Management Specialist) (2010-2011)
202nd MI BN., 513th MI BDE, Camp Victory, Iraq (PBO) (2004-2005)
202nd MI BN, 513th MI BDE, Camp Doha, Kuwait (PBO) (2003-2003)
HQ & A Co., 9-1 Aviation, Ansbach Germany (Supply Clerk), Desert Shield/Desert Storm, Saudi Arabia (1990-1991)

Chief Warrant Officer Three Jacqueline E. Gaddis, U.S. Army Alabama National Guard, Retired

CW3 (Ret) Jacqueline E Gaddis is an Alabama native and began her military career in September of 1977 when she enlisted into the Regular Army, as a truck driver. She received her commission as a Warrant Officer from Warrant Officer Candidate School at Fort Rucker, Alabama in February 1997. She was the second black female warrant officer to be appointed in the state of Alabama was well as the fourth female warrant officer in the state. She holds an Associate in Applied Science degree from Vincennes University.

CW3 (Ret) Gaddis retired March 31, 2004 from the Alabama Army National Guard with a total of 26 years' service. Her assignments included Military Personnel Technician/Branch Chief, HQS Starc Alabama ARNG, Montgomery, Alabama from 1997 through 2004. While serving as Branch Chief she also held additional duties as TAC Officer for the Alabama Warrant Officer Pre Candidate Course at Ft McClellan, Alabama. She was the first black female as well as the only black female TAC officer to serve in this position. She later became the first and only black Senior TAC Officer as well as the Commandant for the Warrant Officer Pre Candidate Couse while serving in this position until she retired.

CW3 (Ret) Gaddis military awards and decorations include the Meritorious Service Medal, Army Commendation Medal, Army Achievement Medal with two Bronze Oak Leaf Clusters, Good Conduct Medal with 3 Bronze knots, Army Reserve Component Achievement Medal with two Bronze Oak Leaf Clusters, National Defense Service Medal with one Bronze Star, Global War on Terrorism Service Ribbon, Humanitarian Service Medal, Armed

Forces Reserve Medal with Silver Hour Glass, Non-Commissioned Officer Professional Development Ribbon with 3 Numeral, Army Service Ribbon, Overseas Service Ribbon, Army Reserve Components Overseas Training Ribbon with 3 Numeral, Veterans Service Medal of Alabama, Special Service Medal of Alabama, Faithful Service Medal of Alabama with Four Bronze Saint Andrews Crosses, and Drivers Badge.

CW3 (Ret) Gaddis resides in Montgomery, Alabama and has a son (Mario Gaddis).

Chief Warrant Officer Claricia Gautier,
United States Coast Guard

Coast Guard Promotes Claricia Gautier to Chief Warrant Officer

By Source Staff
June 7, 2018

Chief Warrant Officer Claricia Gautier U.S. Coast Guard Senior Chief Yeoman (E8) Claricia Gautier, a 1995 graduate of Central High School, St. Croix, U.S. Virgin Islands, was promoted to the chief warrant officer grade, personnel administration specialty at the Coast Guard headquarters in Washington, D.C.

Coast Guard Officer Gautier is currently the Coast Guard Reserve assignment officer where she maintains 1,400+ junior and senior enlisted personnel assignments. Her previous military assignments include: Pay & Personnel Center, Topeka, Kansas; Coast Guard Sector, Miami, Florida; Coast Guard District Seven Miami, Florida; Coast Guard Integrated Support Command, Miami, Florida, and as a seaman recruit at Training Center, Cape May, New Jersey. Her advice for students is to shoot for the stars and never give up on academic and professional goals. Gautier joined the Coast Guard in October of 2002, and her rise through the ranks has been on a steady course of excellence, advancements and professionalism. She added, "never let your past dictate your future." She holds a Bachelor of Science in Human Resource and Organizational Leadership, an Associates of Arts in Business Administration, and she is pursuing a Master of Business Administration in Human Resources. Her son, Lionel, was present at her promotion. She is the daughter of Conrad Prevost and Ghislainne Lazarre of St. Croix and Guadeloupe, respectively. Her professional

accomplishments include Instructor Development course, the Chief Petty Officer Academy, Three CG Achievement Medals, the Commandant's Letters of Commendation, four CG Good Conduct Medals and Sailor of the Quarter.

Chief Warrant Officer Gautier
and her son Lionel

Chief Warrant Officer Five, Donna Gialone, United States Navy, Retired

NAPLES, Italy (November 3, 2008) Chief Warrant Officer (CWO) 5 Donna Gialone recites the oath of office with Capt. Pete Frano during her promotion ceremony. Gialone is the third African-American woman to be advanced to the rank of CWO 5, a community of 25 Sailors. U.S. Navy photo by Mass Communication Specialist 2nd Class Gary Keen (Released)

Chief Warrant Officer Four Destria Denise Gladney, U.S. Army Reserve, AGR

CW4 Destria Gladney is currently assigned as the Liaison, for the Reserve Proponency Chief of Transportation, headquartered Fort Lee Petersburg, Virginia. Her Active Guard Reserve (AGR) assignments include twelve years of active duty. She served as Division Transportation Officer, 412th Theater Engineer Command, Vicksburg, Mississippi "13-17", Senior Mobility Warrant Officer, 310th Expeditionary Sustainment Command (ESC) Indianapolis, Indiana "06-13", as well as, Assistant Deployment Support Chief for Military Surface Deployment and Distribution Command in Fort Eustis, Virginia "04-06" prior to their transition to Scott Air Force Base, Illinois. Prior to transitioning to active duty in the U.S. Army Guard Reserve in 2006, Chief Destria Gladney held positions of leadership in the 1397th Deployment & Distribution Support Battalion, as Cargo Documentation Team Lead and 483rd Transportation Battalion, Mobilization Chief. Her assignments have included the 63rd Regional Support Command (RSC), 511th Movement Control Team, and 377th Theater Sustainment Command, 310th Sustainment Command (Expeditionary) (ESC).

CW4 Gladney is a graduate of the Warrant Officer Staff Course, Warrant Officer Senior Enhancement Staff Course and Senior Transportation Officer Qualification 90A Course. She holds a Bachelor of Arts in Sociology from California State University, Sacramento, California, Associates of Art, in Psychology with a focus on Drug Behavior, and certifications in various fields as Paralegal Studies, Social Services, Transportation management, Knowledge, and

Project Management, to include obtaining an Additional Skill Identifier (ASI) of 8R, Master Resiliency Trainer (MRT).

CW4 Gladney's deployments include Southwest Asia, with the 511th Movement Control Team, Kuwait with the Military Surface Distribution and Deployment Command, and Iraq in the position of Theater Container Manager in which the 310th ESC closed down Joint Base Balad in 2011.

Her awards and decorations include the Meritorious Service Medal (with 2 Oak Leaf Clusters), the Army Commendation Medal (with Silver and Bronze Oak Leaf Clusters), the Army Achievement Medal, National Defense Service Medal, Global War on Terrorism Expeditionary Medal, and Global War on Terrorism Service Medal, Overseas Service Medal, and Meritorious Unit Commendation.

CW4 Gladney is community oriented, and has served as an Executive Officer American Legion, Tyner Ford #213, Vicksburg, MS, Ordained Exhorter, and Elder at Transforming Life Church, Indianapolis, Indiana, and Youth Leader at Word of Faith Christian Church, Vicksburg, Mississippi, and a Certified Layman with Bruised Reed Ministries. Chief Gladney holds recognition in the United States Army Reserves as the First Senior Mobility Warrant, as well as, Cambridge Who's Who; Elite Women in America, and Top Female Executives, Professionals & Entrepreneurs.

Sonia Y. Graves-Rivers, Chief Warrant Officer Five, U.S. Army Reserve, AGR

Date and Place of Birth:
7 November 1963, Macon, Georgia

Total Years in Service:
38 years

Military Education:
Warrant Officer Staff Course 2010
Warrant Officer Advance Course – Supply Systems Technician (2006)
Warrant Officer Basic Course – Supply Systems Technician (2000)
Warrant Officer Basic Course – Property Book Officer (2002)
SARSS Managers Course (2005)
SARSS Structured Query Language (SQL)
CSSAMO Supply Systems
Property Book Unit Supply Enhanced Course (2005)

Civilian Education:
BA Sociology JUN 1988 University of Maryland
MA Computer Science JUN 1998 Webster University

Decorations, Service Medals, and Badges:
Army Service Ribbon
Overseas Service Ribbon
Army Reserve Components Service Ribbon
Armed Forces Reserve Medal
Armed Forces Service Medal
NCO Professional Development Ribbon
Southwest Asia Service Medal
Global War on Terrorism Expeditionary Medal

Global War on Terrorism Service Medal
Good Conduct Medal
Army Reserves Achievement Medal
National Defense Service Medal
Army Achievement Medal (2)
Army Commendation Medal (4)
Meritorious Service Medal (4)
Bronze Star Medal (1)

Chronological Record of Duty Assignments:

Active Duty:
US Army Basic Training – Fort Jackson, SC
US Army Advance Individual Training – (Medical Supply) Fort Sam Houston, TX
US Army Hospital MEDDAC– (Medical Supply) Fort Stewart, GA
US Army Medical Material Command Europe – (Medical Supply) Pirmasens, Germany

National Guard:
Virginia Army National Guard – (Medical Warehouse Supv) Fort Belvoir, VA

USAR:
8th Medical Brigade – (Medical Warehouse Supv) Heidelberg, Germany
100th Station Hospital – (Medical Warehouse Supv) Baltimore, MD
427th Medical Logistics Battalion (Medical Warehouse Supv) – Ft. Gillem, GA
1Bn 347th Regt Lanes Battalion – (Medical Supply Evaluator) Ft Gordon, GA
1015th Maintenance Company (Supply Systems Technician) – Fort Gillem, GA
1Bn, 348th Regt Logistical Support Battalion (Property Book Officer) – Fort Gordon, GA

Active Guard Reserves:

276th Maintenance Company (Supply Systems Technician) – Fort Buchanan, Puerto Rico (2002-2005)

99th Regional Readiness Command (Sr. Property Book Officer) – Coraopolis, PA (2005- 2007)

336th Military Police Battalion (Property Book Technician) – Pittsburgh, PA

166th Regional Support Group (Property Book Technician) – Fort Buchanan, Puerto Rico (2009-2011)

United States Civil Affairs and Psychological Operations Command (USACAPOC) (Command Property Officer/Senior Property Accounting Technician) – Fort Bragg, NC (2011-2014)

174th Infantry Brigade-First Army (Property Book Technician) – Joint Base MDL, NJ (2014-2017)

841st Engineer Battalion (Property Book Technician) – Miami, FL (2017-2018)

Combat Arms Command (Quartermaster Force Developer) Ft Lee, Virginia – Current position

DEPLOYMENT(S):

129th Logistical Task Force - (Supply Systems Technician) Bagram, Afghanistan (2003-2004)

CFLCC-C4 Maintenance – (Supply Systems Technician) Camp Arifjan, Kuwait (2005- 2006)

377th Theater Support Command – (Property Book Officer) Camp Arifjan, Kuwait (2006)

894th Quartermaster Company – (Transportation Officer) Tallil, Iraq (2008-2009)

Sonia Y. Graves-Rivers

Sonia Y. Graves-Rivers

Sonia Y. Graves-Rivers

Chief Warrant Officer Annie Laurie Grimes, United States Marine Corps, Retired

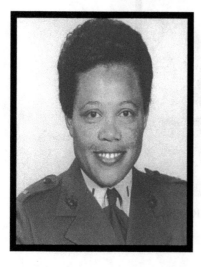

Annie Laurie Grimes was born in Arlington, Tennessee, to Mr. and Mrs. Horace Karr Grimes. She graduated from high school in Somerville, Tennessee in 1946 and attended Ray Vogue Trade School in Chicago, Illinois in 1949. On February 2, 1950, she became the third African American women to enlist in the Marine Corps.

Unlike African American males, who received recruit training at the segregated Montford Point Camp in North Carolina, black women were integrated with other women recruits at Parris Island, South Carolina. Upon completion of recruit training the following May, Annie was promoted to Private First Class.

Private First Class Grimes reported to Headquarters, Marine Corps where she served as a procurement clerk with the Supply Branch until May 1953. During this tour of duty, she was promoted to Corporal, Sergeant, and Staff Sergeant.

In January 1965, Gunnery Sergeant Grimes was transferred to Marine Base, Camp Lejeune, North Carolina and served as Procurement Chief until June 1967. During this tour, she was promoted to Master Sergeant. On August 1, 1966, Grimes was appointed a warrant officer, the first African American woman in the United States Marine Corps to earn the distinction.

Warrant Officer Grimes was then ordered to the Marine Corps Supply Center, Barstow, California, where she was assigned to the Material Division. While at Barstow, she completed the sub courses required for Temporary Officer Training and was promoted to Chief Warrant Officer. This tour of duty ended in December 1969.

In January 1970, Chief Warrant Officer Grimes was transferred to Fleet Marine Base, Pacific, Camp Smith Hawaii and was assigned duty

with the Assistance Chief of Staff, G-4, where she remained until retirement on October 1, 1970.

During her career, Chief Warrant Officer Grimes was awarded the Good Conduct Medal with two bronze stars and the National Defense Service Medal with one bronze star. In 1965, she was awarded a Meritorious Mast by the Commanding General, Marine Corps Supply Activity, Philadelphia, PA.

Chief Warrant Officer Grimes became a life member of the Women Marine Association (WMA) and the Montford Point Marine Association (MPMA). She currently resides in Arlington, Tennessee.

Warrant Officer Annie L. Grimes discusses the Officer Procurement Program with Colonel Barbara J. Bishop, Director of Women Marines. Official Marine Corps Photo # A416512

Annie Grimes

Chief Warrant Officer Three Kea N. Hallman, U.S. Army

CW3 Kea Hallman is a native of Darlington, South Carolina. She entered the United States Army on 11 May 1999. She completed Basic Combat Training at Fort Jackson, South Carolina and Advanced Individual Training at Fort Lee, Virginia as an Automated Logistics Specialist (92A). After serving nine years as a Noncommissioned Officer and achieving the rank of SSG, she received her commission through the Warrant Officer Candidate School in August 2008.

Before her appointment as a Warrant Officer, She served as an Instructor/Writer for HHC, 23rd QM BDE, Fort Lee, Virginia in the Functional Division Branch.

CW3 Hallman is currently assigned as the Senior Supply Technician (920B) at the Tank and Automotive Command- TACOM in Warren, Michigan.

CW3 Hallman has served in a variety of assignments that include Prescribed Load List Clerk-PLL, HHC 2nd BDE, 3rd ID, Fort Stewart, GA and Operation Iraqi Freedom; NCOIC and Stock Control Clerk, 58th Signal Battalion, 10th ASG, Okinawa, Japan; Instructor/Writer, HHC, 23rd QM BDE, Fort Lee, VA; Information Service Technician, Combat Aviation Brigade, 601st Aviation Support BN, Fort Riley, KS; Accountable Officer, 1st Maintenance Company, 541st CSSB, Fort Riley, KS; Supply Systems Technician, 541st CSSB, Support Operations (SPO), Fort Riley, KS; Wholesale Accountable Officer, 541st CSSB, SPO, Doha Kuwait; Master Scenario Equipment List Technician Manager, HHC, CASCOM, Fort Lee, VA; G3/5/7 Chief Future Operations Officer, HHC CASCOM, Fort Lee, VA; Instructor/Writer, ALU, Logistics Leaders Course, Fort Lee, VA.

CW3 Hallman has deployed to Iraq in support of Operations Iraqi Freedom (2002 -2003 and 2009-10) and Kuwait Operations (2011-12)

CW3 Hallman is a recipient of the Quartermaster Corps Distinguished Order of Saint Martin Medal and the Sergeant Audie Murphy Club. She holds an Associate of Arts in General Studies, a Bachelor of Science Degree in Business Management, and a Master of Business Administration Degree in Executive Leadership all from Liberty University, Lynchburg, Virginia. CW3 Hallman is also Lean Six Sigma-Black Belt Certified.

CW3 Hallman's military education includes: Warrant Officer Advanced and Basic Courses, Basic Noncommissioned Officer Course, Primary Leadership Development Course, GCSS-Army Middle Manager's Course and other countless logistics courses.

CW3 Hallman's awards and decorations include: Meritorious Service Medal (2OLC); Army Commendation Medal (8OLC); Army Achievement Medal (5OLC); National Defense Service Medal; Iraqi Campaign Medal; Global War on Terrorism Expeditionary Medal; Global War on Terrorism Service Medal, Most Outstanding Volunteer Service medal and Demonstrated Master Logistician and various other service medals and ribbons.

CW3 Hallman is a proud member of Kappa Epsilon Psi Military Sorority Inc. and shares her life with her husband, Charles, her daughter Shondavia, three step-daughters Shanay, Charlicia, and Haley, and six grandchildren.

CW3 Kea N. Hallman
Biographical Summary

Date and Place of Birth:
19 December 1977, Darlington, South Carolina

Enlisted Military Service: BASD: 19990510
9 years

Source and Appointment Date:
Warrant Officer – August 2008

Years of Active Warrant Officer Service:
11 years

Total Years in Service:
19 years

Military Education:
GCSS-A Middle Manager's Course (2018)
Warrant Officer Intermediate Level Education Course (2016)
Warrant Officer Intermediate level Education-Follow-On Course (2016)
Joint Logistics Course (2016)
Support Operations Course Phase II (2016)
Faculty Development Course Phase III (2015)
GCSS-Army Unit Supply Instructor Key Personnel Course (2015)
Faculty Development Course Phase I (2014)
Supply Systems Technician Warrant Officer Advance Course (2013)
Support Operation Course Phase I (2013)
Level II/III Materiel Management Course (2013)
Logistics Modernization Program End Users Course (2012)
CSSAMO Logistics Systems Course (2011)
Supply Systems Technician Warrant Officer Basic Course (2008)
Small Group Instructor Training Course (2007)
Standard Army Retail Supply Systems 2AD/2AC/2B Course (2007)
Standard Army Maintenance System Course (2007)
Total Army Instructor Training Course (2007)
Support Cadre Training Course (2007)
Action Officer Development Course (2004)
Manager Development Course (2004)
Supervisor Development Course (2004)
Petroleum/Water Spec (TATS) Course (2004)
Petroleum Laboratory Specialist Course (2004)
Unit level Logistics System-Ground Operator Certification Course (2001)
Automated Logistical Specialist Course (1999)

Civilian Education
MBA- Executive Leadership- May 2016, Liberty University
BS – Business Management- June 2011, Liberty University
AA- General Studies- May 2006, Liberty University

Certifications:
Lean Six Sigma Black Belt (2015)
Demonstrated Master Logistician (2012)

QM/MI Medals:
Sergeant Audie Murphy Club
Quartermaster Corps Distinguished Order of Saint Martin

Decorations, Service Medals, and Badges:
Meritorious Service Medal (2)
Army Commendation Medal (8)
Army Achievement Medal (5)
Meritorious Unit Commendation (1)
Army Good Conduct Medal (4)
National Defense Service Medal (3)
Armed Forces Expeditionary Medal (2)
Iraq Campaign Medal (2)
Global War on Terrorism Expeditionary Medal (2)
Global War on Terrorism Service Medal (4)
Most Outstanding Volunteer Service Medal (2)
NCO Professional Development Ribbon (3)
Army Service Ribbon (2)
Overseas Service Ribbon (4)
Combat Action Badge (1)
Driver/Mechanic Badge (2)
Basic Marksmanship Qualification Badge (1)

Chronological List of Appointments:
W01 USAR Aug 2008 – Aug 2010
CW2 RA Aug 2010 – Jul 2017
CW3 RA Jul 2017 - Present

Chronological Record of Duty Assignments:

Active Duty:
US Army Basic Training, Ft. Jackson, South Carolina
US Army Advance Individual Training, Ft. Lee, VA (Automated Logistics Specialist)
HHC 2nd BDE, 3rd ID, Ft Stewart, Georgia (Prescribed Load List Clerk)
58th Signal Battalion, 10th ASG, Okinawa, Japan (NCOIC and Stock Control Clerk)
HHC, 23rd QM BDE, Ft. Lee, Virginia (Instructor/Writer-Functional Division)
Combat Aviation BDE, 601st Aviation Support BN, Ft. Riley, KS (Information Service Technician)
1st Maintenance Company, 541st CSSB, Ft. Riley, KS (Accountable Officer-Forward)
541st CSSB, Support Operations (SPO), Ft. Riley, KS (Supply Systems Technician)
541st CSSB, SPO, Ft. Riley, KS (Information Service Technician-Forward)
541st CSSB, SPO, Ft. Riley, KS (Wholesale Accountable Officer-Forward)
HHC, CASCOM, Ft. Lee, VA (Master Scenario Equipment List Technician Manager-MSEL)
HHC, CASCOM, Ft. Lee, VA (G3/5/7 Chief Future Operations Officer)
ALU, Logistics Leaders Course, Ft. Lee, Virginia (Instructor/Writer)
US Tank and Automotive Command-TACOM, Warren, MI (Senior Supply Technician -920B)

DEPLOYMENT(S):
541st CSSB, SPO, Doha Kuwait (Wholesale Accountable Officer) (2011-2012)
1st Maintenance Company, 541st CSSB, Camp Victory, Iraq (Accountable Officer) (2009-2010)

HHC 2nd BDE, 3rd ID, Operation Iraqi Freedom, (PLL Clerk) (2002-2003)

Chief Warrant Officer Sharon R. Harris,
U.S. Army Reserve, Retired

Sharon Harris is a 30-year veteran and retired chief warrant officer in the Army Reserve, where she served as military intelligence instructor.

Harris served on the Suffolk (Virginia) Public School Board from June 1, 2000 to June 30, 2008, representing the Whaleyville Borough. A native of Baltimore, Maryland and a graduate of Rutgers University, she moved to Suffolk in 1982. Active in the community, she served as president of the Kiwanis Club of Suffolk.

Ms. Harris also served on the Fifth Judicial Justice Committee and also as secretary of the Virginia School Boards Association (Tidewater Region).

Chief Warrant Officer Five Mary E. Hawkins, U.S. Army, Retired

Mary Hawkins was promoted to CW5 in a ceremony on February 14, 2002, in Washington, D.C. Trained as a Property Accounting Technician, CW5 Hawkins' assignments included tours in Germany, Korea, Fort Lewis, Washington, Fort Irwin, California, Fort Lee, Virginia, and Fort Huachuca, Arizona. She was assigned as an Inspector General on the Department of the Army Staff at the Pentagon. Her numerous awards and decorations include four Meritorious Service Medals, three Army Commendation Medals and the Department of the Army Staff Identification Badge.

A native of Lawrence, Massachusetts, Mary Hawkins was born on April 13, 1955. She is a 1970 graduate of Bertie Senior High School, Windsor, North Carolina. Hawkins enlisted into the Women's Army Corps in May 1974. Ms. Hawkins was the Distinguished Graduate of the WOBC at Fort Sill, Oklahoma and the Honor Graduate of the first QMWOTTC at Fort Lee, Virginia and immediately appointed CW2. She is a 2002 graduate of the WOSSC at Fort Rucker, Alabama. Her civilian education includes a Bachelor of Science Degree in Logistics Management from Virginia State University and a Master of Arts Degree in Organizational Management from the University of Phoenix. Mary Hawkins is a Silver Medallion recipient and member of the Distinguished Order of Saint Martin's.

Chief Warrant Officer Five Lana Hicks,
United States Navy, Retired

Fleet Readiness Center Southeast (FRCSE) Commanding Officer Capt. Chuck Stuart, left, presents a length of service award to Lana Hicks, a logistics specialist at Cecil Commerce Center, during a ceremony April 20, 2016. Hicks is leaving FRCSE with 35 years of federal service including 31 years in the Navy and four years of civil service. She retired from the Navy as a Chief Warrant Officer 5 and joined FRCSE under the command's internship program. (U.S. Navy Photo by Kaylee LaRocque/Released)

CWO5 Hicks Retires After 31 Years of Service
From Staff, THE MIRROR, NS MAYPORT, Thursday, April 9, 2009

Chief Warrant Officer Lana Hicks, the Navy's first African American female CWO5 retired April 3 after 31 years of naval service.

Hicks said that during her tenure in the Navy, the biggest change she has seen is the opportunities available for women.

"When I joined in 1978 there were very few non administrative rates open to women," she said. "We were not allowed into ratings that involved combat. There was very limited opportunity for us to go to sea. I started out as a Corpsman and had to change rates because the rating was overmanned with women. In the early 80s, we couldn't go to ships or with the Marines so I had to change rates. That's why I became an Aviation Electrician's Mate. I can remember when the first women went to aircraft carriers and the Navy opened more rates for us. Now women fly in combat; are CO's of fighter squadrons and ships."

Hicks said that she thinks Sailors should take advantage of "every opportunity the Navy has to offer," including education.

"Decide early if the Navy is going to be your career," she said. "If you decide to Stay Navy find out what's required to be successful in your field and do it. The Navy is downsizing and keeping only the best people. Advancement is very competitive and it requires extra effort to get promoted. Find a good mentor. Listen to what they say. I've had several and the advice they gave me was key to my success."

Those mentors and the Navy have taught her several life lessons, including discipline, teamwork, goal setting and confidence.

"I've learned that when we work together any task can be accomplished. You can't do it alone," she said.

"Being a mentor and knowing that I may have contributed to the success of Sailors that I've served with [is the most rewarding aspect of being in the Navy]," she said. "What I think is rewarding is being able to help a Sailor get the orders they want, helping good performers get promoted by giving career advice and being the kind of officer that Sailors want to ask for help or advice. What the Navy gave to me, I was able to give back."

Another rewarding aspect of the Navy is the relationships she has developed, she said.

"When you are deployed or stationed overseas the Sailors you work with are like family," Hicks added. "I don't think that happens in the civilian community. One of the things I'll really miss about the Navy is the camaraderie."

Hicks enlisted in the United States Navy as a Hospital Corpsman in February 1978, she attended Recruit Training Command (RTC), Orlando Fla. After RTC, she attended and graduated with honors from Hospital Corps "A" School. Later that year, she reported to Naval Regional Medical Center, Portsmouth Va. In February 1980 she transferred to Naval Hospital Roosevelt Roads, PR where she qualified as an Emergency Medical Technician and worked in the Emergency Room. She was discharged in March 1982 and reported to MEDCRU 119 as an active reservist in April 1982.

In 1982 she came back on active duty and reported to RTC, Orlando as a NAVET. After attending Aviation Electrician's Mate "A" School in Millington, TN, she was assigned to NAF Diego Garcia, AIMD where she completed a one year tour. In 1985 she was assigned to TACAMO, (VQ-3) "Ironmen" in Barber's Pt, HI. During this tour of duty she advanced to First Class Petty Officer and obtained several maintenance qualifications.

In 1988 she transferred to NAS Moffett, AIMD where she was a Work Center Leading Petty Officer, Quality Assurance Representative, Micro-miniature Repair Tech, and earned her designation as an Enlisted Aviation Warfare Specialist. In 1991 she reported to (VQ-1), World Watchers, where she qualified as Maintenance Control Chief and earned her Safe for Flight designation. She was selected and pinned as a Chief Petty Officer in 1992.

In 1993 she reported for another year tour at NAF Diego Garcia, AIMD which was cut short when she was selected as a Chief Warrant Officer. She reported to AIMD Key West, FL for eight months while she awaited her commissioning date.

In 1995, Hicks commissioned and after attending Mustang University, Pensacola, FL she reported to (VQ-2) Rota Spain. While assigned she served as Detachment Maintenance Officer and Avionics and Aircraft Division Officer and did multiple deployments throughout Europe.

In 1998 she reported to USS Tarawa (LHA-1) home ported at Naval Station 32nd St, San Diego.

She reported to HSL-47 in 2001. During the tour she completed a Bachelor's of Arts degree at National University. In 2004, Hicks reported to HS-7 "Dusty Dogs." In 2008 she was assigned to the "Airwolves" of HSL-40, where she served as Assistant Maintenance Officer and Material Control Officer. While assigned she completed a Master of Arts degree and was recognized as HSL-40's Maintenance Officer of the Year.

Chief Warrant Officer Three Keisha A. Hoffman, U.S. Army, Retired

Photo – Camp Mike Spann, Afghanistan, Holiday Season 2011

Chief Warrant Officer Three Keisha Hoffman Retirement Ceremony by US Forces Command (FORSCOM)

Fort Bragg, North Carolina (May 5, 2016) CW3 Keisha A. Hoffman retired after 20 years of faithful and honorable service to our nation in the United States Army.

CW3 Keisha A. Hoffman

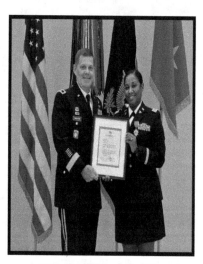

CW3 Keisha A. Hoffman

CW3 Keisha A. Hoffman

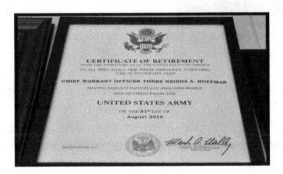

CW3 Keisha A. Hoffman

Chief Warrant Officer Three Linda R. Horton, U.S. Army North Carolina National Guard

Chief Warrant Officer Linda R. Horton, a native of Washington, North Carolina is the daughter of Glenwood and Sue Horton. In 1989, she joined the 213th Military Police Company in the North Carolina National Guard (NCNG), in Washington, North Carolina.

In 2001, Chief Horton was selected to support the State Partnership Peace Training in Moldova, Eastern Europe. She deployed to EUCOM and served as the Sustainment Warfighting Function Chief during a National Guard State Partnership Program's (PfP) MDMP initiative in Moldovia. The PfP initiative links U.S. states with designated partner countries to promote access, enhance military capabilities, improve interoperability and enhance the principles of responsible governance.

She deployed in support of Operation Iraqi Freedom 2003-2005 and instantaneously was thrusted into a new leadership positon with a new command and from the accolades she received the Army put the right leader in the right position at the right time, in 2013 she was selected to command the 440th Army Band which is a Regular Army Command.

Ms. Horton was the first Female to serve this position. She arrived at the unit during a time of turmoil and immediately began to bring back stability and order to the organization and was awarded the Meritorious Service Medal at the end of the tour. She quickly assessed the situation and developed long term plans to increase the readiness of the unit. What made her performance even more significant is that she is not a trained army musician, this fact did not deter her fervor or command presence, and she even performed with the band on numerous occasions as a clarinetist. She implemented Army Talent

Management initiatives which focused on acquiring and retaining highly specialized trained musicians. In an 18 month period, under her guidance the unit increased in strength by 5% which leave the unit with only two vacancies.

Due to her diligence, the unit increased its MOSQ percentage by 15% during the same time. The programs she developed for manning has endured well past her time as commander. In 2016 she was awarded the Eagle Rising Award established to recognize the achievements and dedicated service of Army National Guard Warrant Officers who have demonstrated outstanding leadership, technical skills, and professionalism in their services to country and community - the first Soldier to receive the award from the state of North Carolina). She served as an Executive Council Member 2015-2017 for the NCNG Association and was awarded the President's Award in 2016.

She extends her life beyond the military sector. In her civilian life, she tutors and mentors local students and enjoy participating in read-ins for students, and Schools career day programs.

She is the Past Commander of the American Legion Post 518, Clayton NC, and First Female to hold this position. She serves as the secretary for Raleigh-Wake FSU Alumni Chapter and is a member of Kingdom Life Church in Washington, NC.

Ms. Horton is currently a Deputy Director in Human Resources for the NCNG with over 18 years of service.

Linda Horton studied Sociology at Fayetteville State University (Bachelor of Arts, 2014) before attending Montreat College to receive her Masters of Science in Management and Leadership, (2018). She is currently pursuing a Doctorate in Public Administration with a concentration in Human Resources.

Her philosophy in life is, "as a Community Servant, I am blessed to have the opportunity to give to others, my time and resources. My joy is giving and not expecting anything in return". She is a member of Alpha Kappa Alpha Sorority, INC.

Chief Horton is the proud mother of Calvin and Brittany Woolard. She currently resides in Garner, North Carolina and enjoys spending time with her grandsons, Blake and Carson.

Linda Horton leading the 440th Army Band

Chief Warrant Officer Five Pamela R. Huff, U.S. Army National Guard, Retired

Boozman Recognizes Service of Veteran Who Broke Barriers at Arkansas Army National Guard
Dec 13 2017

WASHINGTON- U.S. Senator John Boozman recognized the service and sacrifice of Chief Warrant Officer (retired) Pamela Huff in 'Salute to Veterans,' a series recognizing the military service of Arkansans.

Huff graduated from Little Rock's Hall High School in 1975. Her cousin was interested in enlisting for the Army National Guard and convinced Huff to join her.

"Believe it or not I signed up for not only the Arkansas Army National Guard but I also signed up for the Air Force, so I said whichever one calls me the first, that's the way I'm going," Huff said.

Huff and her cousin went to basic training for the Army National Guard in Fort Jackson, South Carolina. Unfortunately, Huff's cousin had medical issues that prevented her from completing the training.

Following basic training, Huff was assigned to Fort Sam Houston, Texas for Advanced Individual Training (AIT) as a dental technician.

She used these skills in an Arkansas dentist's office for a few years before changing careers. Huff was encouraged to explore full-time job opportunities with the Arkansas Army National Guard, something she didn't know existed.

"I applied for a job at Camp Robinson with Combined Support Maintenance Service," Huff recalled. "The job announcement actually said 'black hire only.' All of that was explained to me because of a discrimination suit, so lucky for me that I applied at that time, so I was hired." She became the second woman to join the department.

Huff was inspired to become an officer. She chose to pursue the track of a warrant officer and along the way broke barriers. While she worked toward achieving this rank, ultimately becoming the first female in the Arkansas Army National Guard to obtain the rank of Chief Warrant Officer Five (CW5), she also became the first black female noncommissioned officer (NCO) instructor at the NCO academy.

During her assignment with the 119th Personnel Service Company, she learned that her unit would be mobilized for the Gulf War with the possibility of deployment to Iraq. In preparation for deployment, Huff was stationed at Fort Sill, Oklahoma.

Instead of deploying overseas, she operated the mobilization station at Fort Sill. "At the mobilization station, you do everything from A to Z," Huff said. For her work, she was awarded the Meritorious Service Medal.

Huff retired earlier this year with more than 40 years of military service.

"I am grateful for Pamela Huff's dedication and service to our nation. Her memories of military service are an important part of our history and I am pleased to be able to collect and preserve her stories," Boozman said.

Boozman will submit Huff's entire interview to the Veterans History Project, an initiative of the Library of Congress's American Folklife Center to collect and retain the oral histories of our nation's veterans.

CW5 Pamela Huff

CW5 Pamela Huff

Chief Warrant Officer Five Rowmell R. Hughes,
U.S. Army Reserve, Deceased

Rowmell Hughes was born on May 7, 1948 in Bishopville, Lee County, South Carolina. Her parents were the late Booker T. and Luevenia Allen Roary. Ms. Hughes enlisted in the Women's Army Corps in 1970 and upon completion of her active duty commitment, joined the Army Reserve. In 1989, she completed the Warrant Officer Candidate School at Fort McCoy, Wisconsin and the Warrant Officer Tactical/Technical Certification Course at Fort Benjamin Harrison, Indiana. She was then appointed a Warrant Officer One in the Adjutant General Corps.

Her initial assignment as a personnel warrant was with the 319th Transportation Brigade in Oakland, California and she later transferred to the 2nd Medical Brigade as a Personnel Management Officer. In 1993, she became the Supervisory Staff Administrator in the 2nd Medical Brigade. In this dual status civilian capacity, she represented the Commanding General and was responsible for the daily operations of an organization that encompassed seven western states (CA, NV, AZ, MT, CO, UT and Washington).

The brigade was comprised of 6,000 soldiers. The position was the highest civilian position in the brigade and Ms. Hughes was the highest ranking African American civilian within the 63rd Regional Readiness Command. In October 2002, she received the United States Army's Citation Award for Exceptional Service. The award was presented to Ms. Hughes by the Army Vice Chief of Staff. Chief Warrant Officer Five Hughes served as a staff officer on various short tours for major Army exercises in CONUS and in Japan, Korea, and Okinawa.

In 2004, she was cross-leveled and deployed with the 376th Personnel Service Battalion, from Long Beach, California, in support of Operation Iraqi Freedom in Tikrit, Iraq. While there, she served as the Detachment II Human Resources Technician/Executive Officer at the Forward Operating Base (FOB) in Speicher.

During the tour, she and her staff had the responsibility to provide personnel services to the 5,000 Soldiers assigned to five geographical dispersed FOBs in Northern Iraq. In September 2008, Chief Warrant Officer Hughes was assigned to the G-1 Section, 70th Regional Readiness Command, Fort Lawton, Seattle, Washington. She is a graduate of the Adjutant General Warrant Officer Advance Course, and the Warrant Officer Staff and Senior Courses.

Chief Warrant Officer Five Hughes' military awards include the Legion of Merit, the Meritorious Service Medal with Oak Leaf Cluster, the Army Commendation Medal with Silver Oak Leaf Cluster, the Army Good Conduct Medal, Army Reserve Component Achievement Medal with Silver Oak Leaf Cluster, National Defense Service Medal with Bronze Star, Iraq Campaign Medal, Global War on Terrorism Service Medal, Armed Forces Reserve Medal with hour glass and "M" Device, Noncommissioned Officer Professional Development Ribbon, Army Service Ribbon, and the Overseas Service Ribbon. She is authorized to wear the Superior Service Medal for outstanding service as a civilian.

In 2004, Chief Warrant Officer Five Hughes was selected by the California Department of the Reserve Officers Association for the Outstanding Warrant Officer of the Year Award.

In July 2009, Chief Warrant Officer Five Hughes retired from the military with 38 years of service.

CW5 Rowmell Hughes died on December 4, 2015 in Vallejo, California.

FROM SHARECROPPERS DAUGHTER TO STAFF ADMINISTRATOR

By Maj. Ken Plowman

One may ask how a sharecropper's daughter from South Carolina could come to California and rise to the top position at the 2nd Medical Brigade in San Pablo, California. Rowmell R. Hughes attributes her success to the very value she learned from her father. By her putting in a hard day's work in the cotton or tobacco fields. She remembers rising a 3a.m. to 4 to journey into the fields and work hard all day, day-in and day-out. There, in the fields, she discovered the value of responsibility and learned how to be accountable for the things she commits herself to. "I learned to treat people like I wanted to be treated and it is actually harder to be mean than to be polite."

Hughes is the supervisory staff administrator for the brigade comprised of 2,200 soldiers in Northern and Central California, and Arizona who manages equipment in excess of $20 million and people upward of 75.

She began her military career as an enlisted soldier in 1970, got out in 1973 and joined the Army Reserve. Through a stint as the staff administrative specialist at the 483rd Transportation Battalion, back to the 319th as the SSA, and finally to her present position beginning in 1993.

Now a warrant officer in the Army Reserve, Hughes says, "The hard work and long hours are part of my commitment, dedication and loyalty to the organization, my subordinates and my supervisors. I have worked for and with people from many walks of life and have been blessed with commanders who are caring, supportive leaders and mentors.

Hearkening back to her core values, Hughes expresses the importance of looking positive when dealing with a negative situation. According to Hughes, the past several years have brought growing pains to the Army Reserve and she calls it "CYA – challenging your assets."

"With all the changes in the workplace, we must adjust our way of doing business to 'lead change'. Of course, with each new commander, it is almost like a new job. Leadership styles and ways of doing business differ."

Hughes' advice to her fellow full-timers is to "take the time to say 'thank you'. Let the staff know that they are appreciated. Show recognition with awards that are permitted by the system. For instance, I try to provide refreshments for our full-time support staff meetings. Occasionally, we have potlucks or barbeques. I try to make this a fun place to work."

To sum Hughes' attitude, "What keeps me going in this challenging environment, is to do what I can, in any little way possible, to support this organization and staff."

As a share cropper's daughter who received the Superior Civilian Service Award (equivalent to the Meritorious Service Medal) in 1993, her then-commander, Brig. Gen. John T. Crowe said, "Her reputation for professionalism, dedication and sound judgment result in her advice being sought out and relied on by commanders and senior noncommissioned officers at all levels."

(Article from the Winter 1997/98 Flaming Blade)

Rowmell Hughes at a promotion ceremony

Chief Warrant Officer Doris H. Hull, United States Coast Guard, Retired

Tampa Bay Times
Local African-American woman stands as Coast Guard pioneer

By Mike Merino, Times Correspondent
Published: September 8, 2017
Updated: September 10, 2017 at 07:45 PM

TAMPA — For 227 years, the U.S. Coast Guard had never had an African-American woman serve as an officer of any type.

That changed June 1, 1995, when now-Tampa Bay resident Doris Hull broke that storied institution's glass ceiling with her promotion from yeoman first class all the way to chief warrant officer.

In the Navy and the Coast Guard, warrant officers are skilled, single-track specialty officers. Their primary duty is to serve as technical experts, providing expertise and guidance to commanders and organizations in their fields.

Hull said her journey to this historic first began with a positive family upbringing in Miami. She is one of eight children. Her father owned a successful construction company which allowed the family to live comfortably.

"My mother only wanted boys, so I had to learn how to measure up quickly, and I did," Hull said.

After achieving success in school and developing a positive attitude in life, Hull enlisted in the U.S. Coast Guard Reserve in 1973 under the Direct Petty Officer Program as yeoman first class. At the time, she was married and had a daughter. Later, she divorced.

In 1978, after serving five years in the active reserves, Hull left her civilian job and accepted a two-year active duty assignment at Coast Guard headquarters in Washington, D.C.

Just a year later, another momentous change occurred when Doris met a handsome chief warrant officer named Ron Hull at a bus stop.

"When I saw Doris, I had to find a way to introduce myself," Ron said. "I was leaving town that night and I thought I'd never get this chance again. So, I smiled, told her who I was and tore my name and address from the corner of one of my bank checks to show her I wasn't a weirdo."

Hull, laughing, said she first sized up her future husband as a "player."

Their first date amounted to watching the World Series. Many dates later, they married in January 1982.

Hull said her success and rapid progression in the Coast Guard was due to her ability to pass rigorous academic exams and handle difficult assignments, which earned stellar reviews from superior officers.

A difficult challenge came in 1980 when she left the active reserves. The Coast Guard approved her integration into the regular Coast Guard, but she was forced to take a reduced rank, which meant a smaller paycheck and a step in the wrong direction for this forward thinker.

This reduction did not divert Hull from her long-range goal. She immediately created an aggressive plan knowing she would be competing for future promotions against Coast Guardsmen with more service time and awards. Hull then transferred to the recruit training center in Cape May, N.J., where she worked hard and smart at her climb through the ranks.

After three years, Hull returned to Coast Guard headquarters as the first enlisted person to serve as the Women Afloat Coordinator for Enlisted Personnel. Her personal goal was to exceed the commandant's expectations, and she did. Because of the work and initiatives she started, women are now assigned to all classes of Coast Guard vessels throughout the world.

With her numerous achievements and after undergoing rigorous testing and intense competition from many men, Hull achieved her lifetime goal of Chief Warrant Officer.

Asked if she received any personal backlash for her historic success, she replied, "I realize in life, those who are your friends are always there to hold you up. And then, those associates who would try to put you down would be found out fast, and I too found out just as fast."

Hull served as chief warrant officer for 10 years, retiring with 27 years of service on Feb. 5, 2005.

She and Ron continue to serve the community as deacon and deaconess at First Baptist Church of College Hill.

"Doris is a lady for all seasons," said Pastor Evan Burrows. "She is the rock at our church."

Chief Warrant Officer Four Rebecca B. Issac, U.S. Army, Retired

Chief Warrant Officer Rebecca B. Issac enlisted in the United States Army through the delayed entry program. On 11 November 1975 she entered active duty status and graduated from basic training at Fort Jackson, South Carolina. Upon qualifying in the military occupational specialty (MOS) 35M Avionic Navigation Equipment Repairer, she graduated from advanced individual training (AIT) at Fort Jackson, South Carolina.

Her enlisted tours of duty include the following:

- 1976 -1980, 223rd Aviation Battalion, Stuttgart, Germany, where she served as an Avionic Navigation Equipment Repairer.
- 1980 -1984, 15th Military Intelligence Ariel Exploitation Battalion, Fort Hood, Texas, where she served with the OV-ID Mohawk.
- 1984 - 1988, 3rd Military Intelligence Ariel Battalion at Camp Humphrey, Koreas, where she served as an avionics supervisor with the RC-12 Aircraft.
- 1988 – 1989, 6th Calvary Regiment, Fort Hood, Texas, where she served as avionics supervisor on the CH-47 Chinook.

In October 1988, she attended the Warrant Officer Basic Course (WOBC) at Fort Rucker, Alabama. In January 1989, after qualifying in MOS 918B Electronic System Maintenance Technician, she graduated from the Warrant Officer Technical and Tactical Certification course (WOTTC) at Fort Gordon, Georgia. Her warrant officer assignments included:

- 557th Maintenance Company (Direct Support) in Aschaffenburg, Germany and Southwest Asia for operation Desert Shield / Desert Storm; the unit later executed a cohort

move from Germany to Fort Irwin, California. She streamline the mission of the 557th's electronic maintenance shop, which went from a direct support (8 hour) to a direct/general support (24 hour) mission to maintain the National Training Center's fleet of communications equipment.

- 1995 – 1996, 61st Maintenance, Uijongbu, South Korea Direct Support Company at Camp Kyle, Uijongbu, South Korea.

- 1996 – 1999, Communication-Electronic Command (CECOM), Fort Monmouth, New Jersey, as the supervisor for Total Package Fielding for all Satellite Equipment being fielded. Her mission during this assignment included facilitating from cradle to grave initiatives essential to improve and enhance equipment in the field and for archiving equipment historical dates for project managers.

- 1999 – 2000, North Atlantic Treaty Organization (NATO) in Naples, Italy as an Electronic Maintenance Technician.

- 2000 - 2001. 200th MMC, 21st Theater Support Command (TSC), where she first served as an Item manager and Maintenance Technician for communications equipment.

- 2001 – 2004, 21st Theatre Support Command, Support Operations, where she served as a Maintenance Technician; not only for communications equipment, but for all ground equipment and associated items.

Ms. Issac's last assignment was with the Training Directorate, Fort Lee, Virginia as the Senior Training Developer. She was the senior female warrant officer in her field. Chief Warrant Officer Four Rebecca Issac retired on 30 September 2005 after serving 29 years and 10 months of active military service.

Chief Warrant Officer Five Coral J. Jones, U.S. Army, Retired

CW5 Coral J. Jones was born in Barbados West Indies and raised in St. Lucia and the United States Virgin Islands. She earned a Bachelor of Arts Degree in Human Resources Management from Saint Leo University and an Associate of Arts Degree in General Education from Central Texas College.

CW5 Jones' military education includes Warrant Officer Basic and Advanced Courses, Warrant Officer Staff Course, and the Warrant Officer Senior Staff Course.

CW5 Jones enlisted in the Army at Fort Buchanan, Puerto Rico on 24 November 1981 as a Personnel Records Specialist, MOS 75D. She proudly served in the enlisted ranks for 12 years achieving the rank of Staff Sergeant. She was appointed as a WO1 on 19 August 1994. She served in a myriad of challenging assignments and worked several levels of command – Company, Battalion, Brigade, Division, ACOM to include United States Army Europe; Taszar, Hungary; Joint Readiness Training Center and Fort Polk; Allied Forces Southern Europe, Italy; Headquarters, United States Army Training and Doctrine Command; 160th Signal Brigade, Kuwait; and Headquarters, United States Army Forces Command.

Additionally, CW5 Jones served as Rear Detachment Commander, Detachment Bravo, 55th Personnel Services Battalion, Darmstadt, Germany and Detachment Commander, Detachment Bravo, 5th Personnel Services Battalion, Fort Polk, Louisiana.

Her awards include the Bronze Star Medal, Defense Meritorious Service Medal. Meritorious Service Medal with three Oak Leaf Clusters, Army Commendation Medal with five Oak Leaf Clusters, and the Army Achievement Medal with two Oak Leaf Clusters.

CW5 Jones assumed duties as the Chief Warrant Officer of the Adjutant General's Corps on 17 February 2011.

CW5 Jones is married to Derrick Jones and they have two children, Leighton and Cedric Jones. She retired from the military in 2015.

Chief Warrant Officer Four Traci Nicole Jones, U.S. Army, Retired

Chief Warrant Officer Four Traci Nicole Jones was born February 10, 1965 in Detroit, Michigan. She is the 4th child born to the late Lewis Vernon Moore and Gwendolyn Moore. She joined the United States Army on May 12, 1987 and completed her Basic Training at Fort Dix, New Jersey. After completion of her Basic Training, she attended Advance Individual Training (AIT) at Fort Lee, Virginia, Home of the Quartermaster, as a 76V Warehouse Specialist. Her MOS shortly changed to a 92A Automatic Logistics Specialist. CW4 Jones was selected for Sergeant First Class and Warrant Officer Candidate in March of 1999. She decided to attend the Warrant Officer Candidate School in January 2000 at Fort Rucker, Alabama. This was the start of CW4 Jones' career as a 920B Supply Systems Technician.

CW4 Jones was stationed at Fort Bragg, NC, Sinai Egypt (North Camp and South Camp), Germany (Hanau / Ansbach), Korea (Camp Casey) and Georgia (Fort McPherson). Her Military awards include: Legion of Merit (1st Award), Meritorious Service Medal (4th Award), Army Commendation Medal (4th Award), Army Achievement Medal (1st Award), Army Good Conduct (4th Award), National Defense Service Medal, Global War On Terrorism Service Medal, Korean Defense Service Medal and Humanitarian Service Medal. CW4 Jones served her country proudly for 26 years, while enlisting in the Army as a Private and Retiring as a Chief Warrant Officer Four. Her duties and responsibility allowed her to excel in every facet of the Army that she so proudly served. She never wavered but, always put the Mission and her Soldiers first.

She retired from the FORSCOM G-4 July 31, 2013 after serving a superb Military Career.

Chief Warrant Officer Five Alicia A. Lawrence, United States Navy, Retired

Congratulations to the Navy's Newest Senior Warrant Officer of the Navy (SWON) Chief Warrant Officer Five Alicia Lawrence, SC, USN
BY KGABEL
– October 3, 2018

By CWO2 Morio Hall, Food Service Officer, USS America (LHA 6)

On July 26, 2018, onboard USS Midway Museum in San Diego, California, Chief Warrant Officer Five (CWO5) Alicia Lawrence was introduced and welcomed as the senior warrant officer of the Navy (SWON). She assumed the prestigious title and all responsibilities from CWO5 Anthony Diaz. Lawrence is the seventh SWON since the position was created in 2004 and the first female to hold the position. She is also one of 83 CWO5s currently serving in the Navy, a major milestone achievement.

Her 32 years of leadership and professional competence have fostered solid foundations for long-term success in the food service community. She currently serves as the Navy food service training officer at NAVSUP Headquarters. She is sought out by many Sailors and senior leaders Navywide, and recognized for her versatility and expertise in naval service. She is a gifted leader, making a positive impact far reaching across all ranks.

Lawrence is a native of Port of Spain, Trinidad, West Indies. She and her family migrated to New Jersey in 1976, where she later joined the Navy in 1986. Focused and determined early in her career, in 1987 she graduated from Mess Management Specialists "A" School with honors as a third class petty officer. She successfully served in various

sea and shore billets before promoting to chief petty officer. While serving as Chairman on Joint Chiefs of Staff in 2000, she received her commission to chief warrant officer and attended Navy Supply Corps School in Athens, Georgia.

She quickly became an advocate for Navy food service, providing insight and guidance throughout the community. Her first tour as a commissioned officer was aboard USS Frank Cable (AS 40) from 2000 to 2002, serving as food service officer and command sexual assault victim coordinator. She also earned her Surface Warfare Supply Corps Qualification. She later served at Naval Station Norfolk as billeting officer and site director from 2002 to 2004. She was

then promoted to CWO3 and served onboard USS Kearsarge (LHD 3) from 2004 to 2008 as food service officer and postal officer, where she promoted to CWO4. She served as supply officer

Joint Expeditionary Base Little Creek and Fort Story from 2009 to 2011.

While serving at Naval Air Station (NAS) Patuxent River, Maryland from 2011 to 2013 as the N9 deputy director for fleet and family readiness programs, she was promoted to the rank of CWO5 in 2012, as the first female CWO5 and the first female food service officer aboard NAS Patuxent River. From 2011 to 2016, Lawrence served as Navy food service readiness and training officer at NAVSUP Headquarters. Lawrence was reassigned to NAVSUP Global Logistics Support (GLS) as the Navy food service training and readiness officer from 2016 to 2018. After the disestablishment of NAVSUP GLS, she was reassigned to NAVSUP Headquarters as the Navy food service department training officer.

* Chief Warrant Officer Five Alicia Lawrence retired on April 5, 2019.

CWO5 Alicia A. Lawrence turnover
as SWON from CWO Anthony Diaz
during his retirement ceremony.
- photo by CWO5 Theresa Payne

Chief Warrant Officer Two Summer Levert, United States Navy

Houston Style Magazine

Chief Warrant Officer 2 Summer Levert

Navy's First African-American, Female Boatswain's Mate Chief Warrant Officer Shares Her Story
"A First of a Kind: Mesa Verde's Bos'n"
Style Magazine Newswire | 3/14/2017
Story by Petty Officer 2nd Class Brent Pyfrom

NORFOLK, Va. - There is always a first. In the Navy so many firsts are spoken about that they become test questions. Well here's one more first, the Navy's first African-American, female Boatswains Mate (BM) chief warrant officer; Chief Warrant Officer 2 Summer Levert.

Levert is assigned to the amphibious transport dock ship USS Mesa Verde (LPD 19) as the ship's Bos'n. The ship's Bos'n is an officer who is the subject matter expert on all major seamanship functions and the maintenance of topside gear such as; small boat operations, supervising anchoring, mooring, replenishment at sea, towing, transferring of personnel and cargo, and the operation and maintenance of ship's boats. She is depended on by the ship's captain

to execute major seamanship evolutions safely and maintaining the external upkeep of the ship.

Levert, a Cleveland native, began her military service in the Army National Guard in 1997, and was assigned to a military police company. After her time with the National Guard was completed, she decided to join the Navy, and in October of 2000, become a boatswain's mate. After making chief petty officer in 2011, Levert wanted more from her career and set her sights on becoming a chief warrant officer. In 2014, she applied to the chief warrant officer program and was selected.

"Coming up as a junior Sailor in a male dominated field I knew there would be times I'd have to prove to them that I deserved to be there as much as they did," Levert said. "There were times I felt I had something to prove or that I wasn't strong enough, and now by looking at what I have accomplished thus far I realize that the only thing to prove was that goals can be reached through hard work and perseverance."

When achieving success there are always obstacles to overcome. Some obstacles are harder than others, but Levert, an African-American woman, continued to use her family, friends and mentors for inspiration to get her where she is today.

"My first inspiration was my twin sister, who was also a BM in the Navy, but had joined before me. My second inspiration is my mom, who was an Army nurse in the reserves, and then there were the Bosn's that I worked for and observed throughout my years as a BM. They were the smartest people I knew. They taught me my job so well that I thought they read Naval Ships' Technical Manuals in their sleep. They were respected everywhere they went, and I knew that it was well deserved. That's what I wanted to be in my wildest dreams."

According to multiple Sailors on Mesa Verde; Levert is the Bos'n she's looked up to throughout her career. Her leadership echoes throughout the ship and can be seen and heard during any boat operation; one can hear her calling out orders and making sure Sailors comply with safety procedures. It's safe to say that deck department has a female leader who knows what it takes to achieve mission and personal success.

"Bos'n is very humble. She believes in hard work and effort; and only desires to be measured by her character and deed," said Lt. Alvin Weidetz III, USS Mesa Verde's deck department head. "Woe betides the Sailor, junior or senior, that steps out of line or throws safety to the wind. But at the end of every evolution, Bos'n will count heads ensuring all are safe and sound, laud each and every one for their efforts and encourage their improvements to do better."

In December of 2015, she received a plaque of recognition for her service from her hometown U.S. Representative, Marcia L. Fudge, which she viewed as a great honor.

At the end of the day Levert has made Mesa Verde and Navy history, but it's not the past that motivates her; it's the Sailors' and their futures.

"My Sailors motivate me. Not the fact that I'm the first this or that. Through all the madness, the long days, and feelings of wanting to give up, I always think about the young Sailors that tell me how much they admire me, how much they want to be like me someday. If I quit they'll think it is ok to quit and that's not the message I want to send."

Warrant Officer Five Belynda A. Lindsey, U.S. Army Reserve, Retired

Chief Warrant Officer 5 Belynda A. Lindsey was selected as the Command Chief Warrant Officer for the 63rd Regional Support Command on 03 February 2015.

After enlisting into the United States Army Reserve in 1982, Chief Lindsey completed her Basic Training at Fort Dix, New Jersey.

Immediately thereafter, she was trained as an Electronics in Communications Specialist (31V) during her Advanced Individual Training (AIT) held at the Fort Sill, Oklahoma, Signal Corps. After her initial induction into the military, Chief Lindsey was assigned to the 64th Maintenance Company in Los Alamitos, California.

In 1983, Chief Lindsey began her JAG Corps career when she reclassified as a Legal Specialist (71D) and transferred into the 78th Military Law Center (MLC), also located in Los Alamitos, which was under the 63rd US Army Reserve Command (ARCOM), which then became the 63d Regional Support Command (RSC), which became the 63rd Regional Readiness Command (RRC).

During Chief Lindsey's tenure with the 78th MLC, she became a Court Reporter and ultimately achieved the rank of Sergeant First Class before becoming a Warrant Officer in 1994.

In 2006, Chief Lindsey was deployed to Iraq as a Single Augmentee Legal Administrator and assigned to the 13th COSCOM, later renamed the 13th Sustainment Command (Expeditionary)

During her tour in Iraq, Chief Lindsey voluntarily performed the duties of a Therapist with the Combat Stress Unit. After her deployment, Chief Lindsey returned to the 78th Legal Operations

Detachment to serve as the Legal Administrator in Los Alamitos, California.

Chief Lindsey has been awarded the Army Commendation Medal, the Army Achievement Medal, the Army Reserve Components Achievement Medal, the National Defense Service Medal with Bronze Star, the Global War on Terrorism Service Medal, the Iraq Campaign Medal, the Non-Commissioned Officer Professional Development Ribbon with the number 3, the Army Service Ribbon, the Overseas Service Ribbon, the Overseas Reserve Training Ribbon, and the Armed Forces Reserve Medal with "M" devise and Gold Hourglass. Chief Lindsey also wears the Army Superior Unit Award.

As a civilian, Chief Lindsey is a Senior Federal Investigator with the Equal Employment Opportunity Commission's Los Angeles District Office and a Licensed Marriage and Family Therapist. Chief Lindsey and her husband, Joe R. Holmes, have been married over 30 years. They have four children: Joqueeta (George) Williams, Hunter (Amanda) Holmes, Lindsey (Aaron) Jackson, and Sundae Holmes; and four grandchildren: Haley Williams, Jasey Holmes, Noah Holmes, and Ashton Newman.

Chief Lindsey's retirement ceremony was held on June 3, 2018.
PRINT

Angela R. Lowe, Chief Warrant Officer Four, U.S. Army, Retired

In 2001, Warrant Officer One Angela Lowe became the first female Field Artillery Warrant Officer to graduate from Warrant Officer Candidate School. She is a recipient of NAACP Roy Wilkins Award (2007).

Ms. Lowe has an Associate degree in General Studies from Central Texas College; a Bachelor of Science in Criminal Justice/Law Enforcement from Columbia Southern University; and a Master of Arts in Human Service Counseling, Marriage and Family Therapy from Liberty University.

On May 4, 2017, III Corps and Fort Hood honored Chief Warrant Officer Four Lowe at its monthly retirement ceremony held at the Phantom Warrior Center.

Since October 2018, Ms. Lowe is the Training and Development Coordinator at the Millennium Corporation in Killeen, Texas.

Warrant Officer One Latania E. McCook, U.S. Army Florida National Guard

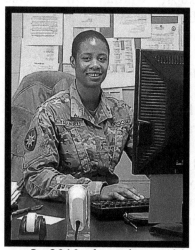

My name is Latania E. McCook. I was born in St. Ann's Bay Jamaica, August 2, 1988 and moved to the United States at the age of 12. I graduated from Poinciana High School in May 2006. In the fall of 2007, I started attending Palm Beach State College, where I became friends with a member of the Florida National Guard, and on April 30, 2008, I was sworn in. I was assigned to 3/116th FWD SPT CO as a Motor Vehicle Operator (88M).

In 2010, the unit transitioned to 356th CS CO and as a specialist (E4) I was reclassified as a Material Control Accounting Specialist (92A). On December 20, 2010, I graduated with my Associates in Arts Degree, Cum Laude, and December 19, 2013, I graduated with a Baccalaureate in Supervision and Management, Magna Cum Laude. I was promoted to a Sergeant (E5), equipment record parts sergeant, in October 2012 to CO F, 53rd SPT BN FSC, where I was the lead 92A in the Maintenance Control Section, height and weight NCO, and a unit SHARP representative. My time with the 53rd SPT BN signified a turning point in my military career and my life personally, because this is where I met my first Warrant Officer, then CW2 Prickette, who became a mentor to me. Mr. Prickette introduced me to the Federal Technician program, as a GS 07 Production Controller/Supply Tech in 2013 which helped me hone my logistics skills. During September 2015 to May 2016, I mobilized with 2nd Battalion, 124th Infantry Regiment in support of Combined Joint Task Force-Horn of Africa and Operation Freedom's Sentinel as a squad leader, and served as a post SHARP representative. Following my deployment, now, CW3 Prickette motivated me to become a Warrant Officer. I was appointed WO1 Supply Systems Tech (P20B) on September 14, 2017 and

graduated my WOBC class as Distinguished Honor Graduate on May 16, 2018. In May 2018, I became a GS 09 Supply Supervisor at the FL MATES in CBJTC, and I am currently pursuing my Masters of Logistics Management at the Florida Institute of Technology.

Latania E. McCook

Chief Warrant Officer Four Petrice McKey-Reese, U.S. Army, Retired

**Hall of Fame Inductee 2018
Army Women's Foundation**

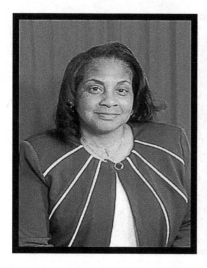

When Petrice McKey-Reese graduated from high school, she faced tougher choices than her classmates. As a single mom of a two-year-old boy, she had to decide what was best for her family. So she opted out of college to enlist in the U.S. Army.

"It was just too expensive to go to college and raise my son," said McKey-Reese. "My thought was I would make some money and then maybe go back to school." Her decision to enlist led to a long and distinguished career with the U.S. Army where she made history by becoming the first African American women to serve as a rigger warrant officer. This month the Army Women's Foundation will recognize that distinction when it inducts McKey-Reese in the Army Women's Foundation Class of 2018 Hall of Fame. "I'm still trying to digest everything. It's very humbling," she said. "I know it is all by the grace of God that this has happened." A native of New Orleans, La., McKey-Reese never intended on a long career in the military when she enlisted. It was a recruiter who guided her towards logistics, citing the few officers and lack of women in that field. "It was a very male dominated Military Occupational Specialty," she remembered. "I didn't really even think about being the first African American woman. I just knew I had to do everything just right." She was named the service's first African American female warrant officer just shy of her tenth year of service and went on to receive four more promotions before retiring as a Warrant Officer 4 in 2014. Her service has taken her around the world including missions

and postings in Korea, Italy, Germany, Kosovo and an exhausting rigging mission to Haiti. "I can't even remember how many plane loads of personnel and equipment were loaded and in the air headed there when the mission was called off," she said. "That was the first mission that made me realize how critical an 18 hour wheels up meant!"

A favorite mission was to Uganda where her unit taught African soldiers how to resupply officers in remote areas. "(We were) working closely with the Ugandan soldiers to test the new methods of airdrops to resupply their troops with much needed supplies," she said. "It was soldiers helping soldiers."

It was on another tour to Korea that McKey-Reese met and married a fellow soldier. Her husband, Eddie F. Reese Sr., is a retired Master Sergeant.

McKey-Reese retired in December 2014 just two months short of 31 years. She lives in Oklahoma where she continues to work with veterans, volunteering for the Sigma Phi Psi sorority, an outreach group established by United States Armed Forces Women that helps military families.

"My intent was to serve three years. Thirty years later I retired," she laughed. "I was just always blessed."

Chief Warrant Officer Three Stacey Ann McNish-Rodriquez, U.S. Army

STACEY ANN MCNISH-RODRIGUEZ: U.S. ARMY CHIEF WARRANT OFFICER AND WELDER - A Different Path (The Lincoln Electric Company / 2014)

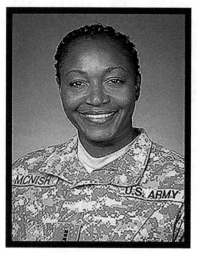

Stacey-Ann McNish-Rodriguez is a chief warrant officer in the U.S. Army... and she is a welder.

"With all the new processes learned here, I can take those back to the Army and improve on the training for the Allied Trades Specialist program."

Welding and the Army: either career is relatively uncommon for a woman; to combine the two together is rarer still. To Stacey-Ann McNish-Rodriguez, welding in the U.S. Army is the perfect combination.

"I was always fascinated with the Army as a child," she recalls.

That fascination would lead her to her career calling. At 15, Stacey-Ann arrived in southern Florida from Jamaica. After high school, not sure of what she wanted to study and concerned with education costs, Stacey-Ann met with an Army recruiter. He mentioned welding as a potential service occupation, and she was sold. Why welding?

"I was fascinated with the welding process because I love to create things," Stacey-Ann says.

So, in February 1994, she enlisted in the U.S. Army as an Allied Trades Specialist. Now, almost 20 years later, CW3 McNish-Rodriguez directs the setup, operation and maintenance of machine tools and welding equipment used to fabricate or repair parts, mechanisms, tools and machinery.

"I will be in charge, training officers and other warrant officers," she explains, describing her next assignment at the Army's Fort Lee in Virginia.

During four combat deployments, Stacey-Ann has witnessed just how welding can play an important role in Army operations.

"Welding is a critical occupational specialty in the Army, and during those deployments it seemed that the welding shop had more work than everyone else," she says, noting that the majority of deployment work involved recovery and repair of damaged vehicles. "When something gets blown up or needs repair, we handle that, and it all must be done quickly. And sometimes we add metal or modify equipment. When a soldier comes in for you to make something new or to repair something, I see it as an art project. It's a type of art form that I really enjoy and appreciate."

First Warrant Officer in Welding-Industry Training Program

To keep up with the latest welding technology and procedures, Stacey-Ann has been training for the past 12 months at the Lincoln Electric Co. in Cleveland. For the past five years, Lincoln Electric has participated in the U.S. Army's Training With Industry (TWI) program, where an enlisted Army soldier reports to work at Lincoln Electric for one year. During this period, the soldier gains knowledge in order to advance welding practices in the military. The program has been so successful at Lincoln Electric that it has been expanded to include a warrant officer. Stacey-Ann is the first to participate.

"Being selected as the first Warrant Officer in the Allied Trades field to fill this position is a definite honor," says Stacey-Ann, who completes her assignment in July before heading back to Fort Lee.

"In this program, competitively selected officers are given extensive work exposure to corporate America," explains Carl Peters, director of technical training at Lincoln Electric. "The officer gains knowledge in welding and private-sector business practices and procedures, and then reports back to a military position for three years in order to transfer the knowledge."

During her time at Lincoln Electric, Stacey-Ann has participated in welding-design and welding-productivity seminars, training in

advanced robotics and Six Sigma operational analysis, and a comprehensive welding course, as well as advanced-technology training and exposure to various types of Lincoln Electric welding equipment. She also earned multiple welding certifications.

Army Gains from Industry Knowledge

"The Army's main objective in sponsoring the TWI program is to develop soldiers who are experienced in higher-level managerial techniques and who have an understanding of the relationship of their industry as it relates to specific functions of the Army," explains Stacey-Ann. "Once TWI students integrate back into an Army organization, they can use this information to improve the Army's ability to interact and conduct business with industry. Participants may also be exposed to innovative industrial-management practices, techniques and procedures that are applicable to, and benefit, the Army."

But there is much more to the program than that, according to Stacey-Ann.

"I see the relationship between Lincoln Electric and the Army welder as far more than just a partnership," she says.

"The advanced robotic training shows how the welding world is evolving and brings to mind ideas of how to accomplish many of the Army's welding needs," she offers, noting also that the VRTEX® system is so effective in training new welders that the Army has added 13 of these innovative teaching aids to its Allied Trades Department at Fort Lee's Center of Excellence.

Perseverance Pays

With her training at Lincoln Electric winding down, Stacey-Ann is set to bring a host of new ideas back to Fort Lee. But what won't change is the attitude that enabled her to succeed as a female welder and chief warrant officer in the U.S. Army.

"Being in the Army as a female and an Allied Trades warrant officer has its challenges, as in any profession," she explains. "You need to ask yourself whether you will allow any small minds and challenges to dictate your career path for you. I have always been a

strong, persistent individual, never allowing anyone or anything to control what is attainable. When I tell people what I do, they look at me and say, 'That is not possible.' The opportunities are there for females, but if you are not on top of performance and knowledge, it will not work out. You have to prove yourself every day.

"My motto has always been to go for the challenge," Stacey-Ann adds. "Never allow another human being to dictate how much you can achieve."

Go for the challenge she did, and looking back she knows she's made the right decisions.

"My overall Army career has been fun," Stacey-Ann concludes. "Four deployments to Iraq, two beautiful kids that are simply amazing, a wonderful husband and family support that is stupendous."

Chief Warrant Officer Three Robin Mitchell, U.S. Army Reserve

SDDC Reservist promoted to CW3

By Johnathon Orrel December 12, 2017

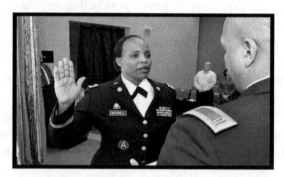

Chief Warrant Officer 5 Johnathan Waddy, the U.S.
Transportation Command mobility warrant officer,
Administers the oath of office to Chief Warrant Officer 3
Robin Mitchel during a ceremony held in the Seay
Auditorium December 11.
(Photo Credit: Mr. Johnathon Orrell (SDDC)

Surrounded by family and friends, U.S. Army Reservist Robin Mitchell was promoted to chief warrant officer three in a ceremony held in the Seay Auditorium here Monday. Mitchell serves as a civilian traffic management specialist in the Military Surface Deployment and Distribution Command's (SDDC) operations directorate.

Chief Warrant Officer 5 Johnathan Waddy, the U.S. Transportation Command mobility warrant officer, presided over Mitchell's ceremony and spoke highly of the accomplishments she has achieved in both her military and civilian careers.

"As a young enlisted Soldier," said Waddy, "Robin was hard-charging and making things happen, and someone saw her potential for service at a higher level as a Warrant Officer."

"She was also the first of her family to join the military and the first of her family to earn a college degree," he added.

Mitchell enlisted in the Army in August 2000 as a transportation management coordinator. She received her commission as a mobility warrant officer in 2010.

During the ceremony, Waddy and Mitchell's husband, Thomas, changed out her uniform jacket rank, while sons Kevin and Chris applied new rank insignia on her uniform blouse.

Thomas, a retired command sergeant major, also works at SDDC.

"I'm very proud of her. She has worked so hard and accomplished so much," he said.

Mitchell was pleased that so many of her friends and family made the trip to Scott Air Force Base for her promotion, including her siblings Eric and Nicole Richardson and childhood friend Tammy Carter-Hill, all from Roanoke, Virginia.

Mitchell will return full-time to service in uniform as she heads to Wichita, Kansas in January to serve as the mobility warrant officer for the 451st Expeditionary Sustainment Command.

Chief Warrant Officer Five Cheryl D. Monroe, U.S. Army

U.S. Army Logistics, HQDA G-4
March 16, 2018

Chief Warrant Officer Five Cheryl D. Monroe Makes History As We Celebrate Women's History Month

In a ceremony at the Pentagon presided by LTG Piggee, CW5 Monroe became the first African American female Chief Warrant Officer Five in the ammunitions field. "She is a pioneer," LTG Piggee said. Today, there are 175,000 women in the Army - making up 17% of our Total Army Team. "I am so pleased that we can push the boundaries, with such a talented and deserving Soldier, capable of handling the toughest jobs."

CW5 Monroe started as an ammunition specialist and served as a Drill Sergeant before become a Warrant Officer in 2003. Since then, she deployed six times, including three times in Iraq – and she went from overseeing $5 million worth of ammunition on her first deployment, to 2.7 billion on her last. She came to the Pentagon in 2015, and is on the front-line of our efforts to improve ammunition readiness.

Chief Warrant Officer Five Joyce E. Morris, U.S. Army Retired

Retired Chief Warrant Officer Five Joyce E. Morris entered the Army in 1976, as a Private, into the Woman's Army Corps (WAC) where she attended basic training at Fort McClellan, Alabama. Congress eliminated the WAC as a corps within the Regular Army in 1978 and assimilated them into the other branches of the Army. She attended Advanced Individual Training at Fort Benjamin Harrison, Indiana.

Her enlisted assignments have included tours of duty at Headquarters US Army Garrison, Fort Sam Houston, Texas; Southern European Task Force, Vicenza, Italy; and 14th Data Processing Unit, Fort Bragg, North Carolina.

Retired Chief Warrant Officer Five Morris was appointed to the rank of Warrant Officer One on 3 July 1984, and served as Chief, Data Processing Section, for the Computer Operations-Fixed Site, at 4th Transportation Command, Oberursel, Germany. She served as the Assistant Director of Information Management, 102nd Signal Battalion, Frankfurt, Germany. She served as Project Officer for the Unit Level Logistics Systems-Ground and later, for the Combined Aircraft Scheduling System-Operations, working jointly with the Navy, at the US Army Information Systems Software Development Center, Fort Lee, Virginia.

Retired Chief Warrant Officer Five Morris' other assignments have included Team Chief, 389th Transportation Detachment, Pusan, Korea, during Operations Desert Shield and Desert Storm, accounting for equipment and supplies departing from port or arriving at port on cargo ships. Information Systems Security Technician, 902nd Military Intelligence Group, Fort George G. Meade, Maryland; Chief, Combat Service Support Automation Management Officer, 45th Corps Support Group, Schofield Barracks, Hawaii; Chief, Army Intelligence Branch, Single Agency Manager, Pentagon, where she provided information systems management, and network security assurance service and support, to the Office of the Deputy Chief of Staff for Intelligence. She was the Chief, Technical Support Team, Defense Information Systems Agency - Pacific, Wheeler Army Airfield, Hawaii. As Senior Signal

Systems Technician, serving in the G6 Directorate, US Army Combat Readiness Center, Fort Rucker, Alabama, she led various information systems projects, and in her most recent assignment, Retired Chief Warrant Officer Five Morris was Communications Security Technician, 5th Signal Command, HQ USAREUR, G6. Joyce Morris holds a Bachelor of Arts degree in Information Systems Management from University of Maryland at College Park. She is a life member of the United States Army Warrant Officers Association and the Veterans of Foreign Wars.

The Legion of Merit, Defense Meritorious Service Medal, Meritorious Service Medal (second oak leaf cluster), Joint Service Commendation Medal, and the Army Commendation Medal (four oak leaf clusters) are among the many military awards she earned.

She retired from active duty on 1 October 2008 and started her own company, Prestige Salon LLC, the following year. She is putting as much effort, love, and passion into that pursuit as she put into her military career.

Chief Warrant Officer Five Tywanda B. Morton (Tee), U.S. Army Maryland National Guard, Retired

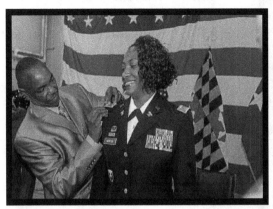

Chief Warrant Officer Four Tywanda B. Morton, senior property book officer, became the first female and African-American promoted to chief warrant officer five in the Maryland Army National Guard. The ceremony took place at the Lt. Col. Melvin H. Cade Armory in Baltimore, Nov. 7, 2013. Morton began her Army career at Cade Armory in 1987. Chief Warrant Officer Five is the highest rank in the Warrant Officer Corps.

CW5 Morton later served as the 6th Command Chief Warrant Officer in the Maryland National Guard.

(Photo by Staff Sgt. Thaddeus Harrington, Maryland National Guard Public Affairs Office).

Chief Warrant Officer Four Sharon M. Mullens, U.S. Army

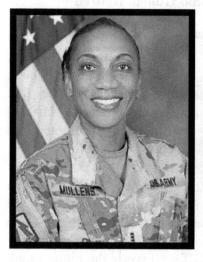

Chief Warrant Officer Four Sharon M. Mullens has had an astounding Army career that expands over three decades. Born in Annapolis, Maryland to a large Naval family, Chief Mullens was no stranger to the military and the lifestyle it represented. She is an accomplished Senior Cyber Management Technician with Headquarters Military Intelligence Readiness Command with multiple Army Staff and operational assignments to include the United States Army Cyber Command and Headquarters, Department of the Army Pentagon. Her areas of assignment include Germany; Korea; Iraq; Saudi Arabia; Kuwait; Washington, DC; Fort Bragg, North Carolina; and Fort Belvoir, Virginia. She has had multiple deployments in Operation Iraqi Freedom and Operation Enduring Freedom to include Kuwait, Qatar and Saudi Arabia. As the HHC Commander of Headquarters and Headquarters Detachment 335th Theatre Signal Command, Sharon was the first Black female Warrant Officer HHC Commander in a forward-deployed contingency operation.

Sharon graduated with a Bachelor's degree in Business Administration, with the honors of "magna cum laude" from Baker College of Flint, Michigan, to include a Master's in Business Administration. Her professional accomplishments' include graduate of the Defense Academy of the United Kingdom, Warrant Officer Professional Senior Military education, Lean Six Sigma, and several information technology certifications, to include cyber skill identifiers. Her awards and decorations include the Bronze Star Medal, Meritorious Service Medal (4th OLC), Army Commendation Medal (3rd OLC), Joint Service Achievement Medal, Army Achievement Medal (3rd OLC), Army Good Conduct Medal (3rd OLC), the

National Defense Service Medal, Southwest Asia Service Medal, Global War on Terrorism Service Medal, and the Global War on Terrorism Expeditionary Medal.

Chief Mullens is the youngest of eight and loves spending annual retreats with her siblings. Sharon's Parents, John and Ruth, along with her Sister Linda, lay in rest at Arlington National Cemetery. Her Parents often reminded the family that life is a platform for the next generation, use it wisely. "If you are knocked down a thousand times, get up and make a difference for that one". Occasionally, Sharon enjoys a trip to Los Angeles and visits with "A-List Celebrities" who are family friends. She and her brother Ken even spent a week in Tanzania, Africa and summited Mount Kilimanjaro during a blistery winter in December. Chief is often quoted as saying: "There is no greater experience than to serve God, Country and your Community. Giving back is priceless, and when done with a humble heart, it is often effortless".

CW4 Mullens in an Army recruiting poster.

In December 2018, Ms. Mullens
climbed Mount Kilimanjaro
Summit, the highest mountain in
Africa and the highest free
standing mountain in the world.

Chief Warrant Officer Five Aurelia "Viki" Murray, U.S. Army National Guard, Retired

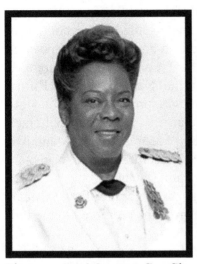

Aurelia Victoria Murray was born in Columbus, Ohio. In 1966, she graduated from Marion-Franklin High School where she was a varsity cheerleader and member of the concert choir. Later that year, she began her government service as a civilian employee with the Defense Construction Supply Center. Chief Murray continued her civilian government service at the Navy Finance Center, Cleveland, Ohio from 1970 until she was recruited by her father, then Senior Master Sergeant Thomas A. Murray, Sr. She enlisted with the 182nd Tactical Air Support Group, Illinois Air National Guard in June 1973 and began her career as a full-time technician.

In 1974, Chief Murray returned to Ohio and transferred to the 121st Combat Support Squadron, Ohio ANG. That year, she traded Air Force blue for Army green and became the first female to work as an Administrative Supply Technician in the Ohio Army National Guard. She was assigned to the 54th Support Center (Rear Area Operations) and later to the Headquarters Battery 136th Field Artillery Battalion where she attained the rank of Staff Sergeant.

In March 1978, Chief Murray became the second female and the first African-American female appointed to the Warrant Officer ranks in the Ohio National Guard. She was assigned as the Military Personnel Technician and full-time Command Administrative Specialist for Headquarters, 136th Field Artillery Battalion. Chief Murray entered the Title 10, Active Guard Reserve (AGR) program in May 1982 with an assignment to the National Guard Professional Education Center (PEC) where she served as the Center's first female instructor. She remained at PEC until June of 1987, having served as a

Training Support Writer for the last two years of that assignment. Her following assignment was at the Army Finance and Accounting Center, Indianapolis, Indiana, where she served as a Financial Assistance Officer in the National Guard Financial Services Office.

At the rank of CW3, Chief Murray was recalled to her home state in July 1988 to serve as the State Recruiting and Retention Specialist where she remained until returning to the Title 10, AGR Program. In March 1993, she reported for duty at the National Guard Bureau (NGB), Personnel Division, where she was promoted to CW4 and served as a Military Personnel Technician in the SIDPERS branch. She was assigned to the NGB Policy, Programs and Manpower Division, in 1995 and in December 1998 became the first woman to serve as the ARNG Warrant Officer Program Manager.

In September 1999, Chief Murray became the first African-American female in the history of the Army to be promoted to the rank of Chief Warrant Officer Five.

CW5 Murray was assigned to the Office of the Deputy Chief of Staff for National Guard, U.S. Army Forces Command from May 2001 until September 2003. She was then assigned to Headquarters, Department of the Army, Office of the Deputy Chief of Staff, Personnel (G-1) at the Pentagon from September 2003 until May 2005. Her 33-year career culminated with her assignment to the NGB-J5, Plans and Policy Division where she served as Policy Analyst and Policy Branch Chief.

Chief Murray is currently a graduate student pursuing her Master Degree. She holds a bachelor's degree in social psychology from Park University, where she graduated magna cum laude in 1998. Her military awards include the Meritorious Service Medal (3 awards), Army Commendation Medal (4 awards), Army Achievement Medal (2 awards), National Defense Service Medal (2 awards), the Humanitarian Service Medal, and the Global War on Terrorism Service Medal.

Chief Warrant Officer Four Kimberly Oliver, U.S. Army
Air Force Institute of Technology

Army Chief Warrant Officer brings joint perspective to cyber education
Posted Wednesday, May 30, 2018

Army Chief Warrant Officer Four (CW4) Kimberly Oliver came to AFIT in April 2017 as a cyberspace instructor within the School of Strategic Force Studies. Her assignment is a result of a partnership between the Cyber Center of Excellence – Ft Gordon, GA and AFIT. She instructs various cyberspace operations courses, such as Operational Design, Joint Doctrine, Cyber Strategy, and the Joint Planning Process, in support of the school's Cyber 200 and 300 professional development courses.

Through those courses, students are provided a broad background in cyberspace operations concepts, including capabilities, limitations and vulnerabilities and their associated application and employment in joint military operations. "It is definitely different being here for the Army and learning how the Air Force does things and understanding how it all fits together. With cyberspace, unlike other warfare domains, we have no choice but to fight together, there is no one organization that has full control or responsibility – we all do. With Cyber 200 and 300 courses being open to sister services, it has made a big difference to the learning outcomes," said Chief Oliver.

Chief Warrant Officers are the technical subject matter experts for the Army, Navy, Marines and Coast Guard. They support officers who are seen more as generalists and work directly with the enlisted who

are the hands-on operators. For cyber network defense, Chief Oliver assists with the technical planning for internal defensive measures. She provides detailed information to commanders on how cyber requirements and capabilities fit into a mission such as securing and defending command and control systems such as e-mail and critical mission essential systems.

When Chief Oliver joined the Army in the 1990s, she was working with mainframes, tapes, and punch cards. She transitioned into the information assurance arena in the early 2000s, and later served as an instructor at the Army's Signal School teaching HTML and UNIX. With multiple overseas and joint assignments, she received her commission as a Warrant Officer on 22 Jun 2004. She has been involved with many high-level cyber defense projects including closing down Operation New Dawn in Kuwait, supporting the Army's migration to Enterprise Email, and shaping one of the initial training pipelines for the Army's Cyber Protection Team.

Originally from Queens, NY, Chief Oliver is fourth generation military. Her great-grandfather served in Europe during World War I, her grandfather served in the Pacific during World War II, and her father was a Marine. "I joined the service because I felt it was my obligation. Previous generations fought for me so serving was my opportunity to make a difference for later generations," said Chief Oliver. She joined the Navy Reserves, graduated from college and worked in the civilian sector for two years. But she longed for the comradery she had observed with active duty service members. "I decided I wanted more. I wanted a challenge, and what better challenge than joining the U.S. Army," said Chief Oliver. Nearly 26 years later, she still loves her job. "I am still having fun and I enjoy coming into work every day. Each day is different – especially here at AFIT," said Chief Oliver.

When Chief Oliver joined the service, only a few people in an organization had computers on their desks and cyber defense wasn't mainstream. Now everyone has a laptop and mobile phone and the responsibility for cyber defense professionals has increased dramatically. "We have increased the number of vectors that have allowed the adversary to take advantage. Years ago the fight was

against specific adversaries, now it could be against the individual sitting in their house who is sending out a distributed denial of service attack. I think in the future we will need to go back to some basic fundamentals and realize that we can't fully rely on technology. Years ago, the only signal given off by a troop was by a radioman, now we have vehicles that have multiple satellites, routers, and switches that are all emanating signals. Even the warrior wears/carries equipment– radios, hand-held devices, things in their head gear – that are giving off signals. The ones coming up behind me have a really tough job because they have to determine how to secure all of those signals/devices, ensure the information is valid and keep the people safe. If the adversary can jam those signals or alter the information, a commander may not have a true picture of the situation. That's life and death," said Chief Oliver.

Chief Oliver has started thinking about what she will do in retirement and it isn't too different from what she does now. She plans to stay in education and work on creating cyberspace curriculum for schools. "I attended a conference recently whose focus was on cyberspace education for grades K-12. I didn't realize the opportunity in preparing the future cyberspace force. I would love to work with schools to build their cyber course work and that way I can still be involved, keep my military relationships and benefit the community. I am always about giving back," said Chief Oliver.

"I have literally seen the world. I have been to Korea twice, Kuwait twice, and Afghanistan twice; I have been to Japan, Egypt, Thailand, the Azores, and Ireland; I have lived in Italy and my feet have been on Russian ground in support of a mission in Afghanistan. Looking back, I never would have thought a young girl from Queens, NY would travel the world, meet President Obama, heads of State, ambassadors, and Prime Ministers and help build the Afghanistan National Army and the Afghanistan Police. I have had an awesome ride and I am still enjoying it," said Chief Oliver.

Chief Warrant Officer Five (Retired) Karen L. Ortiz - 2014 Quartermaster Hall of Fame Inductee

Chief Warrant Officer Five Karen L. Ortiz, U.S. Army, Retired

Karen L. Ortiz is a native of Portsmouth, Virginia. She joined the United States Army in June 1978. She received her Basic Training at Fort Jackson, South Carolina and Advanced Individual Training at Fort Lee, Virginia. In 1987, then Staff Sergeant Ortiz was accessed into the Warrant Officers Corps as a 762A, Support Supply Technician.

Ms. Ortiz assignments include the Accountable Officer and Platoon Leader for the 493rd Supply and Service Company in Wurzburg, Germany. She deployed with the 1st COSCOM, 2nd CMMC during Desert Shield and Desert Storm. She served as the CMMC OIC Item Manager Forward at Logistical Base Charlie. Ms. Ortiz was the Class VII Item Manager for the 4th CMMC at Fort Hood, Texas; Accountable Officer and Supply Technician at the 348th Quartermaster Company, Camp Humphrey, Korea; and Senior Supply Technician with the 45th Corps Support Group, Schofield Barracks, Hawaii. She returned to Fort Hood, Texas as the 21st Calvary's Senior Supply Technician for the Apache Training Brigade. At Fort Lee, Virginia, she served as the Warrant Officer Advanced Course Coordinator and the Director. She then served as the Chief of the Warrant Officer Division. During this assignment, she deployed as a member of the Automated Logistics Team in support of Operations Enduring Freedom/Iraqi Freedom, CFLCC-C4, Camp Arifjan, Kuwait.

CW5 Ortiz holds a Master's Degree in Counseling from the University of Central Texas and a Bachelor's Degree from American Technological University. She is a graduate of the Supply and Services

Management Course, Joint Logistics Course, Multinational Logistics Course, Warrant Officer Advanced Course, Warrant Officer Staff Course, and the Warrant Officer Senior Course.

Her awards and decorations include the Meritorious Service Medal (2OLC), Army Commendation Medal (4OLC), Army Achievement Medal (3OLC), National Defense Service Medal, Southwest Asia Medal, the Global War on Terrorism Expeditionary Medal, Global War on Terrorism Service Medal, Korean Defense Service Medal, Humanitarian Service Medal, and the Kuwait Liberation Medal. In 2006, Chief Ortiz was inducted as a Distinguished Member of the Quartermaster Regiment.

Ms. Ortiz is married to Rafael Ortiz. The Ortiz's have three children – Dontae, Aurilia, and Kiera.

Karen L. Ortiz

PVT. Karen L. Ortiz

Chief Warrant Officer Four Diedra C. Padgett, United States Navy, Retired

Chief Warrant Officer-4 (CWO4) Diedra C. Padgett (Diedra C. Ware during her Navy career) was born and raised in Flint, Michigan. Her parent's Douglas and Augustine Jones raised 8 children, 7 of whom joined the military. Diedra began her career as a Data Processing Technician (E-1) in 1982, and ended it as a CWO4 with over 30 years of service in 2012. When she retired, less than 1% of African American females served as CWO4s in the Navy. She was part of an elite group.

CWO4 Padgett's deployments included Saipan, Japan, Thailand, Guam, and Bahrain. Her duty stations included: Bureau of Naval Personnel (DC); Fleet Intelligence Center Pacific (HI); Fleet Intelligence Center Europe and Atlantic (VA); Headquarters, United States European Command (Germany); USS Seattle (AOE 3) (NJ); Naval Air Maintenance Training Group Detachment (FL); USS Harry S. Truman (CVN 75) (VA); CTF Navy Marine Corps Intranet (DC); PMO Defense Travel System (DC); Office of Naval Research (DC); Commander Fifth Fleet (Bahrain); and Commander Naval Beach Group ONE (CA).

CWO4 Padgett served in a variety of Information Technology/Cyber Security roles. Highlights include: Information Assurance Manager, Deputy CIO, and Department Head. Diedra earned both the Enlisted Surface and Enlisted Air Warfare Officer qualifications prior to commissioning. In 2010, she earned her Information Dominance Warfare Officer qualification. Often a trail blazer- Diedra was the 1st female advanced to Chief onboard the USS Seattle (1997), and she assumed the duties as the Navy Marine Corps

Intranet's first Global Information Systems Security Manager (ISSM) in 2001.

Diedra holds a BS degree in Cyber Security from UMUC, along with several IT Certifications. Her military awards include: Defense Meritorious Service Medal, Meritorious Service Medal, Joint Service Commendation Medal, Navy and Marine Corps Commendation Medal (3), Joint Service Achievement Medal, Navy and Marine Corps Achievement Medal (3) Joint Meritorious Unit Award, Meritorious Unit Commendation, Navy Good Conduct Medal (5), National Defense Service Medal, Global War on Terror Expeditionary Medal, Global War on Terror Service Medal, and Navy and Marine Corps Overseas Service (5). She and her husband Russ have 5 children and 5 grandchildren. She remains very active in several military and veteran's organizations.

CWO3 Padgett on deployment

CWO Padgett receiving the National Naval Officers
Association (NNOA) Dorey Miller Award from NNOA
President Bernard Jackson and Chairman, Joint Chief of
Staff Mike Mullen.

Chief Warrant Officer Two Apple M. Pryor,
United States Coast Guard, Retired

In 2006, Chief Warrant Officer Two Apple Pryor was assigned as the Main Propulsion Assistant onboard the CGXC Boutweil. She was the first African American Woman Naval Engineering Chief Warrant Officer in the Coast Guard.

Apple Pryor served in the Coast Guard from January 1984 – January 2015, 31 years and one month. She has a Bachelor's Degree in Business Administration (Cum Laude Honors) from the Baker College Center for Graduate Studies.

Chief Warrant Officer Two Thalia Ramirez, U.S. Army, Deceased (May 15, 1984 – September 5, 2012)

US Army's only African-American woman helicopter pilot killed in Afghanistan

Internet | 9-19-12 | Mwakilishi
Posted on **9/19/2012, 1:55:46 PM** by **trailhkr1**

A Kenya native enlisted in the United States Army died on Wednesday, September 5th in a helicopter crash while serving in the Afghanistan war. Thalia Ramirez Moll, 28, who is half Kenyan and half Puerto Rican, was an army pilot and was flying a Bell OH-58 Kiowa helicopter before it crashed in the Pul-e Alam district of Logar Province in Afghanistan.

Thalia Ramirez, 28, who was half Kenyan and half Puerto Rican, was an Army pilot and was flying a Bell OH-58 Kiowa helicopter before it crashed in the Pul-e Alam district of Logar Province in Afghanistan. Thalia grew up in Kenya and attended both primary and

high school at the Breaburn School. Her mother is Kenyan, while her father is half Puerto Rican.

Her great passion for helicopters and the Army led her to enlist in the U.S. Army shortly after coming to the United States. Her year-long tour of duty in Afghanistan was almost over, and she was expected back in the U.S. from deployment within a week. Thalia was the only African female helicopter pilot in the U.S. Army and earlier in 2012 she was promoted to a rank of Chief Warrant Officer 2.

Ms. Ramirez served in the 82nd Combat Aviation Brigade, 82nd Airborne Division based at the Fort Bragg, North Carolina. She had flown more than 20 missions and 650 hours in the course of the one-year deployment. A second Warrant Officer who was flying with Ramirez in the helicopter was also killed in the crash.

She earned OH-58D Kiowa Warrior aviator qualification in 2008 and was assigned to the 82nd CAB in 2009. This was her second deployment.

Ramirez's awards include the Air Medal 3rd device, the Purple Heart Medal, Army Commendation Medal with Valor, Army Commendation Medal, Army Achievement Medal with three oak leaf clusters, Valorous Unit Award, Army Good Conduct Medal, National Defense Service Medal, Afghanistan Campaign Medal with three Campaign Stars, Global War on Terror Expeditionary Medal, Global War on Terror Service Medal, Army Service Ribbon, Overseas Service Ribbon 2nd device, NATO Medal, the Combat Action Badge and the Army Aviator Badge.

Thalia Ramirez interment is at Arlington National Cemetery, Arlington, Virginia; Sect 60, Site 10213.

Thalia Ramirez

Thalia Ramirez

Chief Warrant Officer Three Samantha Reed, U.S. Army, Retired

Ms. Samantha Reed retired from Active Duty on 1 October 2004 culminating a 22-year career. Her final military assignment, she served as the Chief Warrant Officer, United States Garrison Command, Fort Stewart, Georgia. She currently serves as the Capability Developer for the Enterprise System Division, Combined Arms Support Command (CASCOM).

Chief Warrant Officer Three, Retired, Reed received her Warrant Officer appointment after completing the Warrant Officer Candidate Course at Fort Rucker. Throughout her Warrant Officer career, she served in a variety of career enhancing assignments that included Property Accounting Technician, Headquarters & Headquarters Command FSGA; Property Book Officer, COSCOM, TSB FBNC. During this assignment, she deployed to Hatti in support of Operation Uphold Democracy, Property Book Team Chief, 172nd Infantry Brigade Alaska.

CW3 Reed retired and transitioned out of the military to a position as a logistics analyst at USAMC Logistics Support Activity (LOGSA) supporting the Global Combat Support System Army (GCSS-Army). Her career in logistics encompasses a vast number of positions as a technical analyst at Northrop Grumman, Common Table of Allowances (CTA) database manager at the United States Army Force Management Support Agency (USAFMSA), a Supply Management specialist at the Defense Logistics Agency (DLA) Belvoir, a multi-functional/ GCSS-Army Fielding Team Property Book New Instructor Trainer at Northrop Grumman Corp and culminated with her advancement as a Logistic Management Specialist (Capability developer), Combined Arms Support Command (CASCOM).

CW3 Retired Reed holds a Bachelor of Business Administration, Master of Science Degree in Management/Logistics Systems Management from Florida Institute of Technology, SAP (TERP10) associate.CW3 Reed was awarded the Women Who Get It Right Grassroots Advocacy Award from the National Breast Cancer Coalition (NBCC). She is a two time breast cancer survivor and is the mother of one adult son, a daughter-n-Law and 1 grandson - Travis, Valisha, and Gabriel.

Chief Warrant Officer Two Katharin Rice-Gillis,
U.S. Army, Retired

Katharin Rice-Gillis is originally from Texas and currently resides in Lawton, Oklahoma, was born into dysfunction. She and her sibling spent quite a few years in foster care until they were adopted by their maternal grandmother. In 1996, when she was 18, Rice-Gillis joined the Navy where she spent nine years, then transitioned to the Army in 2005, under the Operation Blue to Green Program.

In 2007, Rice-Gillis became the first African American female warrant officer to successfully pass marine deck officer school and was assigned to the USAV *MG Winfield Scott* as a third mate, in Fort Eustis, Virginia.

Rice-Gillis, as a Chief Warrant Officer Two, possessed the technical Warrant Officer Military Occupational Specialties Marine Deck Officer (880A) and Electronic Warfare Technician (290A). She served tours of duty in both Iraq and Afghanistan. In 2011, she received a Bronze Star for Leadership performance.

She earned an Associate in Applied Science (Business) in 2009, and a Bachelor of Science in Liberal Arts in 2013, but it was the pursuit of her master's degree in a technological field that was Rice-Gillis's real passion. Rice-Gillis earned a Master of Science in Cybersecurity in 2015 with a 4.0 GPA. All her degrees are from Excelsior College. She is currently pursuing her Doctorate in Strategic Security program with Henley Putnam.

Rice-Gillis has been drawn to cybersecurity ever since she was deployed to Afghanistan in 2010-2011. As an electronic warfare warrant officer with the 101st Airborne Division, she was responsible for frequency manipulation and for utilizing CREW equipment to

protect service members and civilians from IEDs. "Afghanistan really opened my eyes to the importance of protecting the information and systems that we rely on daily," she says. Her interest in cybersecurity was piqued from this experience and she began exploring the discipline.

She retired in October 2016 with 20 years of honorable active duty service.

Rice-Gillis is the first in her family to graduate college and has inspired her children and husband to pursue higher education. In fact, her husband, who served 22 years in the Army, earned a bachelor's degree in information technology from Excelsior College in 2018. Her two sons are following in her footsteps and entering the Navy. Rice-Gillis believes that, thanks to Excelsior, she was able to show her family how higher education can positively change your life. She says, "I believe Excelsior taught to me commit to my own dreams…There is no luck when it comes to success, you just have to be willing to believe in yourself…"

Chief Warrant Officer Four Jean D. Ritter, U.S. Army

Chief Warrant Officer Four Jean D. Ritter was born in the Bronx in New York City. She was raised in the Upper West Side of Manhattan by her adopted mother who was already raising two other children of her own – her sister Karen was 7 being the youngest of three, Jean, thrived. She was raised in the same New York City housing project, Dyckman Projects, and attended the same Catholic School, St. Jude, as Lou Alcindor a.k.a. Kareem Abdul Jabbar. Growing up in a New York City project was fun and different. Jean was an exceptional child – while attending St. Jude School, her mother was asked if Jean could be skipped because she was a gifted child. Concerned for her wellbeing, Jean's mother refused. At the end of Jean's fifth grade school year, her mother, now a single parent, asked Jean if she would like to attend public school.

Understanding the probable financial strain her mother was experiencing and wanting to be with her friends, Jean gladly agreed to attend public school. At the start of the school year, her mom was again asked about Jean being skipped to a higher grade and again she refused. She wanted Jean to remain with her peers. It wasn't until Jean made it to middle school, seventh grade, and was able to skip the high school after successfully completing a rigorous curriculum covering seventh and eighth grade work. All of this time, Jean was the youngest of her class and graduated John F. Kennedy High School in the Bronx in 1986 at the tender age of 16 before becoming a college freshman at Kutztown University in Pennsylvania.

Jean did not complete her college education at that time; instead she went on to work and started a family before joining the Army in 1998. As a Private Second Class, Jean attended Basic at Fort Jackson,

South Carolina and the Advanced Individual Training at Fort Lee, Virginia to become an Automated Logistical Specialist. Her first duty station was Fort Lewis, Washington in 1999. Jean served as part of the 24th Quartermaster (QM) Supply Company Direct Support in the supply warehouse. During her two years at 24th QM, Jean experienced much success as a soldier. She earned recognition for being the Soldier of the Month and Quarter before relocating to her next duty station at Camp Casey, Korea. During Jean's time at Camp Casey, she served with distinction in the Division Support Command, Materiel Management Office as the Automated Processing Department specialist responsible for ensuring successful completion of the automated supply processes.

In 2002, Jean relocated again, this time to Fort Bragg, North Carolina. At Bragg, Jean served as the Repair Parts Specialist for the 189th Combat Support Battalion responsible for ordering repair parts for the equipment for the battalion. Jean was promoted to Sergeant and deployed with the 189th to Iraq in early 2003 and again in late 2004. During her first deployment, Jean again displayed excellence, by competing and winning battalion Non-Commissioned Officer of the Year. It was during her second deployment that Jean decided she wanted to become a Warrant Officer. In August 2006, Jean successfully completed Warrant Officer Candidate School at Fort Rucker, Alabama and then graduated Warrant Officer Basic Course at Fort Lee, Virginia – officially becoming a Supply Systems Technician.

Warrant Officer One Jean Ritter's position was as the Accountable Officer of Supply Point 51 located at Yongsan, Korea for the 59th Maintenance Company. During her two years as the Accountable Officer, Jean again experienced success by winning numerous supply excellence awards at the local and Army-wide levels. Her last year in Korea, as a Warrant Officer Two, Jean worked as the Senior Supply Systems Technician in the 498th Combat Sustainment Support Battalion Support Operations Office. Jean was directly responsible for managing two warehouses and both warehouses won numerous local and Army-wide supply excellence awards. In late 2010, Jean competed and won the chance to represent Eighth Army Army-wide in the

Douglas MacArthur Leadership Award competition on her way to 3rd Sustainment Command (Expeditionary) at Fort Knox, Kentucky.

While serving as the Senior Supply Systems Technician, Materiel Management Officer, in the Support Operations Section, Jean deployed to Afghanistan in 2012. For nine months, Jean was responsible for at least 18 supply support activities (SSA) and was instrumental in the planning of the drawdown for the SSAs. A few months after redeploying back to Fort Knox, Jean was selected to participate in the Training with Industry program in Cadillac, Michigan at AAR Mobility Systems. This program allows select Army personnel to train and work in the private sector for twelve months with a utilization tour at Fort Lee, Virginia. Jean arrived at Fort Lee, Virginia in October of 2014 and served as a Capabilities Developer. She continued to have success both professionally and personally before relocating to Fort Leavenworth, Kansas where she is now a Chief Warrant Officer Four with a Master's Degree in International Management and serving as an Instructor/Writer at the Army Management Staff College, Organizational Leadership department.

CW4 Ritter's awards and decorations include the Bronze Star Medal, Meritorious Service Medal, Army Commendation Medal (5), Army Achievement (3) Medal, Army Good Conduct Medal (2), National Defense Service Medal, Afghanistan Campaign Medal, Iraq Campaign Medal (2), Global War on Terrorism Expeditionary and Service Medals, Korean Defense Service Medal, Non-Commissioned Officer Professional Development Ribbon (2), Army Service Ribbon, Overseas Ribbon (6), Meritorious Unit Commendation Ribbon, and Combat Action Badge.

Chief Warrant Officer Four Mitzie A. Robinson, United States Coast Guard

Chief Warrant Officer Mitzie A. Robinson joined the United States Coast Guard in 1983 and since then she has risen to the rank of Chief Warrant Officer. Born in Jamaica, she chose to become a United States citizen after serving three years of active duty service. She was naturalized in 1987, achieving her goal of U.S. citizenship. During CWO Robinson's off-duty time, she participates in numerous community projects. She assisted Lucy Stone Elementary School, Dorchester, MA in building a playground. Once the plan was approved CWO Robinson volunteered to help build the playground. She also volunteered her off-duty time to participate in school book fairs and tutoring elementary students. In recognition, CWO Robinson was awarded the SECDOT Gold Medal for Outstanding Achievement.

CWO Robinson has been recognized for her work which has earned her many awards including: Coast Guard Commendation Medal, two Coast Guard Achievement Medals, Joint Service Achievement medal, four Commandant Letters of Commendation, seven Good Conduct Awards, two Enlisted Person of the Quarter Awards, Secretary's Award for Outstanding Achievement, and Honoree for the Women Officers Professional Association for exceptional leadership and mentorship qualities.

CWO Robinson is a member of the Chief Warrant Officers and Warrant Officers Association (CWOA) and has served as its National Treasurer. Additionally, she is a Distinguished Member of the CWOA. She is the recipient of the 2006-2007 Outstanding American of Choice Recognition Award.

Chief Warrant Officer Two Pamela Rogers, U.S. Army

Chief Warrant Officer Two Pamela Rogers was recognized as the 2010 Adjutant Generals Corps Warrant Officer of the Year. She is a recipient of the Timothy J. Maude Medal for Distinguished Achievement. CW2 Rogers was assigned as a Human Resources Technician with the 3rd Infantry Division Special Troops Battalion in Iraq at the time of the award.

Chief Warrant Officer Four Monifa D. Rucker, U.S. Army, Retired

Monifa D. Rucker enlisted in the Regular Army in May 1991, serving on active duty until her retirement on 31 July 2018. In 2004, 11 years after being promoted to the rank of Sergeant First Class, she was appointed as a WO1. For the balance of her career she served as the Veterinary Corps Branch Chief (normally a CPT slot), Senior Food Safety Officer and Executive Officer (during a 15-month deployment to Iraq), AMEDDC&S Department Deputy and Senior Instructor, Southeast Regional Food Safety Officer, Theater Food Safety Officer for the Republic of South Korea, and in her final assignment as the Command Food Safety Officer, for the Public Health Command-Pacific Region.

During Ms. Rucker's 27 years of service, she accepted all challenges, regardless of location, and always incorporated the leadership traits of being a mentor, coach, facilitator, and influencer, while promoting professional success and the importance of follow-up

Ms. Rucker has been a United States Army Warrant Officer Association member since 2004, joining immediately after becoming a Warrant Officer. She was active in three chapters, and enthusiastically participated in Warrant Officer activities in two locations where there were no chapters. At the Fort Hood Silver Chapter (Texas), she chaired the Officer Professional Development Committee for 13 months. At the Morning Calm Chapter (Korea), she was the President for two terms. In Iraq, she joined with another Warrant Officer in successfully organizing Warrant Officer professional development opportunities, and sponsored an event for the Warrant Officer Cohort birthday. Ms. Rucker also served as Secretary of the Aloha Chapter

Since retirement from Active Duty, Ms. Rucker is the full-time Senior Army Instructor for Junior Reserve Officer Training Corps at the O. D. Wyatt High School in Fort Worth, Texas. Monifa Rucker has a Bachelor of Science degree in Food Science, Business Industry from Kansas State University.

Chief Warrant Officer Three Octavia G. Saine, U.S. Army, Retired

Octavia G. Saine, CW3(R), US Army JAG Corps, joined the National Oceanic and Atmospheric (NOAA) Office of General Counsel as the Executive Officer in June 2010. Prior to joining NOAA, she served as the Deputy for Financial Management and Public Outreach for the Eisenhower Memorial Commission from 2008 to 2010.

After retirement from the US Army JAG Corps in 2004, she held various leadership positions in the private sector in the Washington, D.C. metro area and Charlotte, North Carolina. Most notably, Federal Home Management Corporation (Freddie Mac), Bank of America, and Charlotte Mecklenburg County Schools.

Octavia has received several awards since her retirement from the Army JAG Corps such as Bank of America's Award of Excellence and Sprit Award, and the Department of Commerce Office of General Counsel Distinguished Employee award for 2013.

Octavia's twenty-year career with the U.S. Army culminated at the U.S. Army Legal Services Agency where she served as the Chief Legal Administrator.

Octavia received her undergraduate degree in 1981 from Winston-Salem State University, Winston-Salem, North Carolina and her graduate degree from Webster University, St. Louis, Missouri, in 1993.

She lives in Springfield, Virginia with her husband Tim Saine and their daughter, Alisha.

Chief Warrant Officer (CWO) Five Valencia Simmons-Fowler, United States Navy

MILLINGTON, Tenn. (November 3, 2017) Capt. Alonza Ross, director of enlisted distribution at Navy Personnel Command, swears in Chief Warrant Officer (CWO) 5 Valencia Simmons-Fowler as the first African-American CWO5 in the information warfare community. The CWO rank is a technical specialist who performs duties that directly related to their previous rating. They are accessed from the chief petty officer pay grades E-7 to E-9, and must have a minimum of 14 years of service. (U.S. Navy photo by Petty Officer 3rd Class Kyle Hafer/Released)

Chief Warrant Officer Five Vickie Slade, U.S. Army National Guard

My Journey to becoming a warrant officer began 09 February 1979 when I enlisted in the US Army Reserve at the young and naïve age of 18.

My career as a Soldier and Warrant Officer was made possible because of the remarkable people God placed along my path. From the Sergeant in basic training, who after two weeks of seeing me cry every day, told me that I really needed to stop crying (I cried when the Soldier standing next to me got yelled at), to the Sergeant in Advanced Individual Training (AIT) who told me that just because there was snow on the ground *in early September*, did not mean I could sleep in and miss formation (stop laughing), to all the mentors who encouraged and supported my endeavor to become a warrant officer, and last but certainly not least, to CW5 Sharon Swartworth, my friend and catalyst for my accession onto active duty. Whenever I'm asked why or how I came to join the military, I tell the story about the day I was at work on my part-time job as a clerk typist for the Social Security Administration. On that day, 08 February 1979, I was proof reading a document when I heard a commotion about 50 feet from my desk. Curiosity got the best of me, so I walked over to the desk where several people were laughing and talking. I asked the young lady sitting at the desk what all the excitement was about. She said, "I just joined the CAS program in the military. I thought this CAS program must really be something if she's this excited. She told me that CAS was an acronym for Civilian Acquired Skills and gave me her recruiter's name and number. I walked back to my desk and immediately called the recruiter. He told me I did not meet the perquisites for the CAS program but that he would be glad to talk to

me about other military options. The recruiter picked me up from my house at 0600 hours the next morning and drove me to the recruiting station. We discussed the Reserve Program and Active Duty. I liked the idea of drilling one weekend a month and attending annual training two weeks during the summer. After completing some paperwork, the recruiter took me to the Military Entrance Processing Station (MEPS). At 1500 hours on that same day, I was sworn into the US Army Reserve's Delayed Entry Program as a Private E-1.

I've had many amazing experiences and opportunities since joining the military; I served in all of the Army's components (Reserve, Active Duty, and National Guard); I was the first Legal Engagements Warrant Officer in the Department of Defense; and I jumped out of perfectly good airplanes. As I look back on that day in February 1979, I was exactly where I was supposed to be and 38 years later I'm a Warrant Officer in the United States Army National Guard, which is exactly where I'm supposed to be. HOOAH!

* Vickie Slade was promoted to Chief Warrant Officer Five on April 19, 2019 at the Women's Memorial at Arlington Cemetery.

Chief Warrant Officer Four Rhonda L. Sloan, U.S. Army, Retired

CW4(R) Rhonda L. Sloan is a native of Uniontown, Pennsylvania. She began her military career in October 1983 where she completed Basic Training at Fort Dix, New Jersey. After completion of Basic Training, she attended Advanced Individual Training (AIT) at Redstone Arsenal, Alabama and awarded the MOS 55B Ammunition Specialist. From 1984 – 1995, she served at Katterbach, Germany; Fort Bragg, NC; Aschaffenburg, Germany; Fort Carson, Colorado; Korea; Fort Campbell, Kentucky and Fort Wainwright, Alaska.

In 1996, she was selected as an Ammunition Technician 910A (now 890A), Ordnance Warrant Officer. CW4 Sloan was stationed at HAAF/Fort Stewart, Georgia; Fort Hood, Texas; Camp Carroll, Korea; Fort Bragg, North Carolina and Fort Lee, Virginia. She also has deployments to Kandahar, Afghanistan; Al Asad, Iraq and Camp Arifjan, Kuwait.

CW4(R) Sloan's military awards include the Bronze Star Medal, Legion of Merit, Department of the Army Superior Civilian Service Award, Meritorious Service Medal (4OLC), Army Commendation Medal (7OLC), Army Achievement Medal (6OLC), Army Good Conduct Medal (3OLC), National Defense Service Medal, Afghanistan Campaign Medal, Iraq Campaign medal, Global War on Terrorism Expeditionary Ribbon, Global War on Terrorism Service Ribbon, Korean Defense Service Medal, NCO Professional Development Ribbon (3 Device), Army Service Ribbon and Overseas Ribbon (7 Device). She has also been awarded the Order of Samuel Sharpe and the Demonstrated Master Logistician award.

CW4(R) Sloan has received a Bachelor of Science Degree in Liberal Arts from Excelsior College and a Master of Arts Degree from

Webster University in Management and Leadership. Her military education includes the Warrant Officer Staff Course, Warrant Officer Advanced Course, Warrant Officer Basic Course, Air Assault Course, Capability Developer Course and the Logistics Assistance Program-Operations Course and numerous other courses.

She has served in nearly every level of ammunition operations throughout her 29 year military career and retired in February 2013 from the Combined Arms Support Command as a Capabilities Developer.

Currently Rhonda Sloan is a Department of Defense Civilian Employee for the Joint Munitions Command as a Logistics Assistance Representative, (Ammunition). Her civilian employment has allowed her the opportunity to continue to serve her country without wearing a uniform.

Chief Warrant Officer Five Sherill D. Small, U.S. Army Reserve

United States Army Reserve Command, Property Accounting Technician

Chief Warrant Officer Five Sherill Small was born in Roanoke Rapids, NC, in August 1962. She enlisted in the Army National Guard in September 1985 as a 92Y, Supply Specialist; and, was appointed as a Warrant Officer from the Warrant Officer Candidate School in Fort Rucker, Alabama in April 1999.

Warrant Officer assignments include Property Account Technician, 60th Troop Command, Rocky Mount, NC; Military Personnel Technician, 449th Aviation Group, Kinston, NC; Joint Property Book Officer, Guantanamo Bay, CU; Property Book Officer, 785th Military Police Battalion, Fraser, MI; Property Accounting Technician, 484th Movement Control Battalion, Springfield, MO; Property Accounting Technician, 324th Signal Battalion, Fort Gordon, GA; Course Team Leader/Instructor, 83rd Army Reserve Readiness Training Command, Fort Knox, KY, and Property Book Officer, Military Intelligence Readiness Command, Fort Belvoir, VA.

Chief Warrant Officer Five Small is currently assigned as the Army Reserve Senior Property Accounting Technician, United States Army Reserve Command, Fort Bragg, North Carolina.

Her deployments include Camp Delta, Guantanamo Bay, CU in support of Operation Enduring Freedom; Camp Bucca, Iraqi in support of Operation Iraqi Freedom, both while assigned to the 785th Military Police Battalion, Fraser MI and Bagram, Afghanistan in support of Operation Enduring Freedom under the 18th Military Police Brigade.

Her education includes Warrant Officer Candidate, Basic and Advance Course, Warrant Officer Staff Course, Warrant Officer

Senior Staff Course, Army Basic Instructor Course, Systems Approach to Training and Contracting Officer's Representative Course. Her civilian education includes an Associate's Degree in Social Work from Edgecombe Community College, and a Baccalaureate Degree in Applied Science from Campbell University.

Her awards include the Meritorious Service Medal with Four Bronze Oak Leaf Clusters, Joint Army Commendation Medal, Army Commendation Medal with Two Bronze Oak Leaf, Army Achievement Medal with one Silver Oak Leaf, 1 Bronze Oak Leaf Cluster, National Defense Service Medal with Bronze Star, Global War on Terrorism Expeditionary and Service Medals, Joint Meritorious Unit Award (permanent), Meritorious Unit Award (permanent), Combat Action Badge, and the Honorable Order of Saint Martin.

Chief Warrant Officer Five Small has one daughter Ashley Montgomery, son-in-law, Aaron Montgomery, and two granddaughters residing in Manassas, VA.

Chief Warrant Officer Five Chery E. Spencer,
United States Marine Corps, Retired

Chief Warrant Officer Chery Spencer enlisted in the United States Marine Corps in October 1978. She completed Basic Training at the Marine Corps Recruit Depot, Parris Island, South Carolina. Chief Spencer is a graduate of the Drill Sergeant School; the Advanced Administration Chief School; Marine Corps Automotive Mechanic Course; and the Officer Basic School the Marine Corps Combat Development Command at Quantico, Virginia.

Her assignments include serving as a Unit Diary Clerk at Headquarters and Service Battalion, Second Force Service Support Group, at Camp Lejeune, North Carolina; as Unit Diary Clerk at Marine Corps Inspector Instruction Staff, at Waukegan, Illinois; and as a Drill Instructor at the 4th Battalion Marine Corps Recruit Depot at Parris Island. She as commissioned as a Warrant Officer on December 14, 1990.

Chief Spencer was promoted to Chief Warrant Officer Five, effective February 1, 2005. After her retirement from the military, she became the Director of the Consolidated Personnel Administration Center at Parris Island.

Chief Warrant Officer Two Latia Suttle, U.S. Army AGR (Active Guard and Reserve), Retired

Personal History: What you want people to know about you:

I was born and raised in Fort Wayne, Indiana. My parents and grandparents are from Alabama. I joined the military when I was 17 years old.

Military Service: Military Branch; time served from - to; Special honors; duty assignments any specialty divisions.

Army: October 1993 - August 2014

Rank: Chief Warrant Officer Two

Duty Assignments: Ansbach, Germany; Dharan, Saudi Arabia; Fort Bragg, North Carolina; Darien, Illinois;

Fort Lee, Virginia; Fort Buchanan, PR (Puerto Rico); Baton Rouge, Louisiana; Kuwait; March Air Reserve Base, California; Iraq.

Education: AA Degree - General Studies
(5 classes away from Bachelors in Business)

Other affiliations: Member of the Los Angeles Association of Black Military Women, Member of the Hollywood NAACP, Member of the American Legion Hollywood Post #43, Member of the American Legion Auxiliary Unit 252, Volunteer for Veterans Homeless shelter, Certified Peer Support Specialist that assist individuals to regain control over their lives and their own recovery process. Advocate for Women Veterans stuck in the Family Court crisis where their children are being taken away from them.

Additional information and clarification:

While I was stationed in Darien, Illinois, assigned to the 863rd EN BN, I did a couple of short deployments with them.

Camp Casey, Korea ~ May 2002

Dangriga, Belize ~ April 2003

On my bio, I put everything under duty assignments. However, Saudi Arabia, Kuwait, and Iraq were deployments.

While I was in the 6/43rd ADA (Air Defense Artillery) which later changed its name to 6/52nd ADA in Ansbach, Germany on Shipton Kaserne base, we were deployed to Saudi Arabia. The unit had a permanent rotation set up to deploy to Saudi Arabia every 2 years. I just so happened to be in the unit on one of the rotations. I guess that's still considered deployment. Half of the unit went to Riyadh, Saudi Arabia and the other half went to Dhahran, Saudi Arabia, where I was.

While I was there living in Kobar Towers in Dhahran there was a terrorist attack. I remember being up, sitting in the living room of the suite, talking on the phone to another soldier in Riyadh. While on the phone, I noticed the marbled floor sinking in and the sliding glass door coming inward like a bubble. The last words of the soldier on the other end of the phone heard me say was, "What the...." The air was leaving the room like suction was occurring. Then everything snapped with a horrific destruction sound. I can't describe the sound, but it was a sound that I never heard before; but I knew it was a bomb beyond a normal bomb. The sliding glass door shattered. The floors, walls, and ceilings all cracked at the instance of the snap. This was late at night and it was already dark. All of my suite mates were in bed asleep except for me, as I was awake and completely dressed. The loud noise and shattering of glass woke everyone up except for my roommate. They slowly came out of their rooms all at once, asking "what was that"? I was then standing in complete shock and responded by saying, "A bomb". At that moment, my supervisor, who was male, opened the main door to the suite and yelled my name. I answered from the living room and then he yelled for everyone to get out of building. As we were running towards the main door, I noticed my roommate had just woke up, but was still in a daze and just standing in the entrance of the

bedroom door. I told her to get her shoes on, but she was still completely clueless as to what was going on. I had to grab her and guide her to her shoes as I was quickly trying to explain that a bomb went off and there was glass everywhere and she could not run barefoot. She then became frightened, but was still drowsy because she took sleeping pills at night to prevent her from talking in her sleep. I still had to hold her up as I ran with her down a few flights of stairs. When we got outside, it seemed like complete chaos. People were running and screaming. Some people were injured, bleeding, and screaming. We didn't know if we were surrounded and still under attack or what. We eventually figured out what happened and saw the enormous hole in the ground and the front of one of the buildings completely gone. I could not believe what my eyes were seeing. I dispatched civilian vehicles. We lived in Kobar Towers, but worked on a different base. We drove the civilian vehicles from one base to another. I would also assist with ensuring the vehicles were repaired by some locals. The military maintenance soldiers were not trained on most of the repairs needed for the civilian vehicles. They could change tires and oil, but anything beyond that had to be contracted for repairs by the locals. I was a 92A.

At Fort Bragg, North Carolina, I was in a Rigger Unit when the majority of the unit packed parachutes. The unit was the 612th QM Company. I was a 92A, but was cross-trained to be a 71L in the main office where the S-1 was located. I eventually got back to my MOS of 92A.

In Darien, Illinois, I was in the 863rd EN Bn. I was a 92A, but later went back to Fort Lee, Virginia to reclassify as a 92Y, so that I may get the full-time active position as the Supply Sergeant for the 863rd EN Bn. From that point forward, I was AGR, which is Active Duty in Army Reserve Units.

I then became a Warrant Officer for the two MOS's that I had received training and worked in for a number of years. As a Warrant Officer, I was a 920A and a 920B.

I went to Fort Lee, Virginia and was assigned to the 429th QM. I was on the books as a 920B, but was working in the 920A position as the Property Book Officer.

I was then sent to Puerto Rico to work as a 920A, Accountable Officer as a Supply Systems Technician. I ran the SSA (Supply Support Activity) on Fort Buchanan, PR. The unit was the 276th Maintenance under the 65th Regional Readiness Command (RRC). I took over from CW5 Sonia Graves. She was a CW3 at the time. We were both there for a while, as we did the change over from her to me.

While I was assigned to the unit in Puerto Rico, I was cross-leveled in a Baton Rouge, Louisiana to fill one of the many vacancies in order for the unit to deploy to Kuwait. I had never heard of this before. So I was still permanently assigned to the unit in Puerto Rico, but flown to Baton Rouge to join the 321st TMMC to deploy with them to Kuwait as a 920B. I did six months in Kuwait and then went back to Baton Rouge to do another six months with the rear detachment to continue supporting theater operations.

While I was in Baton Rouge, I was contacted by the 304th Sustainment Brigade in California to join their unit as a 920A (Brigade Property Accounting Technician). This was a CW4 position and I was a CW2.

I told them that I was already in a complicated situation in two units. The 304th SBDE insisted that I join them and ask for me to come out on "Invitational Orders". I had never heard of invitational orders. I flew out to California on their invitation. They tried to get me to sign their property book, but I refused as I was not an official member of their unit. I told them that I had to clear two other units first and then ensure that I was doing a complete inventory of the property on the books. I went back to Baton Rouge to clear the unit and then flew back to Puerto Rico to clear the unit out there. I then joined the 304th SBDE which was moving from Los Angeles to Riverside, CA. The whole structure of the multiple units underneath the Brigade was changing into different types of units. The equipment and personnel were changing. So, equipment needed to be turned un and new equipment needed to be ordered to get the units to how the needed to be according to their MTOE's (Military Table of Organization and Equipment).

At the same time that this was happening, we were preparing for deployment. It was like building an aircraft while in flight.

I am not sure who specifically chose my name for the assignment. I didn't know the lieutenant colonel who called me to come out on the invitation orders, so he had gotten my name from somewhere or somebody. He ended up getting fired by the Full Bird Colonel. He was moved to a different unit. The FLIPL (Financial Liability Investigation of Property Loss) that I completed, after conducting a complete inventory, was millions of dollars. Someone may have been shopping while moving the unit and equipment from Los Angeles to Riverside, Ca. I knew something was up and that is the additional reason why I didn't sign the property book while I was still assigned to two other units. There were no losses under my watch. I went advance party to Iraq with the 304th SBDE and then placed on medical hold. I was later placed on the TDRL (Temporary Disability Retirement List) in 2009. I permanently retired from the Army in August 2014.

When I joined the military at 17 years old, I was in Fort Wayne, Indiana while still in high school. Before I graduated high school, I switched to Active Duty. So, I went to Germany, Saudi Arabia, and Fort Bragg as Active Duty in Regular Army units. When I joined the unit in Darien, Illinois, I was in the Reserves and then put in a packet to become AGR (Active Duty in Reserve units). I remained Active Duty in Reserve units for the remainder of my career until I retired. I was SSG (Staff Sergeant when I switched over to become a Warrant Officer. I went to Warrant Officer Candidate School at Fort Rucker, Alabama.

Latia Suttle and Congresswoman
Maxine Waters

Latia Suttle

CW2 Suttle receiving award

Chief Warrant Officer Four Emmaline T. Tallmore, U.S. Army

Date and Place of Birth:
13 September 1971 St. Martinville, Louisiana

Enlisted Military Service:
10 years

Source and Appointment Date:
Warrant Officer - Apr 2005

Years of Active Warrant Officer Service:
13 years

Total Years in Service:
23 years

Military Education:
Warrant Officer Senior Staff Course (2018)
Warrant Officer Staff Course (2014)
6 SIG-Green Belt (2012)
Demonstrated Senior Logistic (2012)
Contracting Officer Representative Training (2011)
Warrant Officer Advance Course – Supply Systems Technician (2011)
Action Officer Develop CRS (2009)
Warrant Officer Basic Course – Property Book Technician (2005)
Warrant Officer Candidate School – Property Book Technician (2005)
Property Book Unit Supply Enhanced Course (2005)

Civilian Education
AA – General Studies JAN 2015 American Military University

Decorations, Service Medals, and Badges:
National Defense Metal

Overseas Service Ribbon (9)
Armed Forces Service Medal (2)
NCO Professional Development Ribbon (3)
Korean Defense Service Medal
Global War on Terrorism Expeditionary Medal
Global War on Terrorism Service Medal
Good Conduct Medal
National Defense Service Medal
Army Achievement Medal (5)
Army Commendation Medal (8)
Meritorious Service Medal (3)
Bronze Star Medal (1)

Chronological List of Appointments:
W01 RA Apr 2005 – Apr 2007
CW2 RA Apr 2007 – Dec 2010
CW3 RA Dec 2010 – Nov 2016
CW4 RA Nov 2016 – Current

Chronological Record of Duty Assignments:

Active Duty:
US Army Basic Training – Fort Leonard wood, Missouri
US Army Advance Individual Training – Fort Lee, Virginia
HHC, DISCOM– Fort Stewart, Georgia
3/6 Calvary Brigade – Camp Humphrey, Korea
485th Command Support Battalion – Hanau, Germany
10th Transportation Battalion – Fort Eustis, Virginia
1st Personnel Command – Schwetzin, Germany
30th Medical Command – Heidelberg, Germany
45th Sustainment Brigade – Schofield, Hawaii
8th Theater Sustainment Command – Fort Shafter, Hawaii
Army Training Command – Fort Jackson, South Carolina
Combined Army Support Command – Fort Lee, Virginia

DEPLOYMENT(S):

10th Transportation Battalion – (Property Book NCOIC) AL Shuaiba Port (2003-2004)

Headquarters and Headquarters Company, 1st Personnel Command - (Property Book Officer) Camp Arifjan, Kuwait (2005-2006)

45th Sustainment Brigade – (Property Book Officer) Kandahar, Afghanistan (2011- 2012)

Emmaline T. Tallmore

Chief Warrant Officer Four
Emmaline T. Tallmore

Chief Warrant Officer Four
Emmaline T. Tallmore

Chief Warrant Officer Harriet Thompkins, United States Coast Guard, Retired

Harriet Thompkins made history by becoming the first black female Chief Warrant Officer (CWO) in the United States Coast Guard Reserves in 1996.

She began her career 19 April 1975 when she enlisted as a Yeoman Third Class under the direct petty officer program. Her first duty assignment was at Station Port Canaveral, Florida. In 1978, she transferred to Coast Guard Headquarters in Washington DC to work on a special project in Cutter Maintenance Division. During her tour of duty at Headquarters, she was advanced to Yeoman Second Class after ranking Number One on the promotion list.

In 1981, her civilian job moved her to Miami and she reported to Base Miami Beach for duty. Later she was transferred to Marine Safety Office Miami. Her job again moved her to the Tampa Bay Area and she reported to Station St. Petersburg for duty. In 1986, she was advanced to Yeoman First Class.

In 1991 she was among the first females to undergo the age-old initiation rites into the ranks of Chief Petty Officer. During that time she received her master's degree from the University of South Florida (undergraduate degree from Florida A&M).

In 1996, she was promoted to Chief Warrant Officer and reported to Group Charleston, South Carolina for duty at the Assistant Administrative Officer until her retirement. She also produces and hosts an award winning TV show on Access Pinellas. She has published a book of poems and an inspirational CD.

CWO Tompkins' Retirement Ceremony was on January 25, 2003.

Chief Warrant Officer Five Keisha D. Towles, U.S. Army

Keisha Dornailla Towles is the first African American woman selected to serve as the Proponent Chief and the first African American to serve as the Senior Signal Warrant Officer Assignment Officer for Signal Branch. Keisha was also on the team that created the Cyber Branch and developed the Warrant Officer Military Occupation Specialty (MOS) 170A, Cyber Operations Technician.

Keisha D. Towles was born in Fort Smith, Arkansas. She enlisted into the U.S. Army Reserves in 1993 and attended Basic Training at Fort Leonard Wood, Missouri and the Chaplain's Assistant Course at Fort Monmouth, New Jersey. She then enlisted on active duty in 1994 and attended the Information Systems Operator Course at Fort Gordon, Georgia. She was appointed as an Army Warrant Officer in 2002 and attended the Information Systems Warrant Officer Basic Course at Fort Gordon, Georgia.

As a CW4, Towles deployed in support of Operation Iraqi Freedom (OIF) I, Baghdad, Iraq; Task Force Hurricane Katrina, New Orleans, Louisiana; OIF 06-08, Baghdad, Iraq; and Operation New Dawn and Operation Enduring Freedom Camp Airfjan, Kuwait.

Ms. Towles graduated from University of Maryland University College with a Bachelor of Science Degree in Computer Studies. She has also earned her Master of Science Degree in Information Technology Management with an emphasis in Business Intelligence from Trident University International. SFC Pernell Towles, Jr. from Abbeville, Louisiana married Keisha in 1999 and they have one son name Keeshon.

CW5 Towles continues to serve in the Army as a passionate, tough, charismatic technical leader.

Chief Warrant Officer Three Carrie Jarrell Tuning, U.S. Army, Retired

Carrie Tuning was born on July 29, 1958 in Roanoke Rapids, located in Halifax County, North Carolina. She graduated from Northwest High School and attended Halifax Community College in Weldon, North Carolina.

Ms. Tuning entered the U.S. Army in June 1977; attended Basic Training at Fort Jackson, South Carolina and AIT at Fort Benjamin Harrison, Indiana. Ms. Tuning was assigned to the Staff Judge Advocate Office at Fort Dix, New Jersey. She attended the Warrant Officer Entry Course at Fort Sill, Oklahoma, graduating with honors. She completed certification training and received recognition as the first black female appointed as a Warrant Officer in the Judge Advocate General Corps. Ms. Tuning spearheaded the establishment of the first electronic income tax filing program for the Staff Judge Advocate Office at Fort Belvoir, Virginia. After three years, she transferred to HQ, 7th U.S. Army Europe, Office of the Judge Advocate, Heidelberg, Germany. She spearheaded the establishment of the first electronic income tax filing program for the entire Army throughout Europe.

She authored and published a quarterly automation newsletter for the Judge Advocate General Corps with distribution throughout Europe and the States. After completing her tour in Europe, Ms. Tuning was assigned as the Chief, Information Management Officer for the U.S. Army Litigation Center, Arlington, Virginia.

Ms. Tuning's awards include four (4) Meritorious Service Medals, four (4) Army Commendations Medals, two (2) Army Achievement Medals, and recognition as 1987 Outstanding Woman in the World's Who's Who of Women. She is a member of the United States Army Warrant Officers Association.

Her civilian education includes a Bachelor of Science Degree from the University of Maryland; a Master of Science Degree from Central Michigan University; a Master of Divinity Degree from Howard University School of Divinity; and a Doctoral Degree from George Mason University.

For twenty years, throughout her military career she was under the watch care of military chaplains in various chapels at U.S. Army installations.

God called her into the gospel ministry in October 1994. She was licensed to preach in 1995 and ordained in 2014.

Rev. Dr. Tuning is the pastor the H.O.P.E. (Helping Others Prepare for Eternity) Christian Fellowship Church in in Roanoke Rapids, North Carolina. The Church's motto is "A Church Where Everybody is Somebody and Christ is in Charge."

CW3 Carrie Tuning

Chief Warrant Officer Five Ida Tyree Hyche, U.S. Army Reserve, Retired

After 35 years of serving her country well as an Army Reserve Soldier, a mobilized Soldier in support of Operations Iraqi and Enduring Freedom, and a civil servant Human Resources leader for the Department of the Army, throughout the 121st U.S. Army Reserve Command (USARCOM), 81st Regional Support Command (RSC) serving eight southeastern states; Third U.S. Army Central Command (USARCENT) Special Troops Battalion, Fort McPherson, Georgia; 310th AG Group, Fort Jackson, South Carolina; 3rd Personnel Command (PERSCOM), Jackson, Mississippi; 87th Division East, Vestavia, Alabama; and the 108th Training Division's subordinate command at Fort Gillem, Georgia, Ida Tyree Hyche retired at the top rank of Chief Warrant Officer Five (CW5) in 2011.

The following year, having completed over 30 years in human resource management leadership for the Department of the Army federal agency in Birmingham, Alabama, Vestavia, Alabama, and Huntsville, Alabama, Ms. Tyree Hyche closed the federal civil servant chapter of her life under the Army Materiel Command (AMC) at Redstone Arsenal, Alabama, to begin her legal career by opening up her own law practice. The practice, now a partnership with her daughter, Attorney Shade' A. Dixon, named Tyree Hyche & Dixon, LLC, serves Alabama and Georgia.

One of less than ten African American female warrant officers to achieve the highest rank for a warrant officer during her Army Reserve career in the Adjutant General Corps, Chief Warrant Officer Tyree Hyche served as a reserve warrant officer on active duty during Operations Iraqi and Enduring Freedom as Deputy Adjutant for Third U.S. Army Central Command, Special Troops Battalion in Fort

McPherson, Georgia and Camp Arifjan, Kuwait, Southwest Asia. She further served as Adjutant for the Warrior Transition Battalion at Fort Benning, Georgia, before ending her mobilization tour.

As a CW3, The Reserve Officers Association (ROA) selected her as the ROA Warrant Officer of the Year for the Year 2000, among three finalists who appeared before a board in Washington, D.C. An avid writer, Tyree Hyche published several articles in the ROA Officer Magazine and the United States Army Warrant Officers Association (USAWOA) Newsliner. She served as the first female warrant officer to lead the Southeastern Region of the United States Army Warrant Officers Association, serving chapters in Alabama, Georgia, Tennessee, South Carolina, North Carolina, Florida, and Puerto Rico. In that role, Tyree Hyche was also a member of the Board of Directors of the USAWOA. She also served as the first African American female to lead her local chapter of the Reserve Officers Association in Birmingham, Alabama. For a short period of time, CW5 Tyree Hyche served as the first African American female warrant officer on the Board of Directors for the Warrant Officer Historical Foundation.

"I cherish memories of my military career. It infused a sense of service; service, not only to my country, but to others," Tyree Hyche said. "I believe we grow and develop a strong quality of life by building communities of service to others so self-less service completes me."

Upon retirement, Tyree Hyche brought her skills and commitment to service as an attorney. She is managing partner of Tyree Hyche & Dixon, LLC, a firm that practices workers compensation, probate, and employment law (Title VII of the Civil Rights Act) in Alabama and Trademark, Copyright, & business development in Georgia. Tyree Hyche, in her role of attorney, overcame the United States Patent and Trademark Office's finding of "likelihood of confusion" with an existing organization's trademark to successfully trademarking the USAWOA brand, "*Quiet Professionals*".

Ms. Tyree Hyche was recognized by the Birmingham Bar Association (BBA) in 2014 for her pro bono service to persons who least can afford legal services through the BBA Pro Bono Award for Extended Representation Attorney in District Court. In 2016, she was

named to the Board of the Birmingham Volunteer Lawyers Program. Also in 2016, she completed her term as President of the League of Women Voters of Greater Birmingham and member of the State Board of the League of Women Voters of Alabama.

Author of the book, <u>Bar Studies Inspiration</u>, written after retirement and published in 2013, Tyree Hyche declares, "Some people say I don't know how to retire fully. I say there is life after retirement, and it is BETTER."

Chief Warrant Officer Five Selvina H. Wasson, U.S. Army Reserve

CW5 Selvina Wasson entered the United States Army Reserve in 1982 as an Administrative Specialist. Her first duty assignment was with the 301st Area Support Group at Fort Totten, NY. She served in a variety of positions to include Acting Company Commander, 324th Signal Battalion; CSSAMO, 640th Expeditionary Sustainment Brigade; Section OIC (G6), 640th Regional Support Command; Administrative Specialist and Full-time Support (FTS) Secretary to the ODCSLOG, 90th Army Reserve Command, San Antonio, TX; Multichannel Radio NCO and FTS Unit Administrator, 324th Signal Battalion, Fort Gordon, GA (FGGA); Network Technician, Annual Training Acting Commander and FTS Unit Administrator, 359th Signal Brigade, FGGA; Network Technician and FTS Staff Administrative Assistant, 345th Military Intelligence Battalion, Augusta, GA; Information Systems Technician and FTS Staff Operations Training Specialist, 642nd Area Support Group, FGGA; Information Systems Technician and FTS Supervisory Staff Administrator, 3274th US Army Medical Hospital, Fort Bragg, NC; Information Systems Technician and FTS Supervisory Staff Administrator, 640th Area Support Group, Nashville, TN. In 2010, she was assigned to Human Resources Command, Fort Knox, KY, as the Army Reserve Signal/Military Intelligence Career Manager and the first Warrant Officer to manage Functional Branch Officers.

CW5 Wasson was assigned to the US Army Recruiting Command as Chief, Special Actions Branch Officer and the 84th Training Command as the Automation Technician and Exercise Liaison Officer for the 78th Training Division, Joint Base McGuire, Fort Dix, NJ.

In 1997, at the rank of Master Sergeant, she was appointed to Warrant Officer in the United States Army Reserve. CW5 Wasson holds both a Bachelor and Master of Business Administration Degree with specialization in Human Resource Management from McKendree University. She is a qualified Network Technician and Information Systems Technician. She is a graduate of the Warrant Officer Senior Staff Course, Organizational Leader Course, Supervisor Development Course, Security +, and the Certified KM Process Integrator Course. She has served as President, Vice President, and Plans Officer for the Warrant Officer Association, Derby Chapter.

Her awards and decorations include the Meritorious Service Medal (2 OLC), Army Commendation Medal (3 OLC), Army Achievement Medal (3 OLC), Army Reserve Achievement Medal (8 OLC), Armed Forces Reserve Medal (3rd Award) with M device, National Defense Service Medal with Bronze Star, Armed Forces Expeditionary Medal, Global War on Terrorism Service Medal, Global War on Terrorism Expeditionary Medal, Overseas Service Ribbon, Army Reserve Overseas Training Ribbon (3rd Award). CW5 Wasson is a "Kentucky Colonel" and inductee of Phi Kappa Phi and Sigma Beta Delta for academic excellence.

CW5 Wasson is married to CW4 Joseph E. Wiltz based at NAS/JAX, Jacksonville, Florida. They have five children and four grandchildren.

CW5 Selvina H. Wasson

Celebration photo - 111th USAR Birthday

Chief Warrant Officer Four Carolyn Weekes, Massachusetts Army National Guard

CW4 Carolyn Weekes is a member of the Massachusetts Army National Guard (M-Day Soldier) since 1984 with over 35 years of creditable service. She is a member of the United States Army Adjutant General's Corps.

Ms. Weekes was recently assigned the role of Equal Opportunity Advisor of the 79th Troop Command Brigade. Some of her previous roles and responsibilities include Human Resources Officer, Chief Investigator within the Massachusetts National Guard Inspector General's office, and a Senior Instructor for the Warrant Officer and Officer Candidate Schools at the Massachusetts Regional Training Institute. She received her Master of Management from Cambridge College, Cambridge Massachusetts, and her Bachelor of Business Administration, from Anna Maria College, Paxton MA.

After fifteen years of working in the in the private sector in Manufacturing, Distribution and Purchasing, Ms. Weekes joined the Civil Service branch of the United States government. In conjunction with roles in the Massachusetts National Guard, Ms. Weekes is employed with General Administration Services in Region 1. She is a certified federal Contract specialist with the following designations FAC-C Level III, CFCM, (Certified Federal Contract Manager) and Certified Purchasing Manager (CPM). She currently resides in Boston, with her young adults and her precious grandson, a blessing from God. She enjoys tasting different ethnic foods. Her decedents are from the Island of Montserrat where she was borne. She is a member of the Montserrat Aspirers Community Center and Blacks in Government. She enjoys learning and sharing knowledge.

One historical fact is that Ms. Weekes is the first **Black Female Warrant Officer in Massachusetts.**

Carolyn Weekes

Chief Warrant Officer Two Cicely Williams, Nevada Army National Guard

Nevada Guard's Black Hawk pilot takes flight

By Sgt. Zandra Duran, Joint Force Headquarters February 13, 2019

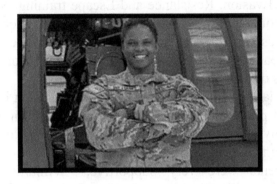

RENO, Nev. - The Nevada Army Guard marked an important diversity milestone recently with the graduation of its first African-American female UH-60 Black Hawk pilot, Chief Warrant Officer 2 Cicely Williams, from rotary-wing aviation flight school.

Williams, 34, of Reno, has been in the Nevada Army National Guard since 2010. She graduated from the U.S. Army Aviation Center of Excellence in July 2017 to become a full-fledged, certified rotary-wing pilot.

"Flight school was extremely challenging," Williams said. "When I graduated, I had never seen that look on my dad's face before. He was so proud of me."

Williams grew up in the small town of Gardnerville, Nevada, and graduated from Douglas High in 2002. She subsequently attended and graduated from the University of Nevada, Reno, and received a bachelor's degree in criminal justice.

After becoming a commissioned officer and joining the 100th Quartermaster Company, Williams began to ponder a career change.

"I became interested in aviation as a young officer when another Quartermaster Soldier, Sgt. 1st Class Marvin Fabella, asked if I

wanted to become a pilot," Williams said. "He encouraged me to try it and start studying for a required test for the flight board. I wanted to try something new that was interesting and challenging.

"When I went before the flight board, I was the first candidate chosen by the board."

Williams never looked back and made it thru UH-60 qualification and Survival, Evasion, Resistance and Escape training. She added she wanted to become a pilot to make her family proud. Her father served in the Marines and at one time also wanted to become a pilot. "Humility, leadership skills, and a good moral compass are all characteristics of a good pilot," Williams said.

Before aviation school, Williams said she was a bit intimidated by the thought of piloting a military helicopter. During flight school, she said her family, friends and 100th Quartermaster Soldiers remained very positive and encouraging.

"My parents were very supportive," Williams said. "They emphasized the military's core values and the equal treatment of everyone."

"We're extremely proud and excited that she chose to become a pilot," said John Williams, Cicely's father.

Williams is confident her fellow Guardsmen will judge her by her piloting skills and not her gender or race.

"I believe it's important to be inclusive and welcoming to everyone versus exclusive because you never know what abilities and ideas an individual can bring to the table," Williams said. "We as Nevada Guardsmen should never include race or gender into the equation when we are making decisions.

"I love this job. I feel empowered by attaining my goal of becoming a pilot and I am very confident and proud of who I am."

Although she is the first African-American female rotary-wing pilot in the Nevada Army Guard, the Army has boasted thousands of female pilots in its history.

A famous influx of women pilots occurred during World War II with the establishment of the Women's Airforce Service Pilots, or WASPs included more than 1,000 female pilots attached to the U.S.

Army Air Forces. Their primary mission during the war was to fly military aircraft from factories to bases around the country.

Chief Warrant Officer Two Cicely Williams

Chief Warrant Officer Five Nicole E. Woodyard, U.S. Army

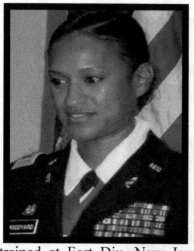

CW5 Nicole E. Woodyard is a Senior Automotive Maintenance, Ordnance Logistics Warrant Officer, 915E. She is currently serving as the Team Lead for the Ordnance Leader Development Branch, Training Development Division, G3/5/7, Combined Arms Support Command (CASCOM), Fort Lee Virginia.

CW5 Nicole E. Woodyard was born in Brooklyn, New York to Winston Shung and Elaine Bennett. She joined the Army in 1989 and trained at Fort Dix, New Jersey as a 63B, Light Wheeled Vehicle Mechanic, with an Additional Skill Identifier (ASI) of Hotel -8, Recovery Specialist. After deploying in support of Operation Desert Shield/Desert Storm and advancing to the rank of SSG, she was assessed in 1996 into the Army Warrant Officer Cohort as a 915A, Automotive Maintenance Warrant Officer.

Military Assignments: Her diverse military career began with 123rd Support Battalion, 1st Armored Division, and Germany where she deployed in support of Operation Desert Shield, Desert Storm in 1990-1991 as a Vehicle Mechanic/Recovery & Evacuation Specialist and Fuel Distribution handler. Her additional assignments includes; Senior Mechanic, Shop Foreman and Motor Sergeant, DISCOM, 24th Infantry Division (3rd ID), Fort Stewart, Georgia 1992 -1996; Battalion Automotive Maintenance Technician, 102nd Military Intelligence Battalion, 2nd Infantry Division, Korea (1997-1998); COSCOM, 39th Ordnance Company, 58th General Support Maintenance Company, and 30th Engineer Topographic Engineer Battalion, Fort Bragg, North Carolina (1998-2003); 69th Air Defense Artillery Battalion, and DISCOM/45th Sustainment Brigades, 25th Infantry Division, Hawaii 2003-2006; 3rd Armored Cavalry Regiment, Regimental Maintenance Officer, Operation Iraqi Freedom 07-09,

(2006-2011) and III CORP G4, Materiel Readiness Branch as the Standards and Inspections Officer (Command Discipline Programs) and Technical Advisor to the General Officer staff and Commanding Generals, Fort Hood, Texas (2011-2014). Recently she served as the Director, Ordnance Warrant Officer Training, Technical Logistics College, Army Logistics University, Fort Lee (2014-2015)

She also completed the highest levels of professional military education requirements, as well as several military training certificates and Operation Contracting Support, Project Management Professional, Lean Six Sigma (Department of the Army and Department of Defense), Army Basic Instructor Course, Instructional Design Basic Course, Blackboard Construction, Test Construction, System Approach to Training, Logistics Assistance Program Operations Course (and a variety of training development and facilitation courses).

Civilian Education:
Associates of General Studies and Liberal Arts, St Leo University;
Bachelor of Business Administration and Marketing, Campbell University;
Masters of Science Administration and Leadership, Human Resource Management, Central Michigan University;
Masters of Humanities in Industrial and Organizational Psychology, Grand Canyon University.

Awards and Decorations: Bronze Star, Meritorious Service Medal with 2 Oak Leaf Clusters, Army Accommodation Medal with 3 Oak Leaf Clusters, Army Achievement Medal with 2 Oak Leaf Clusters, as well as AGCM(2), NDSM(2), SWAB(3), ICMCS, GWOTS, KDSM, HSM, MOSVM, NOPDR(2), ASR, OSR(3), SAKULIBM, Drivers Badge, Mechanics Badge and the Distinguished Ordnance Order of Samuel Sharpe. In addition, she also has Bronze, Silver, and Gold levels of the Honorable Order of the Eagle Rising from the National Level of the United States Army Warrant Officer Association.

Mentorship: "I Believe in People! When we learn people, we teach excellence."
She is the Lead Senior Advisor to the Department of the Army Women's Mentorship Network, Ft. Lee Chapter, founder of WOW, Warrant Officer Women's Mentorship Group, Lifetime member of the United States Army Warrant Officers Association Crater Chapter and the Army Ordnance Corps.
Family: CW5 Woodyard has two children, SPC Nestle' Danielle Woodyard, 42A, United States Army, Fort Bliss, Texas and Devaughn Najee Woodyard, graduate of Baylor University living in Austin, Texas working as a Logistics manager. Her four brothers and sisters also all served in the United States Army and Navy.

Military Assignments: (LIST)
2015 – Current Team Lead, Ord Leader Development Branch, G357, CASCOM School of Excellence, Fort Lee, Virginia
2014 – 2015 Director, of Ordnance Warrant Officer Training Army Logistics University, Technical Logistics College, Fort Lee, Virginia
2011 – 2014 Senior Ordnance logistics Officer III CORPS, G4, Materiel Readiness Branch, Fort Hood, Texas
2006-2011 Regimental Maintenance Officer 3rd Armored Cavalry Regiment, Fort Hood, Texas
2005-2006 45th Sustainment Brigade, 25th Infantry Division, Schofield Barracks, HawaiiMATO
2004-2005 DISCOM, 25th Infantry Division, Schofield Barracks, Hawaii
2003-2004 62nd Air Defense Artillery, 25th Infantry Division, Schofield Barracks, Hawaii
1999 – 2003 20th Engineer Brigade, 30th Engineer Topographic Battalion, 18th ABN, Fort Bragg, North Carolina
1998 – 1999 58th Maintenance, General Support, COSCOM Fort Bragg, North Carolina
1998 – 1998 COSCOM, 39th Ordnance Company Missile Maintenance Company, Fort Bragg, North Carolina
1997-1998 102nd Military Intelligence Battalion, 2nd Infantry Division, Korea

1992-1996 HHC DISCOM, 24th Infantry Division (3rd ID), Fort Stewart, Georgia
1991-1992 123rd Support Battalion, 1st Armored Division, Germany, Monteith Barracks
1991 – 1991 H8, Advanced Skill Identifier Recovery School
1990 – 1991 63B Advanced Individual Training, Fort Dix New Jersey
1989 - 1990 Basic Training, Fort Dix New Jersey

Deployments:
1990 – 1991 Desert Shield/ Desert Storm
2007- 2009 Operation Iraqi Freedom, Mosul Iraq

Military and Professional Education:
1989 Basic Training Fort Dix, NJ,
1990 Advance Individual Training, Fort Dix, New Jersey
1990 ASI H8 Recovery School, Fort Dix, New Jersey
1993 Primary Leadership Development Course, Fort Stewart Georgia
1995 Basic Non-Commissioned Officers Course, Aberdeen Proving Grounds, Maryland
1996 Warrant Officer Candidate Course, Fort Rucker Alabama
1996 Warrant Officer Basic Course, Aberdeen Proving Grounds Maryland
2003 Warrant Officers Advance Course, Aberdeen Proving Ground Maryland
2006 Warrant Officer Staff Course, Fort Rucker, Alabama
2010 Warrant Officer Senior Staff Course, Fort Rucker, Alabama
CW5 Woodyard has earned Several Additional Skill Identifiers throughout her career
3C – operational contract support, 8 – Instructor, 7Q – Developer
She has also completed many professional course including Operation Contracting Support, Project Management Professional, and Lean Six Sigma, Army Basic Instructor Course, Instructional Design Basic Course, Blackboard Construction, Test Construction, System Approach to Training, Logistics Assistance Program Operations Course (and a variety of training development and facilitation courses.

Military Intelligence Corps 2009 Hall of Fame inductee

Chief Warrant Officer Three Doris I. Allen, U.S. Army, Retired

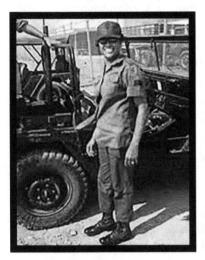

Chief Warrant Officer Three Doris I. "Lucki" Allen, a native of El Paso, Texas, enlisted into the Women's Army Corp through Jackson, Mississippi in late 1950. She completed basic, then advanced training, as an Entertainment Specialist at the Adjutant General School in 1951 at Fort Lee, Virginia. She spent a few months at the Presidio of San Francisco, California and Fort Lewis, Washington before going overseas. Private First Class Allen served for a year and half as an Entertainment Specialist organizing Soldier shows and as the Editor of the Military Newspaper for the Army Occupation Forces in support of the Korean War in Camp Sendai, Japan.

Upon returning Corporal Allen was assigned as a radio broadcast specialist at Camp Stoneman in California. After the closing of Camp Stoneman, Specialist Five Allen was assigned to Oakland Army Base, California and then attended the Armed Forces Information School at Fort Slocum, New York for the Information Specialist course. In 1956, SP5 Allen returned to Japan and served as a Public Information Officer and Newspaper Editor. After two years in Japan, she returned to the U.S. and served as an Information Specialist. From 1958, she served for five years as an Information Specialist for the Headquarters at Fort Monmouth. After completing French language training at DLI in 1963, SP5 Allen became the first military female trained in a Prisoner of War Interrogation course at the U.S. Army Intelligence School, Fort Holabird.

Upon the completion, she was assigned as an interrogator to Headquarters, U.S. Continental Army Command Intelligence Center,

Fort Bragg. For the next two years she would serve as the sole strategic intelligence analyst covering Latin America affairs until 1965. While at Fort Bragg, and as one of only 22 persons in the entire Armed Forces to hold that rank, Specialist Seven Allen completed interrogation and intelligence analyst courses where she was the honor graduate in three consecutive courses conducted by the Third U.S. Army Area Intelligence School in 1967.

SP7 Allen would then report to Vietnam and serve as the Senior Intelligence Analyst, Army Operations Center, Headquarters, U.S. Army (USARV) at Long Binh, Vietnam. While in Vietnam she started her second tour and held the position of Supervisor, Security Division, Office of the Assistant Chief of Staff, Security, Plans, and Operations, Headquarters, 1st Logistical Command, Vietnam. In the Spring of 1970 she would be appointed as a Warrant Officer. She was then one of only nine female warrant officers in MI and one of only 23 in the entire Army at the time.

WO Allen began her third consecutive tour in Vietnam in March 1970 as the Officer in Charge of the Translation Branch, Combined Document Exploitation Center-MACV, Saigon, Vietnam. Despite not being able to speak Vietnamese, WO Allen supervised approximately 40 South Vietnamese nationals employed in the translation of the large amount of captured enemy documents brought to the center on a daily basis. Her loyalty, diligence, and devotion in all of her assignments in Vietnam earned her the Bronze Star with 2 Oak Leaf clusters. Returning to the U.S. from Vietnam in September 1970, she would serve as an Instructor for Prisoner of War Interrogations, Army Intelligence Center and School, Fort Holabird and moved with the school in 1971 to Fort Huachuca. After completing the CI Transition Course in 1971, WO Allen returned to DLI where she completed the German course.

After a stint with the intelligence unit at the Presidio of San Francisco, Chief Warrant Officer Two Allen was sent overseas. Her follow on assignment was as a Special Agent with the 527th MI Brigade, Federal Republic of Germany. In 1977, CW2 Allen reported to the INSCOM's CI and Signal Security Battalion, Presidio of San

Francisco, where she worked as the Senior CI Agent and Security Manager. While at the Presidio, CW2 Allen would be promoted to Chief Warrant Officer Three in 1978. CW3 Allen retired after a distinguished 30 year career in 1980.

Chief Warrant Officer Three Allen's awards and decorations include the Bronze Star (2 OLCs), Meritorious Service Medal, Army Commendation Medal, Good Conduct Medal (6th award), Army of the Occupation Medal (Japan), National Defense Service Medal (1 OLC), (10 Campaigns), United Nations Service Medal, the Republic of Vietnam Campaign Medal, the Korean Service Medal, Presidential Unit Citation, Meritorious Unit Commendation, and the Vietnam Cross of Gallantry with Palm.

African American Army Reserve Female Warrant Officers: Technical Experts, Combat Leaders, Trainers and Advisors

By Farrell J. Chiles

(March 2007)

"**A** warrant officer is a self –aware and adaptive technical expert, combat leader, trainer, and advisor. Through progressive levels of expertise in assignments, training, and education, the warrant officer administers, manages, maintains, operates and integrates Army systems and equipment across the full spectrum of Army operations." That's the definition in the Department of Army's Pamphlet 600-3.

African American Army Reserve female warrant officers are validating the definition. They perform duties in specific military occupational specialties comprising many branches to include: Personnel, Legal, Maintenance, Quartermaster, Aviation, Transportation, Signal, Military Police, and Military Intelligence.

Among female warrant offices in the Army Reserve, a Defense Manpower Data Center Report dated March 2004, showed that there were 100 African American female warrant officers in a total group of 326. That number represented 30.7% of female warrant officers, while white female warrant offices were at 192 and 58.9%. More significantly was the number of junior female warrant officers (WO1) for African American females at 44.7% compared to white females at 42.1%. These numbers mean that an increasing number of African American female soldiers are opting to become warrant officers and are flooding the pipeline to become senior warrant officers.

The Army Reserve has two basic types of warrant officer service. Active Guard Reserve (AGR) warrant officers serve full time and receive benefits and entitlements of Active Duty Soldiers, including full pay, medical care for themselves and their immediate family, and opportunity for retirement after 20 years of Active Service. Troop Program Unit (TPU) soldiers are members of the Selective Reserve Program. Traditionally, these soldiers have civilian careers while they continue to train near their homes and serve their county. TPU soldiers

typically train on weekends and perform annual training. Other warrant officers serve in the Individual Mobilization Augmentee (IMA) Program or in the Individual Ready Reserve (IRR).

AGR Warrant Officer

When **Polly Milton-Cheeks** joined the Army Reserve on June 19, 1978, she didn't even know what a warrant officer was. She completed basic training and her advanced individual training at Fort Jackson, South Carolina and went off to her first duty assignment at Fort Hood, Texas with the Headquarters III Corps with detail at the HHC, Adjutant General Transfer Point. She was selected to participate in a Field Training Exercise – Fort Hood, TASK Force '80 that took place in Kaiserslautern, Germany with Headquarters, 7th Army Reserve Command, Heidelberg, Germany.

Her first overseas assignment was a one year tour at Camp Humphrey, Korea from July 1982 to June 1983 with the Post Medical and Dental Unit serving as a military personnel action specialist.

Milton-Cheeks reflected, "During my assignment in Korea, I worked with a chief warrant officer three. I was influenced by him. He explained that the warrant officer career field was higher than the enlisted field with benefits of an officer and that the promotion systems was better than both enlisted and office. Warrant Officers are the specialists in their area of expertise and being in the Adjutant General Corps, it's important to have good people skills".

After her release from active duty in 1985, Milton-Meeks was assigned to the United States Army Mobilization Support Detachment (Troop Program Unit) in St. Louis, Missouri as a personnel management specialist. In 1989, she was selected as a warrant officer candidate. Upon completion of the Warrant Officer basic Course, Milton-Cheeks entered the AGR program with the 102nd Army Reserve Command (ARCOM). Her next assignment was with the Army Reserve Personnel Center, followed by assignment at the 3rd Personnel Command (PERSCOM) in Jackson, Mississippi.

Milton-Cheeks has participated in the 3rd PERSCOM Bright Star Field Training Exercise in Cairo, Egypt and from February 2003 –

March 2004 was deployed to Kuwait as the senior Personnel Administrative Staff Office and Advisor for all units in Theatre support of Operation Iraqi Freedom (OIF). CW4 Milton-Cheeks is currently assigned to the 89th Regional Readiness Command in Wichita, Kansas, serving as the manager of the Full Time Staff (FTS) Management and the Special Actions Branch. She is a graduate of the Battalion Training Management System Course, the senior Military Personnel Records Course, and the Warrant Officer Advanced Course. Her awards include two Meritorious Service Medals, four Army Commendation Medals, two Army Achievement Medals, the Global War Terrorism Service Medal, and the Global War Terrorism Expeditionary Medal, among others.

When asked if she ever served or worked with other African American warrant officers, Milton-Cheeks replied, "I served with CW4 (Retired) Willie Charles Piggee who wrote my entry letter. We served together from 1985 to 1995 and Mr. Piggee was my mentor and guide into the officer world. I worked with CW4 Martha Ervin for a short time and stayed in touch by providing advice, sharing information, and keeping me updated on current Army Regulations".

TPU Warrant Officers

Mary Carter began her Army career by joining the Army Women Corps (WACs) in November 1966. She received a direct appointment as a warrant officer in1984. Her warrant officer assignments include duty with the 349th General Hospital in Los Angeles, California; the 6222nd United States Army Reserve School, Pasadena, CA; 6218th Reception Battalion, Bell, CA; the 63rd Regional Readiness Command, Los Alamitos, CA; and with the 104th Training Division in Pasadena, CA. CW4 Carter is a Personnel Manager with the County of Los Angeles. She has a Master's Degree in Public Administration from California State University – Dominquez Hills. Chief Carter served on the Board of Directors of the United States Army Warrant Officers Association for four years and was selected as the CW4 Albert M. Holcombe Warrant Officer of the

Year in 1994. Ms. Carter is currently mobilized and stationed at Fort Riley, Kansas.

Belynda Lindsey joined the Army in 1986 and was assigned to the 78th Legal Support Organization as a legal specialist. She became a JAG warrant officer in 1994 after completing the Warrant Officer Candidate Course at Fort McCoy, Wisconsin and her Basic Course at the JAG School in Charlottesville, Virginia. In her civilian capacity, she is a senior investigator for the Equal Opportunity Commission, Los Angeles District Office. In 2006, CW3 Lindsey was cross-leveled with an active duty unit, the Headquarters, Headquarters Company (HHC), 13th Sustainment Command (Expeditionary) at Fort Hood, Texas with deployment to Anaconda, Balad, Iraq.

Lindsey states, "I have many missions that take up my time. The missions include: coordinating a JAG Conference; naturalization ceremonies, officer evaluation reports, awards, and issues regarding the building and other contracts that I must manage, besides personnel issues".

She further states, "I am not exaggerating when I tell you that about 97% of what I do is new to me. And, there is no one else her to assist me because there is only one JAG office in Iraq. I am the only legal administrator. So, not even anyone in my office can assist me, even though they have been deployed before. And every mission that I have received, I have achieved".

CW4 Ida Tyree Hyche has excelled professionally as a warrant officer and as a federal civilian. Ms. Tyree Hyche graduated Magna Cum Laude from Stillman College in Tuscaloosa, Alabama and then earned her Juris Doctorate degree from the Birmingham School of Law in Birmingham, Alabama. With over 24 years in the federal civil service, she is employed as a Supervisory Human Resources Management & Labor Relations Specialist for the 81st Regional Readiness Command and Chief, Personnel Management Division.

Tyree Hyche is a graduate of the Personnel Management Course, Warrant Officer Advanced Course, Warrant Officer Staff Course, the Staff Judge Advocate's Course for Federal Labor Relations, Staff

Officer Course, and the Organizational Leadership Course for Executives.

Tyree Hyche was a member of the last basic training course that was segregated by gender. Suring the Chief's twenty-seven years in the Army Reserve, she has served as a Military Personnel Technician, Mobilization Readiness Branch Officer, and Action Officer in the Personnel Management Branch of the 81st Regional Readiness Command. Ms. Tyree Hyche has had an additional assignment as a Replacement Operation Personnel Warrant Officer for the 3rd Personnel Command in Jackson, Mississippi.

CW4 Tyree Hyche was selected as the Reserve Officers Association's CW4 Michael Novosel Warrant Officer of the Year in January 2000. She served as Assistant Vice President for Reserve Affairs of the United States Army Warrant Officers Association for two years (2003-2004). In January 2007, CW4 Tyree Hyche was mobilized for Operation Iraqi Freedom with assignment in Kuwait.

CW4 Rowmell Hughes enlisted in the Women Army Corps in May 1970. She attended basic training and advanced individual training at Fort McClellan Army Base, Anniston, Alabama. At that time, Fort McClellan was the only base where female soldiers were trained. Hughes spent the next three years of active duty stationed at the Oakland Army Base, California where she served as a personnel specialist. Immediately after discharge from active duty, she joined the Army Reserve and continues to serve.

In 1989, Hughes applied and was accepted into the warrant officer candidate program After completing the warrant officer tactical course at Fort McCoy, Wisconsin, and the warrant officer technical course at Fort Benjamin Harrison, Indiana, she was appoint as a warrant officer in the Adjutant General Corps in August 1989. She was assigned and served as a Military Personnel Warrant Officer with the 319th Transportation Brigade, Oakland, California until September 1993. In October 1993, Chief Hughes transferred to the 2nd Medical Brigade, San Pablo, California where she is currently serving.

Ms. Hughes, in her civilian capacity, is employed as the Supervisory Staff Administrator for the 2nd Medical Brigade, a

General Officer Command. She represents the commander and is responsible for the daily operations of an organization that encompass the western states (CA, NC, AZ, MT, CO, UT and Washington). She serves as the senior brigade full time civilian with supervisory responsibility for full time support (FTS) personnel (military and civilian). With a staff of approximately 300 FTS, she provides support to 6,000 soldiers in the areas of personnel, logistics, and training comprising of 48 different units in the western medical region.

Chief Hughes' duty assignments as a warrant officer have provided her the opportunity to travel extensively in the United States and abroad. She has served short tours in Japan, Korea, Okinawa, and most recently in Iraq. In 2004, CW4 Hughes was cross-leveled to the 376th Personnel Service Battalion out of Long Beach, California and subsequently deployed to Iraq. While in Iraq, she was assigned to Forwarding Operating Base (FOB) Speicher in Tikrit. There she served as Human Resources Technician and Detachment Executive Officer. The Detachment was responsible for providing personnel services to approximately 5,000 soldiers and civilians at five Forwarding Operating Bases in Northern Iraq. CW4 Hughes returned to her current assignment with the 2nd Medical Brigade in December 2005.

Ms. Hughes has attended and completed a wide variety of civilian and military schools. She is a graduate of the Army Organizational Leadership Course for Executives and the Army Supervisors and Managers Course. She is authorized to wear the Superior Service Medal for outstanding service as a civilian. In October 2002, she received the United States Army's Citation Award for Exceptional Service. This award was presented to Ms. Hughes by the former Army Vice Chief of Staff. In 2005, she was presented with the Reserve Officers Association Department of California's CW3 James H. Witcher Outstanding Warrant Officer of the Year Award.

Her military awards and decorations include the Meritorious Service Medal. Army Commendation Medal, Army Achievement Medal, Good Conduct Medal, Army Reserve Component Achievement Medal, Armed Forces Service Medal, NCO Professional Development, National Defense Service Medal, Army Service Ribbon,

Global War on Terrorism Service Medal and the Iraq Campaign Medal.

CW4 Hughes comments regarding her experience in Iraq, "A very long year, a very long time to be away from your family and friends. Having to adjust to a life style of inconveniences, loneliness', and living in fear of life was quite a challenge. In retrospect, what a journey and experience for me, one that I will never forget. Although, there were many sacrifices, this journey took me to places I would never ever dream of visiting. Imagine sitting or standing on the bank of the biblical Tigris River or walking the halls of former Iraqi regime Palaces near Tikrit Iraq".

CW3 (Retired) Roxana Beattie joined the Army Women Corps in 1976 as an active Army Reserve, Troop Program Unit member of the 445th Civil Affairs unit, Oakland Army Base, Oakland, California.

In 1988, while assigned as a Senior Supply and Retention NCO, with the 353rd Psychological Operations Battalion, Presidio of San Francisco, California, she was accepted as a warrant officer candidate. After completing the tactical first phase Warrant Officer Entry Course, Fort McCoy, Wisconsin and the technical Warrant Officer Basic Course at Fort Lee, Virginia, Md. Beattie was appointed a Quartermaster Corps Warrant Officer in 1990. Her initial assignment was as a property book officer and a long list of additional duties with the 801st Engineer Port Construction Company, Oakland, California. In 1994, she transferred to the 55th Materiel Management Center (MMC), Fort Belvoir, Virginia / 55th Theater Support Command (TSC), Eighth Army, Korea. In 1996, Chief Warrant Officer Beattie was mobilized with NATO-IFOR, Operation Joint Endeavor, Bosnia.

Ms. Beattie attended and completed a wide variety of civilian and military schools in her 28 years of service. Without a break in service, she retired in 2004.

Beattie's military awards and decorations include the Meritorious Service Medal, Army Commendation Medal with four oak leaf clusters, Army Achievement Medal with two oak leaf clusters, Armed Forces Service Medal, Humanitarian Service Medal, NCO Professional (#3), National Defense Service Medal with Bronze Hour

glass, Armed Forces Reserve Medal with Silver Hour glass, Armed Forces Reserve Medal with "M" device, Army Service Ribbon, Army Reserve Component Overseas training Ribbon (#2), NATO Medal, and the Army Forces Expeditionary Medal.

Ms. Beattie has had a distinguished career in the federal service with the Department of Defense and is currently employed in Northern Virginia. *

Leading the Way

Army Reserve African American female warrant officers have exhibited leadership qualities that have propelled them well above their peers. They joined the military for different reasons. Each has had successful civilian careers in addition to their outstanding military careers. They set the example by fostering mentorship and relationship building. Each has dedicated their lives in support of Army goals and in defense of our country. Each has responded to the call of duty and deployed as ordered. Hey serve with honor. They are pioneers for all African American females. They are the role models for enlisted, officers, and other warrant officers to emulate.

African American female warrant officers in the Army Reserve – the Quiet Professionals – Making a Difference.

* CW3 (Retired) Roxanna Beattie died in July 2009 in Woodbridge, Virginia.

Women Warrant Officer History - Signal Branch

In 1968, the Army Signal Branch had two women assigned as Warrant Officers. It would be nearly 30 years before Signal Branch promotes a woman to CW5. Deborah Jones was the first woman to achieve the rank of CW5 in the Signal Branch on active duty in 1995/1996. In 2003, **Joyce E. Morris** was the first African American woman to achieve the rank of CW5 in the Signal Branch on active duty.

CW5 Selvina H. Wasson assumed responsibilities as the Senior Signal Warrant Officer Advisor—United States Army Reserve (USAR) for Signal Warrant Officers in 2018 at the U.S. Army Signal School, Fort Gordon, GA. She is the first African American of Hispanic decent and female to achieve the rank of CW5 in the Signal Branch for the USAR. As of 2019, Signal Branch has four Military Occupational Specialties (MOS): 255A, Information Services Technician; 255N, Network Management Technician; 255S, Information Protection Technician; and 255Z, Senior Network Operations Technician.

Questions and Answers

1. What influenced you to become a Warrant Officer?

During a deployment with the ARCENT Legal Team, I was afforded mentorship from many different leaders, including the Chief Paralegal NCO, the Legal Administrator and the Deputy Staff Judge Advocate. These leaders encouraged me to pursue the warrant officer ranks due to my civilian educational background, work ethic, organizational skills, networking capabilities and professionalism. Additionally, as I climbed through the ranks in the National Guard as an enlisted Paralegal Soldier, I was determined to be the Warrant Officer that I needed when I was an enlisted Paralegal Soldier. I was, and have been, determined to be the champion of Paralegal Soldiers throughout the National Guard. – **WO1 Alana Alamon-Scott**

As SPC Small in 1986, during a field exercise at Fort Bragg, North Carolina, I was very impressed by CW5 Strickland; not sure if he was a 920A Property Book Officer or 920B, but his knowledge of logistic at our LSA (Logistic Staging Area) was outstanding. He knew what was on ground and the distribution of it. He also had the attention of the CPTs and MAJ that he worked with. His work ethic was never questioned. He was often sought out for guidance. I knew then that I wanted to be just like him; Warrant Officer in logistic. I have achieved that goal and I know that my professional and personal character lead other into the Warrant Officer Corps. – **CW5 Sherill D. Small**

When I first came into the Army my first duty station was Ft. Hood, Texas as a 63B light wheel vehicle Mechanic. I was stationed to the 13th COSCOM. My Maintenance Tech had us working on third shop level equipment and he took me under his wing and he told me I could become a Warrant Officer because I already had my degree. I wanted to really become an officer and I saw that as a Warrant Officer you had the best of both worlds; you were the subject matter expert; and you always had the Commanders ear. Unfortunately, I had to wait

until I made E-5 (SGT) before I could apply, but while I was patiently waiting, I learned my skill set and perfected it as much as I could. I then went to Desert Storm / Desert Shield where I went to the board and made E-5 in the Desert. During this time, I had my first evaluation and I did really well on it. I had to get at least three or four evaluations under my belt before I could create a packet. The ground war didn't last that long and I made it back to Ft. Hood to reenlist for duty assignment of choice and I PCS'd to Ft. Stewart GA. It was at this time I was assigned to 44th Medical and my Mentor at the time was CW2 Dudley Moering who took me under his wing to help me get ready for Warrant Officer School. Also, it was at this time, I had made E-6 (SSG). I finally took the leap and put my Warrant Officer Packet together and sent it off. The first time it was accepted and I had a school date to report to candidate school. I had heard all of the stories of school and what to expect but my mentor just reassured me it was only for six weeks. So, I have really had great mentors who have influenced me to go on to the next level of my career even before I made that decision to become a warrant Officer. I guess someone saw something in me as a leader to go to the next level in my career and I am glad I took advantage of the opportunity to make a difference in the United States Army. I strive to really make a difference to help those along the way and afford the opportunity of becoming a Warrant Officer. I am just passing it forward. Something someone once did for me. – **CW5 Kimberly L. Bonville, Ret.**

I wanted more out of the Army, life and myself. A former W4 inspired me as a female Soldier to challenge myself and follow my dreams. – **CW5 Selvina H. Wasson**

2. What was your greatest accomplishment as a Warrant Officer?

In the two years since becoming a Warrant Officer, I have been exceptionally blessed. Upon my return from my basic course, my State Command Chief Warrant Officer tasked me with the legal research pertinent to the development of the Warrant Officer Cohort which was

presented to the Commanding General of Colombia, our State Partnership Program Country. Immediately following this, the State Command Chief Warrant Officer tasked me with legally researching incentive payments for NCOs who access to become Warrant Officer while in a Military Technician Status. Another research project was the modernization of the Army Aviation Career Incentive Bonus Payments, which highlighted the disparities for Aviators to achieve the required flight hours as well as incentives for all Aviators. However, since the career management of Paralegal Soldiers was my primary interest, I worked on a statewide consolidated legal office project which included promotion opportunities for the Paralegal Soldiers and recently learned that my project received endorsement from the Commanding General of the South Carolina Army National Guard and his Deputy Commanding General. This, by far, is my greatest personal accomplishment. – **WO1 Alana Alamon-Scott**

As a very knowledgeable logistician, I pride myself in knowing my craft and I expected other to know theirs. But until I became an instructor at Fort Knox, Kentucky, I did not realize how little some Soldiers and Civilians knew. I quickly learned that some commands did not provide additional training and a lot of incorrect knowledge was being passed along. As an instructor, passing along correct policy and procedures to Soldiers and Civilians was very rewarding. To see in their faces when they understood a process or comprehended a procedure was an extraordinary feeling; it was the greatest accomplishment. – **CW5 Sherill D. Small**

I think my greatest accomplishment as a Warrant Officer was making CW5 as the Second African American Female 915E when I didn't think that I had it in me to make it especially, in a MOS where it was a male dominated field. Again, my mentor CW5 (R) Harold Deberry saw something in me that I didn't see. At this time, I was interviewing for a job and have the opportunity to teach at the USSAOMS. During the interview, CW5 Deberry asked me where did I see myself in the next ten years. Keep in mind, I had just finished WOAC course and I had pinned CW3 at Fort Carson Colorado. I told him "well Sir, I see

myself as a CW4 and nothing more" he said "Well, I see more for you". Shortly after that, I was told I had been accepted to teach at the USSAOMS School and I PCS'd from Ft. Carson Colorado to Aberdeen Proving Ground, Maryland within a short period of time. While I there teaching, my records were looked at and I made CW4 915E. My three years were up and it was time for me to PCS, so I accepted an assignment to Kuwait where I was the DOL at Camp Buerhing and I really saw a different part of the country instead of being deployed there I was stationed there and I actually liked it. After a year, I PCS'd to Hawaii. I stayed three years and decided to extend but, the opportunity came up as the Senior Logistics Ordnance Officer at the United States Army Test and Evaluation Command - a CW5 slot. I jumped at the opportunity. I called my branch manager I told him if nobody took the assignment. I would like to have it. Well, I got orders reassigning me to Aberdeen Proving Ground at the USARMY Test and Evaluation Command. Wow, this was truly an opportunity of a life time. This unit was a Direct Reporting Unit to the Office of Secretary of Defense so I sat on different projects and I wrote different reports that went directly to the Office of the Secretary of Defense and decisions were made to accept that report and implement the changes for the Army. So I think the greatest accomplishment is becoming a Chief Warrant Officer 5 and also being the first African American Female CW5 915E in the Army to work at the United States Army Test and Evaluation Command. **– CW5 Kimberly L. Bonville, Ret.**

Leave a legacy to my children. I am the "first African American of Hispanic Descent and woman to achieve the rank of CW5 in the Signal Branch of the USAR" and the first Warrant Officer in the family. - **CW5 Selvina H. Wasson**

3. What was your best Warrant Officer assignment? Why?

In my two years as a Warrant Officer, I have been in two very different assignments: full time Legal Administrator of the South Carolina Army National Guard and Legal Administrator of the Army

National Guard Trial Defense Service. Both roles have presented unique challenges and opportunities. I certainly appreciate the learning experiences both positions afforded me. – **WO1 Alana Alamon-Scott**

My best assignment was as an instructor at Fort Knox, Kentucky. When you realize you have the ability and opportunity to shape individual knowledge and character; it is empowering. When I and former students cross paths, and to hear how I have added value to their careers lets me know that I have taken the correct career path. I have done something that matters. I have made a difference. – **CW5 Sherill D. Small**

I think I have two assignments that were the best. The first one was Kuwait. I was assigned as the Senior Logistics Officer for the Directorate of Logistics in Camp Buehring. The last time I was in Kuwait in 2003, I was deployed getting ready to move forward into Iraq. But this time in 2008, I was stationed there and I had a different outlook of this beautiful city. During this assignment, I was in charge of the Logistics in whole base camp so everybody will come through us to open up accounts. Also, I was the Contracting Officer Representative for the maintenance of the Combat Support Services Contract-Kuwait contract valued at $200M which included 300 government contracted employees. I was the Project manager and logistical liaison for the Bradley Reactive Armor Tile kits installation for the Bradley Fighting Vehicles. I provided coordination of maintenance support to all of the units stationed in or passing through Camp Buehring, Kuwait in support of Operations Iraqi Freedom and Global War on Terrorism. I served as the Contracting Officer and I helped to developed statements of work, Performance Work Statements and acquisition packets in support of mission requirements. I provided technical advice and assistance to assess the capabilities, limitation and deficiencies of the contractual maintenance support and Class IX supply activities. I developed, revised quality assurance surveillance plan generation adherence, contract oversight/compliance and audit assessments. I developed briefing as and orientations to units during planning conferences and Reception, Staging, Onward

Movement and Integration (RSOI). I served as the principal briefer to newcomers and visitors. So I got a chance to meet people from different units and some of my students that was really special to me to know that I have given them the tools for their tool box to survive out there on the battle field as young Warrant Officers. The other assignment was at the Aberdeen Proving Ground Maryland USAOMMS where I was an instructor/writer, curriculum developer and facilitator for the Warrant Officer Advanced and Warrant Officer Basic course at the United States Army Ordnance Center and Schools. I conducted training, managed, mentored, counseled and evaluated Warrant Officer Students attending their resident training courses. I was directly responsible for the technical instruction in the principles, theory and functioning, operational characteristics, and diagnostic/troubleshooting of complex systems. I served as the accreditation officer for overall responsible for the department requirements, review and organization for the Combined Arms Center/TRADOC institution accreditation. Responsible of the success of the integrated detailed systemic procedure to insure all areas of instruction and administration met the stringent regulatory guidelines, resulting in the Warrant Officer Education system of the USOC&S receiving a rating of "Fully Accredited" with no significant deficiencies. This was a humbling experience and assignment. I enjoyed every bit of teaching. Also, during this tenure I got a chance to work with some really great mentors who taught me how to really groom my skill set and bloom like a butterfly. All of my mentors had an impact on my career in positive way so much they influenced me to stay in and make CW5. – **CW5 Kimberly L. Bonville, Ret.**

My best assignment is the one I currently hold, Senior Signal WO Advisor – United States Army Reserve (USAR) for Cyber/signal Warrant Officers in 2018 at the U.S Army Signal School, Fort Gordon, Georgia. I've returned to where my Signal career began. The position enables me to affect the lives of young Soldiers in a way that will inspire them to attain the maximum out of their military career and also, as citizen Soldiers. - **CW5 Selvina H. Wasson**

4. How would you summarize your career?

This is a very interesting question. I feel as though I am at a pivotal decision making point in my Warrant Officer career. While my journey began with two really great years and a delayed promotion, I am seriously considering whether to stay beyond four years. In four years, I will have accumulated 20 combined years of service, 10 of which will be active federal service. So, in a word, I would summarize my career to this point as vibrant. – **WO1 Alana Alamon-Scott**

I would sum up my career as a job well done. I joined the military as an Enlisted Soldier; as a single parent; and needed the financial side. I stayed because I fell in love with the organization. I love and respect the structure of the military. Meeting other Soldiers and Civilians from different backgrounds help shaped my leadership skills, knowledge and character. It has provided what I needed for my family and for my personal growth. I would not change a thing; not even the when things weren't so good; that added to growth. – **CW5 Sherill D. Small**

Overall, my 30 year career as a Warrant Officer, a leader, and Subject Matter Expert were the best, and I cannot complain about the decision I made back in 1988 of entertaining the thought of becoming a Warrant Officer. This has been the best decision I could have ever made - the people I have met and the places and assignments I have been on. I would truly do it all over again if I had the chance. I am truly honored to have been blessed with the decision of becoming a Warrant Officer.

I would like to thank my parents, James and Daisy Geartin, for being my first mentors and standing behind me in all of my endeavors throughout my military career and my first foundation. – **CW5 Kimberly L. Bonville, Ret.**

The best decision I've ever made was to join the Army Reserve and now the Active Guard Reserve. My career summarized is "I've been all

that I can be and blessed to attain the highest rank as a Warrant Officer; but more importantly, I've been able to mentor many Soldiers and blessed to see the fruit of such mentoring materialized in this lifetime." Doing for others what I did not receive is perhaps the greatest accomplishment of my career. - **CW5 Selvina H. Wasson**

Other Notable African American Women Warrant Officers

Lavonia Bass, CWO4, USCGR. Became the first African American Woman to be promoted to CWO in the Coast Guard Reserve when she was promoted to CWO2 in June 1991.

Marie Blanding, WO1, South Carolina Army National Guard.

Tammy Brooks, CW3, Army National Guard.

Cyntranelle J. Brown, CW4, USAR.

Dee Dee Shantell Chavers, CW2, U.S. Army. Retired on November 1, 1995.

Delores Cooley, CW4, National Service Officer, Military Order of the Purple Heart

Mechelle Cunningham, CW4, Active Guard & Reserve (AGR).

Ernestine Ebbs, CW3, Delaware Army National Guard.

Rita Bell Eubanks, CW4, Active Guard & Reserve (AGR), Retired.

Sharon Gibbs, CW4, U.S. Army, Retired. Served in Iraq and Kuwait.

Juliette Anita Hallman, CW3, USAR, Retired.

Lila Holley, CW4, U.S. Army, Retired. Author – "Camouflaged Sisters: Silent No More!"

Angelique Hoskins, CW4, U.S. Army, Commander, 1st Warrant Officer Company

Laquitta Joseph, CW4, U.S. Army, Retired (2010), Material Maintenance Technician/Supervisor.

Ruth N. Kelly, CW4, Active Guard & Reserve (AGR), Retired.

Rosa L. King, CW3, U.S., Army Retired.

Nathanette Perry, CW4, Georgia National Guard.

Yolanda Peterson, CW2, U.S. Army.

Brenda Phillips Payne-White, CW2, Kentucky National Guard, Retired.

Alice Reid, CW2, U.S. Army. Former National Treasurer, United States Army Warrant Officers Association.

Katharin Rice-Gillis, CW2, U.S. Army, Retired. First African American Woman Warrant Officer to successfully pass the marine deck officer school.

Roberta Sheffield, CW5, U.S. Army, Retired

Lynda Smith, Ph.D., CW3, U.S. Army, Active Guard and Reserve (AGR), Retired.

Esther W. Steward, CW4, U.S. Army, Retired (Deceased). According to a study in 1963, she was the only African American woman warrant officer on active duty. Ms. Steward served in Vietnam as a cryptographic technician.

Joy Y. Teagle, CW5, National Guard Bureau. Former Secretary, United States Army Warrant Officers Association (1996-1998).

Rennee "Nae" Townsend, WO1, U.S. Army, Retired.

Edryce N. Tucker, CW3, U.S. Army, Retired, Deployed for Operation Desert Shield/Desert Storm.

Rhonda Faye Watson, CW2, U.S. Army, Retired.

Marcia E. (Sierra) Williams, CW4, U.S. Army; Appointed CW2 on February 14, 1986, Retired.

Andria Louise Wimberly, CW2, Retired, New Jersey Army National Guard.

Julia A. (Reece) Woods, CW2, U.S. Army, Retired. Final assignment with the Joint Field Support Center, Defense Intelligence Agency.

Salute / Shout Out to Our Sister Warrant Officers

Since 1988, I have closely watched the rise and development of African American Women Warrant Officers from Warrant Officer One to Chief Warrant Officer Five. They have set very high standards and greatly improved the lives of everyone around them while serving with distinction, admiration and pride. It's their time!

It's their time! When given the opportunity, the African American Women Warrant Officer greatly improved the lives of everyone around them with superb duty performance, honor, dignity and respect. **- CW5R Rufus N. Montgomery**

I just wanted to say that becoming a Warrant Officer is the best decision I could have made personally and professionally. My love of knowledge and my appetite to share that knowledge inspired my decision. I can count on one hand how many of us I have come across especially in my MOS, which is why I talk proudly and encourage all African American Females who show interest, to join. We are stronger than we give ourselves credit for, so let's continue to step up and prove ourselves. **- WO1 Latania McCook**

Conclusion

African American Women Warrant Officers are a unique group of military warriors. Given the opportunity, they have excelled at every level of the Warrant Officer echelon. They have served in Vietnam, Desert Storm, Desert Shield, Iraq, Afghanistan, and other places around the world. They are continually demonstrating their patriotism and loyalty to the United States.

African American Women Warrant Officers have served as Command Chief Warrant Officers in the National Guard and Army Reserve. They have served as TAC Officers and instructors at the Warrant Officer Career College and served in Senior Warrant Officer Positions at the MACOM levels.

These "Quiet Professionals ®" are definitely the New Trailblazers in the Warrant Officer Cohort today. Whether serving in the Army, Navy, Marines, or Coast Guard, they have demonstrated remarkable leadership and their accomplishments are noteworthy.

This book presented just a small representation of HerStory. There are many more stories and hopefully they will continue to be told.

I thank the African American Women Warrant Officers who shared their biographies and accomplishments for the book.

To all African American Women Warrant Officers – I salute you.

Index

About the Author

FARRELL J. CHILES, Cultural Historian, is a Vietnam Veteran and a retired Chief Warrant Officer Four. Chiles was honored as the Warrant Officer of the Year in 1998 by the United States Army Warrant Officers Association and in 1999, he was the first recipient of the Reserve Officers Association's CW4 Michael J. Novosel Outstanding Warrant Office of the Year Award. As a CW3, Chiles served on the Warrant Officer Executive Panel for the Army Leadership and Training Development Program (ATLDP). In 2016, he received the Don Hess Lifetime Achievement Award from the United States Army Warrant Officers Association.

Chiles is the author of "African American Warrant Officers…In Service to Our Country" (2014); "African American Warrant Officers – Their Remarkable History" (2018); and "African American Warrant Officers: Preserving Their Legacy" (2019). His first book, "As BIG As It Gets" (2010) chronicles his tenure as Chairman of the Board of the National Organization of Blacks In Government (BIG) for five consecutive years.

Farrell Chiles resides in Phillips Ranch, California.

9 781647 180089